Letters of Intent

Women Cross

the Generations

to Talk About

Family, Work,

Sex, Love

and the Future

of Feminism

◆ ◆ ◆ ◆

Edited by

Anna Bondoc and Meg Daly

THE FREE PRESS
A Division of Simon & Schuster Inc.
1230 Avenue of the Americas
New York, NY 10020

THE FREE PRESS and colophon are trademarks
of Simon & Schuster Inc.

Designed by Carla Bolte

Manufactured in the United States of America

10 9 8 7 6 5 4 3 2 1

Library of Congress Cataloging-in-Publication Data

Letters of intent : women cross the generations to talk about family,
 work, sex, love and the future of feminism / edited by Anna Bondoc
 and Meg Daly
 p. cm.
 Includes index.
 1. Young women—United States—Correspondence. 2. Middle-aged
 women—United States—Correspondence. 3. Intergenerational
 relations—United States. 4. Feminists—United States—
 Correspondence. I. Bondoc, Anna. II. Daly, Meg.
 HQ1229.L55 1999 98-51896 CIP
 305.4′0973—dc21

ISBN 0-684-85624-7

The letter, written in absorbed solitude, is an act of faith; it assumes the presence of humanity . . . To write a letter is to be alone with my thoughts in the conjured presence of another person.

—Vivian Gornick from *Approaching Eye Level*

Contents

Acknowledgments

◆ There are numerous people who have been instrumental in bringing this anthology to fruition. We would like to thank our editor, Liz Maguire, her assistant, Chad Conway, and the Free Press for their enthusiastic support. Also, a warm thanks to Jennie Dunham who has shepherded us and the book through all the various stages of publication and has offered her agenting know-how with great generosity.

We are grateful to all the contributors for their incredible insights, for their willingness to be candid, for their patience, and for their excitement about the project. Thanks also to the women whose manuscripts we were not able to publish—each letter that we've read informed the final book in significant ways.

Several individuals facilitated our contact with authors and offered helpful advice including: Veronica Chambers, Farai Chideya, Tara Roberts, Peggy Tiger and Karen Gomez at Tiger Gallery, Stefanie Kelly, Amy Richards, Karin Cook, and Phyllis Chesler.

Anna would like to thank Matthew Sand for his limitless patience and faith in her daydreams, friends who egged her on daily, her family for asking enthusiastically about "that letters book," the Sand family for teaching her chutzpah, and Gloria Steinem for the conversation that inspired this book. Meg thanks her mom for showing her how to be strong and independent, her family and friends for their unwavering encouragement, Ken Allan for listening so well and not minding her early morning work hours, the women at In Other Words bookstore for a working model of inter-

generational collaboration, and those unsung heroes of publishing: the guys at Kinko's in Portland, without whom this book would have arrived on Liz's desk in tatters.

Editors' Disclaimer

◆ While not all of the views and opinions expressed in these letters reflect our own, we celebrate their breadth and variety. We're proud to have brought together a diverse group of women with sometimes similar, sometimes discordant perspectives. Though each letter was written expressly for this anthology and therefore edited to some degree, we have tried to preserve each author's personal style and language choices.

We also want to acknowledge that the letter exchange format has built-in limitations. Because the younger women frame the issues and set the stage, the older women "have the last word", which has been uncomfortable for some authors. On the other hand, further dialogue and new alliances have been made in some cases that extend beyond the letters printed here. We encourage you to read these letters as excerpts of ongoing dialogues, and to allow these letters to spark cross-generational dialogues of your own.

Letters of Introduction

Anna Bondoc and Meg Daly

Dear Anna,

When you approached me with the idea for this book and the suggestion that we collaborate, I was equal parts thrilled and apprehensive. For one thing, neither one of us could claim a female mentor. While we had worked for female bosses, and met famous women and feminists, no one felt like "ours." I, for one, felt this to be a serious lack in my life, and while I loved and appreciated the men who had mentored me, I longed to have a feminist foremother to sit down to coffee with once a week and just shoot the breeze (or plan a revolution!).

Being a writer, I have "met" my chosen foremothers through the written word, and to this day, most don't know how much I respect and value them. I imagine this is true for many women. Some young women have had the good fortune to have a live mentor/friend/teacher/boss with whom they've formed a relationship that will last a lifetime. I hope also to develop such relationships, and one thing our book has shown me is that positive relationships across generations are possible and fruitful. In fact, with several of the "foremothers" I've met through working on this book, including my chosen foremother, Sandra Butler, I have begun a dialogue that I do think will continue in the future. I'm thankful for the enlightening conversations I've had with foremothers Phyllis Chesler, Katha Pollitt, Betty Millard, and others.

As much as this book has expanded my circle of foremothers, it has put me in close contact with some of the most innovative and exciting young women in the country. In the course of soliciting for and editing this anthology, I have compared notes with contributors about everything from bisexuality to bosses from hell, from body image to racial politics, from career angst to the necessity for political activism. I think you must feel it too, that we are amidst an interconnected web of groundbreaking women with whom we might build further creative projects and for whom we might help clear one another's path when possible.

My greatest joy, however, has been to work with you. It's absolutely magical what happens when you and I put our minds together! Time and again, we've marveled at how we balance each other out, whether in writing proposal drafts or coping with setbacks. Our friendship has deepened considerably through our collaboration, which is a testament to the importance of female friendship, correspondence, and collaboration. I see more clearly than ever how each woman in this anthology, including you and me, is elemental in a movement of women towards a healthier, more balanced world. We make up a movement that has been pushing up through time far before us and will continue on long after we've passed our wisdom on to the next generation.

I want to reflect on what I've learned doing this book, the surprises, and how we've changed as individuals because of the work we've done. As you know, I've been experiencing a sort of renaissance of political awareness lately. My commitment to feminism has never been stronger, and that is a direct result of the women I've met in these pages. Feminism is most decidedly not "dead"—clearly a rhetoric that serves only a conservative, patriarchal order—and many of the women here have literally put their lives on the line to protect or advance human rights and feminism. I am inspired and humbled by their work.

A couple things I've learned: One is that if I had to make a generalization about the older generations of women in this book (the forty- to eighty-year-olds), it is that the second-wave feminists among them have a tendency (I know I'm going to catch flak for this!) to talk as if femi-

nism and women's rights were invented in the '60s—an idea that the popular media has seized upon and which is a damaging myth concerning feminism floating around today. Women—feminists and not-yet-feminists—need to remember, constantly, that we are part of a legacy. The very fact that we have the rights we have today is due not only to the marvelous work of feminists in the '60s and '70s, but also the '50s, '40s, '30s, '20s, and the 1800s, and farther back in time and including every time any ordinary woman has demanded her basic human rights.

What I have learned about our generation (the twenty- and thirty-somethings) is twofold. One is that many of us have a very hard time with the notion of feminism. In fact, I doubt all the women in this anthology would call themselves feminists (though I do think of this as a feminist book). Some of them write about this, some don't. Some of the older women, too, have moved away from feminism. I find this all very troubling. Certainly, a concept and a movement such as feminism are open to and in need of critique. But by disavowing it, what is left in its place?

The other thing I learned about our generation is that a lot of us have an intense case of "handholding" syndrome. We're pissed off at our foremothers for not helping us out more professionally, rolling out the red carpet for us, and treating us like princesses. (I'm *really* going to catch flak for this generalization!) We use our anger at our "mothers" as an excuse for inertia and lack of focus. We're jealous that they got an exciting revolution and we got . . . Bill Clinton? While I think friendships and working relationships between women of different generations could only be a good thing, I must agree with Katha Pollitt when she responds to Emily Gordon's question about why more older women don't act as mentors to younger women:

> [A] reporter [who approached me] had your question: Why wasn't my generation welcoming hers into leadership? I asked her the same question I ask you: Where's you activism? . . . If NOW is too stodgy, start your own group. If *Ms.* is too granola, start the magazine *you* want to read. (I'll subscribe.)

3

Angela Davis has similar words for Eisa Ulen:

> So when you ask of my generation, "What formal structures do you have
> in place for us," my answer takes a similar form: "What formal structures
> do you envision successfully moving all of us into the future, your future?"
> . . . You possess your own wisdom. And you will make your own revolution.

So you see, as usual, I saved all my most candid and heartfelt feelings
and opinions for you. Except that thousands of other people will be read-
ing them this time around! But that is the whole point of letters: capturing
the intimacy between two people, the raw edges, the unfinished thoughts,
the quirks, and the passion for life. I hope everyone is as inspired by these
letters as we are. I'm very proud of us, my friend.

 Love,

 Meg

◆ ◆ ◆

Dear Meg,

 I never doubted that I wouldn't do this book *without* you.

But I too had apprehensions about this project: How would we get so
many busy women to write letters expressly for the book? How would we
select our contributors? Which issues should be covered? Even if we
found young women to write letters, would the foremothers respond?

What kept me fueled was memories of my days in the world of repro-
ductive rights conferences, where women of different generations came
together but didn't necessarily talk. Usually a panel of established,
"older" women sat on a podium, while a smattering of starstruck, impas-
sioned young upstarts like you and I sat in the front row, waiting for the
moment when the moderator opened the floor for Q&A. When young
women stepped up to the mike, often we would get tongue-tied and blurt
out a gushing, "I love you and your work" (embarrassing everyone) or
issue a feisty question about why "third wavers" concerns were nowhere
in the agenda. Typically, the older woman's response to the latter was,

"Aren't you grateful for all the hard work we've done for you?" or, "We'll look into it."

So on the one hand, you could say this book was born out of disappointment about older women's bewilderment toward our generation. They seemed to be waiting for us younger, privileged ones to pick up their cause—only to discover that we didn't always approach things the way they did, wouldn't choose the same battles, wouldn't define success as they did.

On the other hand, both of us were baffled to hear some members of our generation say, "I'm not a feminist, but . . ." But what? It's easy for us to forget that we enjoy certain rights that were fought hard for—and not invulnerable to reversal. Like you, I am renewed in my conviction that women who refuse to ally themselves with the feminist movement are like guests who stuff themselves at a banquet but refuse to step into the kitchen to put in their shift. Eventually the chefs on duty will burn out, leaving everyone to go hungry. You're right when you say that feminism's death certificate benefits the patriarchal order. But it also feeds younger women who eschew activism, saying, "I've got my job, my sexual liberation and my rights. See ya!"

We have both been inspired by our conversations with older women, whose stories remind us of our place in history. When I told a successful female attorney about our book, she recounted her early days as an attorney, when her boss invited her up to his apartment for a drink and she accepted because she felt her career depended on it. She returned his kiss at first, only able to put a stop to his further advances with, "I'm flattered, but I'm engaged to be married." (She then went on to specialize in prosecuting sexual harassment cases.) Some impulsive part of me asked, "Why didn't she tell the asshole to go to hell? And why didn't she report him?" I had to remind myself that I lived in an era where a friend was propositioned by her supervisor and could bring a sexual harassment suit. My friend and I were both college-educated and had both come of age during the Anita Hill–Clarence Thomas hearings, when it was easier to be publicly incensed and political among thousands of supportive women. Still,

even in 1998 my friend still found herself worrying, "What was I wearing that made him come on to me?" Obviously, our work isn't over.

And so you and I committed ourselves to assembling a book of letters between twenty- and thirtysomething women and their "foremothers." We found some pairs of women who fit the mold and had a long-standing mentor-protégée relationship or friendship. For the most part, though, the young women we approached were like ourselves: in need of an excuse to write intelligently and thoughtfully to someone we admired or were puzzled by from afar. While we wanted women to write to each other instead of idolizing, discounting, or pontificating at each other, we got some first drafts that, like those times at the microphone, were nervous and emotional—either too gushing or too angry to be constructive. We were faced with the delicate task of trying to edit "conversations" without censoring and diluting the original intent.

We wanted the letters to illustrate how life had or hadn't changed for women over the past forty years or so. Yet we were disappointed that so many said that things hadn't gotten better and in some cases had worsened. Eisa Ulen put it this way: "Sometimes I think black folks were better off when we had less rights and more revolution." But we had asked our contributors for real answers, not false, glib, or feel-good "solutions," and we got them.

You voice frustrations about how feminism is "spin-doctored" in the media. How many times have we talked about The Media's gleeful portrayal of the death, or at least the unhipness of feminism? Maybe this explains our generation of pundits' attempts to write feminist stories from more sexy, quotable, attention-getting angles palatable for *Entertainment Weekly* or the talk shows. There's "Do Me Feminism," "Girl Power," "Conservative Feminism," "Antifeminist Feminists," and, most recently, *Time* magazine's baffling "Ally McBeal Feminism." And while it's all well and good to investigate new feminist paradigms, it seems to make for superficial discussions of all-too-enduring problems. So celebrating bitchiness is "in," for example, but does that mean breast cancer is "out"? And who decided that feminism needed niche marketing?

What I'm most proud of is that these letters were, for the most part,

more personal, real, and deep than the usual sound bites and glib solutions. Sure, our contributors wanted to get into current front-burner issues like women in the military, lesbian parenting, motherless daughters, and racism. But they also wanted to ask questions and admit uncertainties. And seeing these letters alongside each other places seemingly unrelated issues into a context of larger, more complex factors like self-empowerment, distribution of power, and accountability.

Like you, I now feel connected to an incredible network of women and feminists. Like you, I want this book to jump out of its covers and become a site of activism, fervent discussion, and even disagreement. I want the women in this book to call each other up and say, "I was thinking about your project, and I want to get involved," or even "I can't believe you said that! Can we talk about this?" I want our readers to say, "I'm fighting for such and such, too," or even "They left out so-and-so, and she needs to have her work acknowledged." You see, Meg, our work could never be finished, in a way. We might have spent the next ten years finding contributors to this book! We left out so many women with stories to tell and questions to ask—female priests, basketball players, actors, sex workers, and CEOs. But doesn't that just prove the point that feminism will never be "over"?

After rereading our manuscript for the umpteenth time, I am struck by a kind of beauty about the unruly, unwieldy, nonhomogeneous nature of the book. We brought together women who share a fierce commitment to women's right to self-actualization but who may have different strategies for social change. For example, Arie Taylor's success as a black woman in the military matters to Sara Hammel, a young white journalist who would never choose to do hand-to-hand combat. Lisa Tiger's struggle to educate people about HIV in her Native American community is just as critical as and, in fact, linked to Tayari Jones' struggle to teach her students about feminism and homophobia in Texas. If our struggles remain isolated or if we refuse to listen to each others' conflicting agendas, we have no movement—just a slew of individual therapy sessions. Instead, we might build a feminism whose members accept that the movement is as complex, undecided, unclear, but as driven, impassioned and necessary as the individuals who make it up.

And so, Meg, for me this book has been about a feminism of acceptance. Our readers and even you and I have to accept correspondence that isn't all pleasant or even conclusive. Some letters diverged from the topic that we asked to see covered. Younger women searching for advice had to settle for some "figure it out for yourselfs." Some younger women's questions were almost deliberately ignored by their foremothers. Older women had to accept being "called out." We could have gone in and "demanded" happy endings, pat answers, treatises on the way things should be. But that wasn't only unrealistic, it's a moot point.

Feminists are here not just to survive (although sometimes it seems like that's the only thing we have time for). We are here to thrive. But first we must open our mouths, commit pen to paper, and declare our intent to act. And to talk to each other. We are supposedly the "more communicative" gender, but we have to be good listeners, too.

In the last six incredible years of friendship, Meg, you have bestowed upon me the generous gift of listening. I hope that I have returned the favor, because our numerous conversations, E-mails and letters have nourished my growth as a woman and as a feminist.

With great love and respect,

Anna

Part One

RADICAL NOTIONS

*Intergenerational Approaches to Activism
and Social Change*

Amy Richards and Gloria Steinem

Emily Gordon and Katha Pollitt

Tayari Jones and Pearl Cleage

Catherine Sameh and Suzanne Pharr

Marie Lee and Elaine Kim

◆ Contemporary young women have not come of age amidst the fervent political movements of their foremothers' formative years. Some say this is because the women's movement of the 1960s achieved so many of its aims. Others say older women continue to do the hard work and younger women have "slacked," not thinking they have to continue to fight hard for social change or that much change is needed. Some young women want to focus only on victories and not connect around victimization.

The letters in this section point to something else: Changing times bring new challenges and, accordingly, different strategies. The authors in this section are deeply committed to social change yet refuse to follow a prescribed activist formula. Their exchanges with seasoned activists illuminate what activism is and could be. Is writing activism, for example? What changes still need attention? And who exactly—established or newer activists—should set the priorities?

How Are Our Experiences with Abortion and Feminism Similar?

Amy Richards and Gloria Steinem

Dear Gloria,

We met on a Saturday in early September 1991 when I was a junior in college. You were about to finish *Revolution from Within* (well, almost) and needed help fact-checking and researching. I rang your doorbell, having no idea what to expect. I had a larger-than-life, child's vision of you in my head. You answered the door, warmly welcomed me into your home, finished a phone call, offered me tea, and gave me a chapter from your manuscript to read. If I did have any comments, I don't remember. I do remember thinking, "Who am I to comment on Gloria Steinem's work?" You quickly helped me move beyond this toward a place of mutual respect.

Although I grew up with a feminist mother in a house scattered with *Ms.* magazines, I still didn't really know who "Gloria Steinem" was. You had something to do with women and equality, although at the time I probably didn't use that word. I knew you and your life in an external and romanticized context. I assumed that you were just "born a feminist" and that the rest of us weren't lucky enough to have built-in "shit detectors," as you would say. Now, six years later, I do know you as a friend, role model, mentor, employer, and soul sister on this quest for equality—and I know that feminism has been as challenging, delayed, and difficult a journey for you as it has been for the rest of us.

When I met you my activism was in its infancy, whereas yours was an

innate reflex. I wasn't "political," nor was I a student leader in the traditional sense of the word. I took women's history courses out of sheer interest, prided myself on being the daughter of a single mother, and nurtured my female friendships. That was pretty much the extent of it. Now I see that I was emerging as a young feminist activist, but back then I wasn't "uneducated" enough to give credence to the words feminism or activism. I'm hopeful that my actions spoke louder than words. Why was it, for example, that I fought to be the first female head of my high school or to make sure that the girls' soccer team didn't have to wear the boys' old uniforms? My mother inspired many of these actions, but I needed your nonfamilial example to appreciate these as feminist acts. Like me, you took several early steps—all part of a natural progression toward feminism: you were the vice president of your senior class (I was vice president of my senior class), you went to Smith College (I went to Barnard College), and you worked for the liberal presidential candidate Stevenson. (When I was a junior in high school, I worked for Senator Ted Kennedy.)

From working in the women's movement, I have learned about "the click"—the moment you finally acknowledge that things just aren't right for women—which became synonymous with your generation's introduction to feminism. Many women of my generation, on the other hand, came to feminism through a steady realization. In many instances we were simply living feminist lives, even if we didn't yet call ourselves feminists. My most obvious introduction to activism was a 1989 pro-choice rally and march. On a rainy November day, amidst a sea of women and children (and a few men), I chanted, "My body, my right." At that time, I translated that phrase as "pro-abortion," not yet understanding the deeper roots of reproductive freedom. I marched for other people to have the right to abortion, never thinking that I personally would have to use it. I also hadn't yet connected the "political" act of marching to any "personal" experience. I was experiencing the excitement and comfort of being among people united for something that we believed in individually and collectively.

Now I know that reproductive rights encompass much more than the right to have an abortion, including access to information and to resources that enable us to make informed choices about our bodies and

lives. It begins with comprehensive sex education and "praise for women's bodies," (to borrow a title from one of your articles) and ends with controlling our bodies and, in turn, ourselves. As you have often pointed out, reproductive freedom is a basic human right, like freedom of speech and freedom of religion.

My friend Zoe was the impetus for my being at this march. A few months later, she bought me a home pregnancy test when my period was two weeks late. My test was positive, and I was forced to deal with my own misconception that "teenage pregnancy" was something that happened to other people. For the first time, I was confronting my fear of "ending up where I began" (a sentiment you first put into words for me), remembering the girls from my working-class neighborhood who were sent off to "homes" for nine months or were single mothers by the age of sixteen. I knew my choices: adoption, irresponsible parenting, or abortion—and there was never a question in my mind that I was going to have an abortion. It was the best choice for me and for any potential child.

Regardless of my certainty, I still carried around guilt and shame about having been "knocked up." This little voice in my head whispered, "You knew about birth control; you knew it only took once." Plus, I was trying to live up to society's unrealistic expectations that girls be infallibly good. So I hid these feelings and tried to protect myself from having to tell anyone. I soon realized that this was hurting me more than protecting me.

The minute I dared to hint to a few select friends that I was pregnant and about to have an abortion, some acknowledged they had made the same decision, and we shared sighs of relief. During these moments of honest exchange we connected our personal lives to larger political issues. Why, we wondered, were we made to feel as though we were bad people just because we had become pregnant and decided we weren't ready for it? We were confronting the fact that our guilt and shame came not from within but from a powerful, gendered caste system that judged women's lives in an unrealistic way. Verbalizing our experiences was the most difficult leap. Once we did, we realized, one, that our feelings of "being judged" went away, and, two, that those judgments were inflicted on us because we were female. Discovering that we weren't in control of our de-

cisions—because these decisions were actually in the hands of the "state"—made the personal/political link all the more obvious and, likewise, all the more frustrating.

I remember sitting with you one night watching a documentary about women's reproductive choices. You said that you "had yet to see any film capture your experience with abortion"—one that was void of guilt and shame. You told me you have never once thought about "what 'it' would look like or how old 'it' would have been by now." Knowing this realigned my thinking because I was still trying to make myself feel guilty for becoming pregnant in the first place. When I have made remarks like, "After having had a legal and safe abortion, I will always fight for reproductive freedom," or "Such and such happened when I was pregnant . . . " people have responded, "I'm sorry." Sorry for what, I wonder. Sorry for "my loss"? Sorry that I made that choice? Could we all still be victims of antichoice brainwashing? And, how, Gloria, have you managed to fend it off?

I made a promise to always speak openly about having had an abortion to keep others from feeling isolated. Each time I have shared, I feel relief—my openness has helped others deal with similar decisions, just as your openness in the pages of *Ms.* about having had an abortion comforted many women, myself included. I know that it was this kind of consciousness raising that inspired the feminist movement of the 1970s—and that is needed to continue to inspire the feminist movement of the 1990s.

My abortion was safe, legal, and in the most basic sense accepted. The doctor who performed your abortion made you promise two things: one, that you would never tell anyone his name; and, two, that you would always do whatever you wanted with your life. The doctor who performed my abortion didn't need to use those words with me; he didn't have to: My decision was a commitment to do whatever I wanted with my life. What we share is that both experiences brought us to our feminist activism. I had assumed that going undercover as a Playboy bunny sparked your feminism, but, in fact, it was a public hearing on abortion. Both of us awakened our personal commitment to approaching wrongs through a gender lens—the push we needed to stop divorcing the "us" from the "them"—those whom we wanted to "help."

14

Once I'd arrived in a feminist world, I couldn't imagine where I'd be without it. But I can't help but ask why so many people wait for a personal experience to make that political connection? I look at Anita Hill and how she was jettisoned into feminism by being forced to painfully revisit her sexual harassment on national television. Through my work with Third Wave (a national philanthropic and activist organization for young feminists), I see many young women—and men—who are reticent to speak out on issues unless they themselves are directly affected. But I cling to Third Wave's philosophy: See It? Tell It. Change It! I just wish we could work on "changing it"—whatever "it" is—without having to first experience it so intimately. Do you think it's inevitable that we get motivated to be activists only when we experience injustices?

The journey toward equality will hopefully bring some answers, and it's because of your work and others' that we can even formulate the questions. As a feminist activist on this journey, I'm privileged to have your life and work as an example. It makes my trip a little less lonely and certainly less daunting. Still, as you have calculated, we have at least a hundred years left on our quest to a world "where women matter." To combat frustration, I always remember your standard reply when people ask why and how you do what you: "Because it's harder not to."

I am always thinking of ways to thank you for your example and for all that you have exposed me to. Nothing seems like quite enough. The most appropriate way is to promise to provide others with the example you've given me . . . and to do whatever I want with my life.

With thanks, sisterhood, and oh so much love,
Amy

❖ ❖ ❖

Dearest Amy,

I like this idea of writing to each other. For one thing, it makes a place for us to understand each other even better. Though we've spent six years working together, we're both too subject to outside demands and deadlines to have enough time to talk and explore, so in a way this assignment is a gift. For another, I think our letters may help disprove the myth that younger women learn more from older women than we older women do from you.

In my experience, it's pretty balanced: experience in return for fresh perspectives, a longer view in return for a clear focus on the present.

With you as an individual, I also have special rewards. You are one of the most constructive, energetic, intelligent, and empathetic people I've ever met, regardless of age. I learn from you every day. For example, I learned from your letter that even you, who were born into a time when abortion was legal and women were allowed to be sexual beings, still tried to force yourself to feel guilty about needing and having an abortion. That surprised me, for more than thirty years before, I had done the same thing. This makes me more aware that deep change comes slowly, that even though decriminalizing abortion has saved women's lives and health, women are still being held more responsible for sexual behavior, not to mention for the decision to give birth to ourselves instead of (or before) giving birth to someone else.

However, I'm glad your time of feeling alone was measured in weeks and months, not years. That's the difference between struggling in isolation and having a women's movement. You could share your experience and know you were not alone. That didn't happen to me for more than a decade. Yet we were both prevented from exploring our true feelings at the time and honoring our decision as taking responsibility for our own lives. It makes me understand that if I focus on how much better it is for you than for me, I will fail you. This is the way older women often fail younger women: by comparing emotions instead of respecting experiences as absolutes. As Letty Cottin Pogrebin has said, there can be no "competition of tears." Tears are tears, joy is joy, and all of our feelings are to be honored. There is no hierarchy of emotion. Neither of us should have to decide whether it's better to be young or old, born into this era or that, with or without a particular race or class, with this sexuality or that ability. Feminism is not about ranking, but linking; about creating a community with others who are just as unique as we are. Unless women act together with this consciousness of balance between sameness and difference, we will remain a very long way from the vision of the old Irish woman taxi driver who said to me in Boston many years ago, "Honey, if men could get pregnant, abortion would be a sacrament." She understood what was shared, regardless of age.

What you and I experienced is also an example of the large body of research that shows—despite media depictions of abortion as an always agonized choice—that the most common emotion after an abortion is relief.* Regret, depression, and guilt occur mainly when abortion is the result of pressure, and is not freely chosen. Nonetheless, its popular image is still one of tragedy—more tragic than going through a forced pregnancy and bearing an unwanted child, even as a result of rape. (To assess the real cost, we need only think about the torture used to break the will of women political prisoners: forcing them to bear the child of their torturer.) In other words, most women who choose abortion have an experience that is closer to yours and mine in taking control of our own lives, yet the idea of abortion as always tragic renders our two realities invisible, and also devalues the tragedies of women who are coerced and pressured.

Maybe this respect for similarity and difference—for a shared emotion, created by a different cause in a different time—is the key to making friendships across generations. It keeps older women from telling younger ones, "You shouldn't be feeling thus and so" (because your circumstances seem so much easier than ours), and keeps younger women from saying, "You can't possibly know what I'm feeling" (because circumstances were so different from the world as it is now).

To put it another way: We all fight for our lives on the barricades of our times, in ways large and small. Each generation fights to clear more safe territory—or fails to fight and loses territory. So the next generation experiences a parallel struggle, but in a different place.

For example, you and I were both the daughters of single mothers and spent most of our lives as partners in a family unit of two. This made us independent and taught us how to survive in the world. We also shared feelings of shame at being different and a romantic envy of the so-called "normal" family we didn't have. On the other hand, my mother came of age in the regressive years between the first and second waves of feminism, and was made to feel crazy for wanting to follow her personal star,

*See *Abortion: A Positive Decision,* by Patricia Lunneborg, and *Abortion and Woman's Choice,* by Rosalind Petchesky.

instead of following her husband—a struggle that had broken her spirit long before I was born. It was different for your mother. Younger than I am, she had more support for her courage in leaving an impossible marriage, struggling for her own education, and finding work that could support her and her daughter. She didn't remarry, yet she did have male companionship (which my mother would have rejected as improper, even though she, too, had fallen in love with another man after my father). She also found an alternate family in her women's group, a small circle of friends who have supported each other for more than twenty years.

All of this means that you and I shared independence and outsiderness—as well as respect for our mothers' struggles—yet we grew up with a very different model of female strength and possibilities.

I don't know whether you will marry, live alone, with a partner, or choose some combination of these in sequence over your lifetime, but I see you and your generation as much better able to forge equal partnership. Mine absorbed the message of marrying the person we wanted to become, not becoming that person ourselves, and so marriage came to seem to me like the end of all possible change—a little death.

You can imagine an equal partnership and redefine marriage as an institution for two whole people, not a person-and-a-half. Your sense of self can continue to grow after marriage—not to mention your legal ability to keep your name and civil rights—in a way that rarely existed in our hopes, much less our realities. Still, inequality is likely to arrive when and if you decide to have a child. Men are not encouraged or required to take care of children and the home as much as women do—to put it mildly—so women still sacrifice more of their own time, possibilities, and sense of self. Equal parenthood will have to be imagined before it becomes real, and even so, it will take big societal shifts in work patterns and a new vision of both men and women as achievers and nurturers. In other words, my generation demonstrated that women can do what men can do. Yours will have to demonstrate that men can do what women can do.

Barriers in the workplace have also moved, leaving more free territory, but much still to be cleared. I was turned away from jobs and entire professions for being female: "Help Wanted—Male" and "Help

Wanted—Female" were categories in want ads until the 1970s (as "White" and "Colored" had been until the civil rights movement), and professional schools categorically excluded or allowed only small quotas of females. Your generation can enter the work force pretty much anywhere and do well for a decade or more. But then the barrier reappears: The glass ceiling shuts you out of high positions, and the sticky floor of the pink-collar ghetto still keeps most of your generation of female workers in poorly-paid, mostly female jobs. Future victories will be won partly by the tactics that worked for us—and we'll be glad to share them—but you will also need tactics that only you can imagine.

You also may have learned from observation that women are the one group that gets more radical with age. In the suffragist era, the critical mass of activists were over fifty, sixty, even seventy. In the current feminist one, most are over forty or fifty. In a patriarchy, this political pattern makes sense: women lose power as we grow older, men gain it; women gain more reason to rebel, men grow more conservative. The miracle that you and many other young women have performed is measured by the degree to which you have overcome this pattern. You are honoring yourself and other young women.

But you still may need the comfort of remembering—especially when looking at your contemporaries who are still fearing feminism and playing by the patriarchal rules—that life itself will eventually radicalize them. You also will see this pattern disappear little by little, a decade at a time, until female power is finally no longer derived from youthful sexuality, childbearing, and finding Mr. Right. Eventually, women and men will be valued for all the varying periods in our lives, not for playing one conformist gender note.

You said you were surprised that my feminism was as "challenging, delayed and difficult a journey" as yours. Perhaps each of us sees the other as having been "born feminist," or generally having an easier time. That's the impression we get from all the no-process, no-struggle images of the media. The only answer is to talk to each other and, whichever side of the generational divide we're on, to answer each other's questions honestly.

For example, we both feared "ending up where we began," the

penalty for those of us who have traveled a long distance in our lives. I can only tell you that as time and confidence increase, the fear melts. Sooner than I did, you will bring all your worlds together.

Which leads me to something I think we both need in form, even though it varies in content: a group of women friends to meet with once a week or so. My generation called this a consciousness-raising group; and later, a networking group. Some young women now call it a book club, a coven, or just "my group." But as long as women are marginalized, we will need a place where we are central. At least for a few hours, we can nurture strength and a collective vision.*

Besides all these examples of cleared and uncleared territory, there are free spaces only you as an individual inhabit: You are so responsible that you never forget the largest political issue or the smallest need to lock the door; you are ten times faster than I am at every task and give me the feeling of wind whistling past my ears; you not only know what's wrong with the welfare system but take your personal time to help a mother on welfare go to court to keep her children; and in the midst of growing into a world-class feminist organizer, you never forget the joy of cooking or dancing, shopping or having fun with friends—which is, of course, part of being a world-class organizer.

After all, revolutions must include dancing and sex, poetry and good food, friends and fun. Otherwise, we won't have them when the revolution is over. Never forget: The means *are* the ends.

No matter how equal our exchange and mutual learning, however, I'll always have one great advantage over you. Because of my age, I'll never have to live in a world without you in it.

With love and trust,

Gloria

*These groups seemed so often the missing element in women's lives, especially young women who missed the consciousness-raising groups of the 1970s, that I included guidelines for creating them in Appendix II of *Revolution from Within*.

Does Your Generation Resent Up-and-coming Young Women?

Emily Gordon and Katha Pollitt

Dear Katha,

Didn't you once tell me that lateness was my most serious short-coming, the one I would do well to fight back now if I wanted to save myself (and others) grief in the years to come? Yet this letter has been extremely hard to send. Is it because you're never hesitant about telling me what you think of my writing—that you hold me to higher standards than any other reader, that after everyone else has signed off on a book review or essay, you find whole paragraphs to cut and new points to introduce? Or is it that I fear you'll think I'm an intellectual lightweight for making this personal? But personal is what our relationship has been ever since I began babysitting for your kid, then as your intern and then copy editor at *The Nation,* and now as a friend who sees and talks with you often. And I think I'm damn lucky to know you this way.

Our relationship could, in fact, be a model for feminist mentorship: You advise me on my book reviews, and I help you with the Internet. I fax you a new poem, and you ask me for my understanding of date rape for a piece you're working on. You tell me to stand up to the muddled editor who garbles my prose. You eradicate my mixed metaphors and vague generalizations. You stoke the fire of my political outrage—and I can talk back to you. There is power and strength to be drawn from worthy predecessors, and I know that first hand. It's not only because my friends ad-

mire your work that they're envious of our rapport. Sadly, it's all too rare that a twentysomething woman can learn about being a feminist, a writer, a professional, a book critic, a poet, a woman, an adult, from someone of your stature.

We were talking about Katie *"Morning After"* Roiphe some months ago, and you said that younger women need to take action, grab the floor from such pseudoradicals, and join in more thoughtful debate. As for me, I wish I could contribute more to our intergenerational feminist conversation. When we talk about politics or culture, sometimes I hit a groove and can articulate my thoughts, and what I say is a useful part of the dialogue. Other times—most other times, I fear—I falter and stumble, my speech filled with those inevitable "ums" and "likes" and "y'knows" that litter the speech of my peers and that I try in vain to exorcise.

I seem to project a lot of my anxieties about the future onto you, which isn't really fair. But you've become many things to me: additional parent figure (you were the first person I called when I got mugged a few years back), boss, teacher, confidante. You're the force that questions easy satisfaction and any tendency toward complacency— the only person who'll say to me, immediately upon reading a completed book review that's taken weeks to write, "This has two problems: the structure and the thinking."

People might say such comments are overly harsh, that they don't take into account my hard work, writer's block, good intentions. Well, I'm tired of good intentions. I want to make something of myself, and I've finally learned to listen to you when you try to help me do that. Of course, I need to take what you say with a grain of salt, too—to remember that not *everything* you say is right just because you're Katha Pollitt—as well as listen just as hard to your praise.

When I wrote my first magazine piece on feminist themes, I was intimidated by the thought of discussing it with you. For one thing, I felt the pressure of being on your turf; after all, I was writing about Roiphe's new book, and you'd made eloquent hash of her first one. But we talked about it and thus, untangled my opinions. Just as you pare my poems to the core, drawing a definitive line through each overindulgent adjective, you

get to the heart of my logical inconsistencies and clouded thinking. I can't put anything over on you—I have to be prepared to defend or explain all of my opinions, attitudes, and inherited ideas.

Not all my dealings with older women writers have been so fruitful. My mother keeps urging me to call an old friend of hers, a well-published poet who would be generous with her advice, contacts, criticism, and time. I know she'd be kind, but I hesitate, even while feeling stupidly self-thwarting. Though I hate to say it, I think older women writers generally don't—or choose not to—have a great deal to say to younger ones.

Here's an example. Earlier this year I went to a poetry event commemorating John Berryman. There were three poets there I wanted to talk to. Poet Number One, an anointed and idolized professor, was leading the Famous Poets to their seats; she swept by me in a flush of importance, pausing long enough to give me a noblesse-oblige hello. Poet Number Two was a former workshop teacher of mine, whose commitment to sharing the craft and history I loved and vowed to emulate someday. I got her friendly attention for a minute, until she caught sight of the Famous Poets loitering nearby. "Sorry! I just wanted to . . . ," she said anxiously, and sped away, fobbing me off on another student (who looked as bereft as I felt). An odd thing to witness: a woman I respect, who seems to be about as secure professionally as you can be as a poet, yet still so obviously eager to be approved by creatures with far more recognizable names.

As the event wound down, I approached Poet Number Three, whose book I had reviewed (positively) a few months before. Excited to be face to face, I introduced myself, and as she gave my hand a cold little shake, she gave me the once-over. She looked stunned. Her expression shouted, "Who the hell are *you* to review my book?" I was clearly too young to be an acceptable peer. I was stunned, too. I'd expected indifference or puzzlement at worst; I hadn't expected hostility. The look in her eyes haunted me for weeks.

Why so much acrimony, so little trust, so little time taken out to pass along skills and information? Maybe one explanation is the continuing sense of tokenism in professional literary circles—on magazine mast-

heads, heading prestigious arts committees, receiving major cash prizes. Encouraging a young woman in journalism or publishing might mean she takes away your job and even your sexual status, in some ugly *All About Eve* scenario. Hence, perhaps, Poet Number Three's impulse to haughtily reestablish the pecking order. It's a common perception among younger feminists (and I'd be curious to know your take on this) that older women feel we were born with all the rights and respect they won, so we don't need any help. But magazines and newspapers are still sexist institutions, with old-boy regimes and connections, and we could use the warnings, advice, and phone numbers.

I was lucky to go to Barnard, where there was no shortage of formidable women professors and serious individual attention. If a professor said I reminded her of herself at my age, it was a compliment (usually). There was no threat in any successes I might have as an undergraduate. So it still surprises me—four years after entering the real world of publishing, journalism, and that odd tangle of people who consider themselves working poets and novelists—that my very existence can be perceived as anything from puzzling to a vague menace. It turns out that in the literary world it's every woman for herself; there's little sense of solidarity, even among many younger women.

Granted, journalism demands a certain brash thick-skinnedness; poetry another kind of courage, the courage to continue in deafening silence, with few accolades and little or no remuneration. The only things we have are the usual faith and madness that fuel politics and art and the encouragement of our "peers"—which in a perfect world would be an ageless category. You might say the world of writing is necessarily a barren place. But is it that way more often for women?

If so, it's frustrating. Didn't I grow up giddy with the belief that ERA or no ERA, women had won their rights and equality once and for all, that I could grow up to be whatever I pleased, that there was no stopping this more-than-half-the-world who were united in their previous oppression and their superior communication skills? Reality shaded that pretty picture, but for me as for many women my age, the ideals remain.

In journalism and publishing, it's still true that shamefully few women

have broken through to the highest ranks. In my more suspicious moods, I sometimes think that under the continuing boys' club, most educated twentysomething women—with their computer-compatible minds, high energy, and degraded wage-and-benefits standards—are kept working as glorified secretaries until they move (horizontally) on.

It seems to me that women in journalism, publishing, political activism, the arts, can and should make a commitment to helping out the younger women in their fields. I'm not sure what an ideal mentorship would consist of; it's nice to imagine a fantasy old-girl network, with the equivalent lunches, invitations, and introductions. Maybe when all things are economically, socially, and professionally equal, all that will simply fall into place. That could also take until 2999. Isn't there a leap we can make here and now toward that goal? If so, that leap would be primarily the responsibility of those in power—or who at least have more power than we do.

Do your writer friends ever talk about this? It's been so crucial for women of your generation to prove themselves and make a place in a male world that it seems they haven't yet made it a political agenda to help up-and-coming young women find their place in the professions. I'm not, of course, saying the old-boy networks are such laudable institutions that we should imitate or be absorbed into them without some considerations. When women in power are haughty and dismissive, they may as well be imitating men—as though compassion were the sphere of softies whose weakness in looking back whence they came will only drag them down.

Everyone knows male writers whose love for themselves and the awe they inspire is unrivaled in Shakespeare, and they tend to be the same men whose books and articles are curiously unmarred by acknowledgment of editors, researchers and administrative assistance. Maybe power just does that to a person, but I don't think so. I think women can and should act more like evolved humans, decidedly not from some biological impulse to care but because we haven't always had the chance to give someone else a leg up.

I may be a member of the disaffected Xers, but I have little interest in rebelling against my elders. And with every piece I write, I find I'm less

devastated by your criticism. A few years ago, when one of my first book reviews was about to be published, I hadn't given it to you to read. In fact, I was afraid to, but I finally fed it through the fax. The review was in its final page-layout form—I wasn't supposed to be mucking around any more.

Boy, did you have a lot to say! I was crushed. No one else had seen anything wrong with the piece, and I had been thrilled to be finished. I've been repeating the story you told me that night ever since: "Emily, when Isaac Bashevis Singer was a young man, he had a novel accepted and published. Just as it was about to be released, he realized he couldn't stand it and didn't want anyone to read it. So he went to the publisher and bought all the books. They never even went to the stores. Don't ever let something be printed with your name that you're ashamed of." I worked through the night, and the review got better. Whenever I look at the published version, I remember your advice and I'm grateful.

In a final note of optimism, here's a sequel to the Night of the Poet Women I described: At a recent reading (this one honoring a woman poet!), who should approach me but Poet Number Two, with an invitation to talk over lunch or coffee: "I've been so busy, but just call me and I'll gladly give you an hour." When I become most downhearted about the fundamental loneliness and cold comfort of writing, I'm revived by generosity like this and yours.

And what about from your end; how do you think we younger reasonable creatures can best make our point, and can we make it as well without the extension of time and effort on the part of women like you? Can anything we do in the twenty-first century approach those revolutions you witnessed and were transformed by? A tall order, I know. Then again, I've never known you to give anything but a straight answer.

Love,
Emily

❖ ❖ ❖

Dear Emily,

I had to laugh when you said I'd made you conscious of your generation's verbal tics—saying "um" and "you know" a lot, especially in light

of the theme of your letter and this book. Last fall I spoke on a panel with a number of other writers, including an older, celebrated woman poet. Afterward, I told her I thought she'd done a terrific job, which was a bit of a social fib, to which she responded by telling me I should learn not to say "um" when I spoke in public. I barely know this woman, I thought, and I'm forty-eight years old! What is it about me that allows people to think they can instruct me in this confiding, intrusive way? Do I possess no personal dignity at all? The same thing happened the first time I read at the 92nd Street Y, when I was already in my mid-thirties, after *Antarctic Traveller* came out. Of course I was a bit nervous—my whole family was there and many good friends—but I thought I had gotten through it all right. And then afterward up comes a woman poet maybe fifteen years older than I, a total stranger although I knew her work, and she puts her hand on my arm and says, "Katha, you have to learn to speak louder and with more authority, not so much like a 'girl'." I mean, really, I thought, "Who asked you?" And of course, given how taken aback I was, and the age difference and also, maybe, something else, some mixed-up, probably deceptive feeling of understanding the other person better than they understand you, the moment passed. I never did say, "Thanks so much, Ms. Mini-talent of the Decade, let me know next time you give a reading and I'll come review *your* diction."

Did I mention that both of these women are feminists? And that although sometimes I have longed to tell a younger woman poet not to read "like a girl" (for instance, with that awful "poetic" end-every-sentence-like-a-question inflection), so far I have managed to keep my remarks to myself?

I bring up these incidents because I think they suggest how hard it is to give—and receive—advice across the generations. You tell three stories about what you take to be unfeminist rejection by older women poets and contrast those experiences with our friendship. But isn't the difference really that you and I *are* friends? I'm interested in your life, I like gossiping with you on the phone, I like to read your writing, and you can take my sometimes strenuous critique as well-meant, not because we're both women or feminists, but because we like each other and know each other

well. You can't expect the same kind of attention and concern from strangers, casual acquaintances, and such, even if they are female. Women are just people. *Feminists* are just people. Many of the famous ones are preoccupied and self-centered, as celebrities tend to be; many of the literary ones possess the common character distortions of being a writer: anxiety, self-doubt, envy. All those days in a little room alone!

Now add to this volatile personality cocktail your expectation that these women will be kind, attentive, helpful—well, you can see why you come away from these encounters feeling slighted. But, you know, if you met some famous middle-aged male poet at a reading you might not expect more than a cordial nod (of which I've received many!). You might even think it presumptuous to expect more or at least decide that it was up to you to bring about some deeper exchange (and if you were me when I was in my twenties, you'd find that nearly impossible and console yourself with spiteful banter in the company of your coevals). You seem puzzled that Poet Number Three did not seem to appreciate your lengthy review of her latest book. Would it shock you if a leading middle-aged male poet wasn't thrilled to have his book handed over to an as-yet-unpublished poet, however talented? Unfair as it may be, the standing of the reviewer makes a statement about the book.

I've always hated that word "mentor." It's part of the general diffusion of bogus business-school-guru terminology throughout other areas of life. Its use in poetic contexts particularly depresses me, because it shows so clearly that poetry is becoming more like other professions—you get your MFA, publish your book, give readings, teach here, teach there, retire, die. Poetry has its own weird, artificial star system now, one which, unlike the star systems of, say, fiction or journalism, has very little to do with readers or with having some kind of presence in the larger culture, and lots to do with the tastes of a handful of gatekeepers. Was Verlaine the mentor of Rimbaud? Or Marianne Moore of Elizabeth Bishop? Did Whitman or Dickinson (or Cavafy or Baudelaire) have mentors? Or, for that matter, "careers"? Sure, I can think of poets of both sexes whose "success" (publication, prizes, teaching jobs) is due at least in part to their cultivation of influential elders, male or female. And you could be right

that women writers aren't noticeably generous in extending this kind of help, although, now that I think about it, I wouldn't formulate the issue that way. I'd say that women writers are probably just as helpful to the young as it's reasonable to expect writers to be—certainly they're as helpful as male writers. But even today, there are fewer women writers, they have fewer plums to give out, and they are also more likely to help young men than older male writers are to help young women (unless, of course, they're sleeping with them, in which case the sky's the limit!). Thus, if my math is correct, young men get about three-quarters of the total available elder help, which is, after all, a finite resource. The women writers you want to nurture you may already be tapped out.

But, you know, so what? This whole notion that writing is all about mentoring and networking and each generation smoothing the way for the next like party hacks down at the clubhouse is the wrong idea. Writing is about *writing*. That's what you should be thinking about! Don't worry about what Poets number one, two, and three think of you—worry about what William Blake thinks of you. If you can write seven or eight wonderful poems, you won't have any trouble finding older people to interest themselves in you, unless of course those poems are so strange and original and shocking that your elders fail to understand them, which will only add to your glory when the world eventually comes round. Did you know that Howard Moss, the poetry editor of *The New Yorker*, a lovely man who befriended many young writers, rejected all but one-half of one of the more than thirty poems Sylvia Plath sent him in the last five months of her life, poems that will live in the English language forever? And Knopf rejected *The Bell Jar*? Plath was a champion networker, and it helped her quite a bit in the clubby British poetry scene. But in the end, it's the work that has to carry you where you want to go.

Now what does all this have to do with feminism? You write that you are disappointed in my generation—too insecure and jealous to welcome the threatening young. As I said, I think that's not quite fair: The world is full of not-so-nice people, prima donnas of both sexes, and climbers who work the room at literary parties. It's even fuller of people who, whatever their personal qualities, are too busy or too committed already to pay at-

tention to you. There may even be a few who just don't like your writing, or, although this is hard to imagine, you. Even so, advocacy by women my age, in publishing and academia, is a major reason women of the next generation get teaching jobs and publishing contracts, win fellowships and prizes. I've sat on those committees, and I know how many men there are for whom the writing of women simply does not register. This is particularly true with respect to serious poetry, which for complicated literary and sociological reasons has historically been a mostly masculine domain.

No, I would say that the sources of the difficulties of transmitting feminism down the generations lie elsewhere. It lies, perhaps, in the underlying assumption of your letter, which is that feminism was my generation's preoccupying task and its fruits should be, but somehow are not, your generation's inheritance. But this model of orderly succession is not how politics works—it isn't even how families work. My generation faced specific circumstances—there we were, the best-educated and most birth-controlled generation of women in history, coming of age in the '60s and early '70s, with the economy booming and an antiwar demonstration around every corner, and we were supposed to be chaste wives? To spend our lives worrying lest we threaten what the women's magazines invariably called "the fragile male ego," by showing too much talent, drive, independence, sexuality? Out of personal need and an unusual historical opportunity, second-wave feminists were able to defy unjust and antiquated models of women as inferior, subject, lesser, dependent that had informed law and custom for centuries. Your generation faces different historical circumstances, equally challenging: Society is more atomized, the '60s political movements largely dissipated; and with the lifting of legal discrimination against women, the obstacles to women's liberation are more covert. But they're not all *that* covert, you know. It's not exactly a secret that women are still paid less for the same work and that most men are not interested in equal sharing at home. Women's bodies are every bit as objectified and commodified as they were when New York Radical Women picketed the Miss America Pageant in 1968—maybe even more so. But where is your generation's

energy to fight these injustices? Where is your solidarity with each other? You could be meeting with each other by the thousands and tens of thousands organizing, forming caucuses at work, starting your own organizations, calling your own demonstrations. When did sisterhood become mother-daughterhood?

Last summer I worked with a young woman reporter—excellent journalist, good writer—who was trying to write an essay for *The Nation* about the failure, as she saw it, of the established feminist organizations to share leadership with the young or to incorporate their perspectives. The leadership point is valid enough, but what *were* these perspectives, I asked? Less time on abortion, more on pop culture seemed to be the answer. She got me thinking, because of course abortion is very much a young woman's issue. Most women who seek abortions are young, and access to abortion is one of the things that makes the contemporary middle-class twentysomething life pattern—postponing marriage and children in favor of education and jobs—possible. Moreover, young women are particularly vulnerable to abortion restrictions—they're less mobile and have less money, not to mention being the targets of parental notification and consent laws. Forget sisterhood the metaphor. What about your own real-life younger sisters still at home? How come I'm still writing columns and articles and essays about abortion—shouldn't your generation have taken over this issue by now? Almost half of all medical students today are female, but where are the young women doctors to replace the rapidly aging abortion providers? And what about daycare—another young woman's issue that the young haven't made their own?

This reporter had your question: Why wasn't my generation welcoming hers into leadership? I asked her the same question I ask you: Where's your activism? I don't blame the young for the decline of feminism as a mass social movement (as opposed to feminism the cultural force, which is still very much in evidence). Social movements require particular circumstances to come into being, and today the time may not be right. But it would be nice to see a bit of passion, even some of that rebelliousness you disclaim for yourself—and I don't mean the phony rebelliousness of a

Katie Roiphe or a Rene Denfeld or a Naomi Wolf, who present them-
selves as daring iconoclasts even as they embrace the most shopworn con-
ventional views. I mean rebellion from the left, from women who want
there to be more to feminism than increased opportunities for individual
self-advancement and the purchase of one's very own set of politicians.
The truth is, the big second-wave institutions—the professional lobbying
groups, the political organizations, the publications, even the women's
studies programs—could use a shake-up. I could probably use a shake-up
myself! I'd like to see more of those qualities so beloved by your genera-
tion—attitude and edge. Why so wistful, pierced and tattooed ones?

So here's what I think: If NOW is too stodgy, start your own group. If
Ms. is too granola, start the magazine *you* want to read. (I'll subscribe.)
And—just to bring this I'm afraid slightly testy letter back to its starting
point—if you don't get enough encouragement from older writers, forget
them. Just forget them! Do what young writers have done together for
centuries: Stay up all night reading and talking, fall in and out of love,
argue, praise each other outrageously, criticize each other ditto, and re-
mind each other constantly that your reason for living is to set the world
on fire.

Love,
Katha

Which Come First, Our Paychecks or Our Principles?

Tayari Jones and Pearl Cleage

Dear Pearl,

College was easy.

There were 343 Black women in Spelman College's freshman class of 1987. We sat in Sister's Chapel as Johnetta Cole, the first sister president of that institution, addressed us for the first time. "Look to the left," she said. "Now look to the right." We did so. I had read enough books to know that this was the part when the president warned us that only one of us would be seated in the auditorium on graduation day. Instead, Dr. Cole said, "These are your sisters, and it is your responsibility to see that all three of you are seated here in 1991." The sisterhood was nearly tangible. At that moment, it did not matter much that Sister's Chapel was not named after us, the Spelman sisters, but after the wife and sister-in-law of John D. Rockefeller or that the college itself was named after this wife of a very powerful white man. Her words impressed us that *we—young Black women*—were the center of this world that we were to inhabit for four years. This was our universe.

The next year, I enrolled in a course called "Images of Women in Literature." One of the early reading assignments was Richard Wright's *Native Son*—a rather maudlin and preachy story of a young Black man, Bigger, who accidentally kills a rich white girl and is executed for the crime. I am ashamed to admit it now, but as a seventeen-year-old college

sophomore, I cried buckets by the time I put the novel down. By class time, the tears had dried and anger had set in. I arrived ten minutes early and was overwrought with anticipation as I waited for Dr. Gayles to make her dramatic entrance, always about five minutes late. She swept in and, pretending not to notice our anxiety, asked off-handedly, "Did Bigger kill on purpose?" She was rummaging through her bag looking for her glasses, which were resting atop her pretty Afro. I had my hand up, and it was all that I could do to keep from waving it around like Horshack on the old TV show, *Welcome Back, Kotter.* Finally, she called on me. "No." I answered emphatically, partly out of passion and partly because I wanted to impress this popular professor. I was ready to ramble on about how the white man was always trying to accuse the Black man of raping white women and how the brother man deserved more respect when she cut me off. "Bessie," she said, slowly and dramatically pronouncing the name of Bigger's girlfriend who was casually murdered in the second book of the novel. "He killed Bessie on purpose and you forgot her." She was looking at me but was addressing the entire class and, I felt, the world. "You forgot her," she repeated. "This is why we must study Black women's literature. So that we will not forget Bessie and the Bessies in our eagerness to protect the Biggers from racism."

I could fill an entire ream of paper with revelatory moments that occurred at Spelman College between 1987 and 1991. But you know of these already. As both an alumna and an instructor, you have witnessed and created these types of instances that affected me so deeply.

I wonder if you know the effect you have had on me as a writer, a scholar, and a feminist. My first publication was in a magazine you edited. But more significant than this was the perspective you offered in your creative writing course. I remember your passing out to us a copy of a letter sent to *Vanity Fair.* The letter was from a woman named Aida who said Miles Davis had tortured her. Then you passed out copies of your own work, a choreopoem called *Mad at Miles* in which you demanded that we hold brothers accountable for their crimes against sisters with the same intensity with which we hold white folks responsible for racism. I accepted the challenge, and many of my sisters did too. I am sure you remember my

classmate Andrea who made T-shirts asking "Have you hurt a Black woman today?" I wore my shirt and felt very brave.

That was college. Then the battles were mostly symbolic or academic. We protested the sexism inherent in beauty pageants by picketing the homecoming queen competition at Morehouse College, our brother institution. Prospective suitors who referred to us as "women" rather than "girls" were trusted, and those who used terms like "chick" or "babe" were acknowledged with a disdainful roll of the eyes and a defiant flip of the hand. We volunteered at battered women's shelters and read every single book bell hooks wrote. We made bold statements with our hair, which refused to relax, and we called ourselves Afrikan—with a "k."

Every now and then, there were incidents that challenged my new way of approaching the world. For example, I had a boyfriend who always said "*women*" and wore kente like a uniform. After we broke up, his new girlfriend called me and said that he was beating her. She said she had heard that I was a feminist and that I would believe her. I helped her find a safe place and went to bed that night convinced that feminism was the answer to everything.

That was college. The stakes were low—the most serious consequence of my activism was that one of the contestants in the Miss Maroon and White Pageant refused to speak to me and assured me that I would never get her vote if I ran for a student government position. I felt anointed by her scorn. I felt driven, dedicated, and consequential. Pearl, you said once that feminism is the only rational response to sexism, just as black nationalism is the only rational response to racism. I believed you then and I still believe that now. But then I was convinced that a combination of these ideologies, made real through activism and literature, would save the world.

Since college, however, things have gotten tricky.

After finishing my MA, I moved to Texas where I was hired to teach remedial reading at Prairie View A&M University. Although both campuses are predominantly Black, PV is a different kind of place from Spelman. The obvious distinction is that PV is coed. The next one—at least equally significant—is that PV serves many low-income students. And this differ-

ence is the whole reason that I even had a job. At Spelman there is not a large remedial program because students who have the money to pay Spelman's tuition also tend to have the skills necessary to master a college curriculum. Further, a place like Spelman that accepts only young women with high scores on standardized tests hires very few instructors who hold only master's degrees.

After the first semester, I was depressed. How could I have ever believed that literature would save the world when there were at least 543 (the number of students enrolled in the reading program) who did not read well enough to decipher a masterwork like Toni Morrison's *Beloved?* And these were the ones who made it to college. Suddenly my goal to be a creative writer seemed lofty and incorrigibly bourgeois. It seemed equivalent to my resting upon my laurels, scribbling cryptic tracts legible only to people just like myself. In order to assuage my guilt at having such snobby aspirations, I taught my heart out, as though there were a sort of intellectual checks-and-balances system in effect. If I spent hard time in the trenches, then I would have earned enough sweat equity to buy the right to write.

I didn't teach much feminism. There was really no time. My students had only a fifteen-week semester to learn crucial skills like context clues and main idea. Further, ideologically charged texts are usually written at a reading level far too challenging for my students. So I staged small battles like using the word "misogyny" to demonstrate the use of prefixes, suffixes, and roots. But minute subversions here and there were not what I had in mind when I went into teaching. I wanted to duplicate the Spelman experience for my students. I wanted them to look up from their texts and shout, "I *understand*—not just context clues but the *world!*" When they finished my class, the students did have a better understanding of the fundamentals of reading. But I wanted them to have more. They deserved it. At one point, I tried to include two "political" articles in my syllabus. One was about the use of language in the Black community as a resistance to racism, and the other challenged homophobia. I was informed that the president of the university demanded that I take the articles off the syllabus or I would lose my job. I became unhinged. The

president was an African-American man who had served for several years as a general in the United States Army before taking the helm of PV. I had suspected that a militaristic frame of mind would be antithetical to the type of critical thinking espoused by academia. And indeed, recent events on campus made it clear that this president thought of all university employees as "inferiors" from whom he demanded dog-like obedience. I had even been made privy to a memo sent to a dean in which he ordered her to explain her "non-compliance." But when I received the ultimatum concerning my syllabus, I was stunned. Since I could not afford to lose my job, I quietly removed the articles.

I was surprised by the incident involving my syllabus, but I understood it completely. Oddly enough, this is no consolation. Last year I was discussing Zora Neale Hurston with my friend, Riché. She remarked that being the "mule of the world" is bad enough but being the mule and knowing exactly why is even worse. I laughed when she said it but now her words stay with me like a hangover. I knew that I would not have been treated the way that I had been if I were a man and probably not if I were white. I knew that the president's sense of entitlement most likely sprang from his military background, which is rooted in sexism, racism, capitalism, and imperialism. I knew the history back and forth, yet I was as disempowered as a person who had never heard the words hegemony, misogyny, or patriarchy.

I "chose my battles," as they say. I have always thought that expression was a coded way of saying "run away with your tail between your legs." No one ever says "chose your battles" when they mean "took a stand." Choosing battles is especially difficult to me in light of my family heritage. My mother led one of the first sit-ins in the country in 1963—two years before the ones at Greensboro made national headlines. She was only fifteen years old. She was advised to choose her battles, and she chose to fight. My father was thrown out of college for demonstrating. Neither of them has a single regret. I, on the other hand, have risked nothing. I feel as though I am assigned as the keeper of a flame that I have not fanned.

My parents are proud of me and my accomplishments. Most people congratulate me when I list them: published at nineteen, college graduate

at twenty, etc. But these milestones are not really evidence of my own re-
sourcefulness. I feel as though I am reaping the fruits of seeds sown be-
fore I was born. What seeds will I sow? "Choosing battles" does not yield
the crops that the next generation will need to nourish themselves.

I am turning to you now, Pearl, as I think nostalgically of the days when
you could tell how committed a person was by the way she wore her hair.
But now, it seems that the only way you can tell the committed people
from those who are not is that the committed ones feel really bad as they
do what they must in order to preserve their lifestyles.

For me, doing what I must is going back to school to study the things
that I love: literature and writing. I have left the experience of Prairie
View behind me, but I have also left my students. I feel hopelessly bour-
geois as I am starting my new life. It would seem that a feminist in the tra-
dition of Sojourner Truth would have remained in Texas and vowed not to
leave until the students at that institution were able to receive as fine an
education as those at Spelman. Maybe I should have bared my textbooks,
the way Sojourner bared her breasts, and declared, "Ain't I a scholar?"
and demanded my academic freedom. I can think of no role model whose
claim to fame is a retreat to grounds more comfortable.

I look forward to reading your thoughts on these matters. Your letters
have often served to calm me at life's craziest moments. Your advice to
"write, write, write" has gotten me over the hump more than once. Maybe
you can work that magic one more time.

In Sisterhood,
Tayari

❖ ❖ ❖

My Sister Tayari,
Your memory is failing you, little sister. College was never easy. It
just looks that way to you now because those struggles are over. The col-
legiate battles that demanded all your courage and strength and ingenuity
seem trivial to you now only because you emerged victorious from your
intellectual, political, and emotional middle passage. And how did you en-
sure that victory? You pushed yourself to investigate, to understand, and

to act. You required of yourself not only intellectual understanding but passionate engagement. The personal was unequivocally political—from choice of hairstyle to choice of boyfriends!—and every decision was rigorously scrutinized for self-deception, counterrevolutionary backsliding and intellectual sloppiness.

The process was ongoing in settings both formal and informal. Think of all those long nights of discovery and debate when you and your sisters sat up in the dorms arguing this book or that choice or that way of approaching the world. Think of all those classes where your teachers challenged and frustrated you by forcing you to look beyond what you already knew to what you were only beginning to imagine. Now it seems easy, but at the time it was exhausting and exhilarating and clearly only the beginning of a journey that would last you a lifetime.

And you accepted the challenge of that journey. You accepted it with joy and curiosity and confidence, and when you finished your four years at Spelman you looked your teachers and your parents in the eye, assured us that you were ready for the world, and stepped out into it. Which is, of course, when it starts to get really interesting. All the questions seem more complicated, all the solutions seem more ambiguous. The rewards are harder to identify, and the punishments seem, suddenly, so severe. Principles are not always shared by those in charge, and the urgency of change is often lost on those in whom you want most passionately to inspire revolution.

Teaching is hard. Changing the world is hard. Becoming a free woman is hard. Pulling free of the shadow of your parents is hard. Finding true love is hard. Writing is hard. All of the things that are worth doing are difficult to do. That's the whole point. The hard stuff teaches you discipline and patience and clarity and humility and courage and confidence. The hard stuff forces you to question what you believe and why you believe it and how you are going to incorporate those beliefs into what you do every single day.

Remember how people were always telling you that while you don't appreciate algebra when you are forced to study it in school, you will appreciate it later? They're right, but it's not the actual algebra you appreciate. It's

the discipline you develop trying to understand it. What you finally appreciate is your own hard-won ability to get to the root of the problem and find the solution. It's the same with all this stuff that is driving you crazy.

And it's going to drive you crazy. We're at war, right? Fighting for our lives, right? Struggling ceaselessly for our freedom? Taking our blues underground to teach it how to be a demolitions expert, right? We do, after all, live in a place where women are routinely beaten, tortured, mutilated, and murdered by men, and almost nobody talks about it. A place where the jails are full of black men and the housing projects are full of black women and children and nobody seems to notice. A place where there is always rape; the kind of place where blues is always the dominant state of mind for anybody who's got half a brain and an ear to the ground.

We are, after all, members of a group that is in a state of serious and probably terminal crisis, caught up in weird, high-tech, MTV-kind of crack-fueled genocide that we don't even understand yet, but when we do, it will be a terrible moment to end all terrible moments. We will see the future that is laid out for us, and it will be so overwhelming that we will all stop working or hanging out or making love or raising children or cooking dinner and just wail, moan, holler, beat our breasts and tear out our hair, and ask the goddess to please explain what the hell we did to deserve to be black and female in the belly of the beast, locked into a decadent goose step toward the decline and fall when we never even got to run the damn thing. It's enough to make you feel cynical and abandoned and hopeless, but you don't have time for that right now, little sister. There is too much work to do.

Consider this: Last year, a million black women gathered in Philadelphia. They looked around, amazed and exhilarated by all that sisterhood, but when the time came for agendas, agreements, strategies, and battle plans, things fell apart. There wasn't anyone there to tell the story, to hold that mirror up so we could see ourselves in all our Amazonian wonder, hurtling toward the twenty-first century. So we climbed back into the cars and buses and subway trains that had brought us together in the first place and went back home to wait for further instructions. And we're still

waiting, one ear to the ground, one eye on the gathering storm clouds, our spirits yearning for a sign, a password, a prophecy, a promise.

And that is your work and mine. We have to craft the words that tell our stories true. We have to bend the forms we work in until they reflect the shimmer and the shape of our dreams. And yes, it is very hard, but when we get it right, freedom never sounded so sweet.

Stay strong!

Love you madly,

Pearl

If Feminism Has Been Absorbed by the Larger Culture, What Purpose Do Feminist and Lesbian Projects Serve?

Catherine Sameh and Suzanne Pharr

Dear Suzanne,

As pleased as I am to be included in this anthology, in many ways I feel an outsider—straddling the two generations at dialogue in this collection. As a thirtysomething, my feminist activism has been significantly informed by the work and thought of many second-wave feminists. My bookshelves hold the works of Audre Lorde, Adrienne Rich, Marilyn Frye, and you—lesbian feminists with radical politics—next to the books by new queer and feminist postmodern theorists and activists, who push my thinking in new ways. I find something useful and challenging in the old and the new. It seems much and little has shifted in lesbian and feminist thought and activism since the late eighties when I became an activist.

After graduating with a degree in women's history, I was eager to apply my years of feminist study in the real world. I began working in a nonprofit, women-run abortion clinic, learning about the history of the women's health movement. Abortion was under attack, and after helping organize a local rally in 1989 to coincide with NOW's march on Washington for abortion rights, I helped found a grassroots activist group called the Portland Reproductive Rights Committee (PRRC). Most of

the women in the group were, like me, seasoned in feminist theory but new to grassroots feminist activism. While we had read about feminist coalition-building around a range of issues, few of us had experienced the actual work of networking and alliance-building. Two women in the group were of your generation, second-wave feminists who'd been active in various movements since their own college days. They had a wealth of experience doing cross-class, multiracial, and multi-issue organizing.

When the Oregon Citizen's Alliance (a Christian-right organization based in rural Oregon) began to step up their attack on abortion and queer rights, PRRC responded with an educational campaign that challenged the OCA's propaganda. While the OCA was organizing around a politics of scapegoating—blaming women, queers, the poor, and immigrants for all of the country's ills—we countered with a radically democratic vision of the world, where all women had sufficient economic and social resources to control their reproduction, sexuality, and social life. We produced a brochure that explained how the OCA pitted oppressed groups against one another by shifting the blame from those with real power (rich white men) to those who were marginalized—women, people of color, queers, working people, and the poor. We went door to door in our neighborhoods and spoke at schools, neighborhood associations, and other women's organizations. We met with some resistance but mostly encountered open ears and hearts.

It was around this time that I, and PRRC, became familiar with your work. As a founder of the Women's Project in Little Rock, Arkansas, you had been tracking the Christian right in your own state and had just published your book, *Homophobia: A Weapon of Sexism.* Your book was extremely helpful in developing a politics that moved beyond single issues to link not just homophobia and sexism but racism and poverty as well. Your book spoke to many of the concerns PRRC was addressing and further illuminated the need for activist groups to work together to fight a common enemy. If my memory serves me correctly, Suzanne, you began working with groups in Portland who were monitoring Christian-right activity, and I believe it was this work that finally brought you to Portland to live.

PRRC continued to build relationships with groups like the Oregon

Human Rights Coalition, a low-income women's organization fighting punitive welform reform policies, through the end of 1993 when PRRC disbanded. Many of us went on to found Portland's nonprofit feminist bookstore, In Other Words Women's Books and Resources, which has been the focus of my feminist activism for the last four years; others moved away or became busy with other projects. And, strangely, the feminist/queer/left movements actually won many of our battles against the OCA.

With a break from defensive battles against the OCA and room to breathe, new issues came to the forefront. Young lesbians revisited butch/femme identities, transgressive sexuality, and gender politics. Bisexuals continued to demand a place at the queer table, as did transgendered people. While the Christian right still posed loud challenges to queer life, they were usually met with a strong, well-organized movement of queers and their allies.

So much has changed in a handful of years, Suzanne! While the Christian right continues to organize, they've suffered electoral losses in many states, as antiqueer ballot measures have been defeated year after year. Our own OCA has suffered a decline in membership and a demoralized leadership. Queers really are everywhere these days. Many are out, proud, and even living the good old American life—getting married, buying homes, and having babies. Lesbians have been on the cover of nearly every mainstream national magazine and on every major television network. In most major cities, and even in small cities and rural settings, queers can move in the world in previously unimagined ways. Feminism helped pave the way for this later revolution, as many women fought for and won access to greater personal, political and economic freedom.

Suddenly a new generation has arrived in a time distinctly its own, where the struggles of the past have given way to new challenges and new questions. If feminists and lesbians have essentially won their demands for increased freedom, visibility, and opportunity, what relevance do these identities have in this new world, they ask? What are our differences and similarities, they pose? Is there a collective "we," they wonder, and if so what are "we" fighting for?

I write to you as a thinker and author, Suzanne, but also as a fellow activist trying to do lesbian organizing in a time when the very definition of lesbian is completely unclear. You recently updated your book, devoting more discussion to gender politics and the revolutionary potential of some of the activism that has come out of organizing around gender issues in the past few years. You have taken on an active leadership role in Portland's Lesbian Community Project, which for the past few years has struggled to figure out its raison d'être. I wonder what you envision for the LCP, as it once again becomes a prospering organization? Who will it serve, and how will you make it a viable project?

When In Other Words was started, we believed that a distinctly feminist project was viable. I still believe it is, though many notions abound about feminism's futility in this day and age. Why do we need women's spaces when feminists and lesbians have made so many strides, achieved so much? If feminism (and lesbianism, to a lesser extent) have been thoroughly absorbed by the larger culture, what purpose do feminist and lesbian spaces and projects serve?

Some of this questioning can be heard in the writings of this younger generation of feminists. While their voices are many, their concerns diverse, a common theme can be extracted from the articles, essays, and books by younger feminists. They resist focusing on one of the underlying assumptions of second wave feminists: women are oppressed/victimized/marginalized and therefore need to come together to resist the forces that hold them back. Younger feminists do experience and acknowledge injustice but resist the older or more rigid frameworks that theorize that oppression. They want to talk not about how bad things are but what they can do to make changes.

I am inspired and challenged by the adventurous, forward-looking tone of feminists younger than I, who rrriot through music and dance, who box, snowboard, write, and organize in these confusing times. They are bisexual, lesbian, transgendered, and they call themselves dykes, bi-dykes, queers, questioning, and unclassifiable. They are challenging traditional identity politics and asking new questions about gender and sexuality.

And yet, while their hopes and concerns, questions and criticisms are insightful and point the way toward a more open and inclusive feminist and queer politics, I worry that traditionally feminist concerns like child care, access to decent jobs, affordable and adequate reproductive health care, and safe homes, neighborhoods, and streets often get overlooked in this period of postmodern, postfeminist, posteverything theories.

Do you share my concerns, Suzanne? Do you believe, as I do, that perhaps there isn't so much a generational divide as there are competing notions of what feminist and lesbian politics should look like? And if so, I'm certain you'll agree that the time has come for those politics to be inclusive, fluid, shifting, broad, and constantly evolving. It seems, Suzanne, feminists have so much work yet to do!

In struggle,
Catherine Sameh

❖ ❖ ❖

Dear Catherine,

Your letter to me kindles my sense of hope for our ongoing work because it reminds me of how very many people are working for liberation in ways that fit no one pattern. That refusal to follow a political prescription is an act of rebellion and individuality that leads to new thinking and unexplored possibilities. My admiration and appreciation of you and your work as a feminist activist originates from what you call "straddling two generations": It seems to me that rather than "straddle," you blend the two with an open and changing awareness of feminist principles and of world-changing gender politics. You are a hallmark of the present, and I am honored to be in correspondence with you about political ideas.

Your questions to me go right to the heart of my current political concerns. After thirty-plus years of working for social change and now facing increasing right wing activity, I am engaged in assessing the beliefs and practices of the several movements I have been involved in. And, of course, that means I am looking hard at my own life. I am asking myself questions that are often difficult: Just how much liberation have we gained for women, for all people of color, for poor people, for queers?

Have we gained integration or equality? Have we succeeded in redistributing both power and wealth? Did we radically change the world or simply shift the balance or application of injustice? And where do we go from here?

I began my activist life in the 1960s on the periphery of the civil rights movement and in the antiwar movement, interrupting that work with two years in New Zealand as an expatriate. The murders of Martin Luther King, Jr. and Bobby Kennedy made it imperative to return to the United States and commit my life to social change. When I stepped off the returning plane in Atlanta in 1969, I stepped into the beginnings of the women's movement, which forever changed my life. In days filled with direct action, feminist services, confrontation with authority, consciousness-raising, women's music and communications, high sexual energy and activity, and constant, far-ranging conversations about liberation, I found a place of meaning and wholeness for my life. I felt so intensely alive that I would have sworn that my very presence hummed in any space I occupied.

Through the '70s and '80s I worked as a frontline feminist on a variety of issues: fighting the spraying of 245-T (Agent Orange) on farmland, working against rape, organizing battered women's shelters, opposing militarization and nuclear weapons, working with poor white and African-American women on economic issues, working for lesbian and gay liberation (as it was known then), organizing with popular educators, presenting workshops on homophobia and racism, monitoring and organizing against bias violence—all of the issues so many feminists worked on during these decades. In the 1990s the increased presence of an organized theocratic right led me to focus most of my energy on working with people to stop the rise of the right and to create a vision and strategy for equality and justice.

Because I began my activism in the civil rights and antiwar movements, I had a sense that social and economic issues were connected. However, it was the 1970s Combahee River Collective Statement, made by Black feminists, that was the major influence on my politics. In it they said they were "actively committed to struggling against racial, sexual, heterosexual and class oppression . . . ," and their work was "the devel-

opment of an integrated analysis and practice based upon the fact that the major systems of oppression are interlocking."* I came to understand that this statement should be the core of progressive belief and practice. This understanding led me to found the Women's Project in Arkansas in 1981 to work against sexism and racism through focusing on ending violence and economic injustice.

And now, after years of work on so many issues, I am asking the hard questions, just as you are. To the questions I posed earlier in this letter, I would have to answer that I think our work over the years has led to partial victories, at best. We have opened doors for many people to enter the mainstream of this country, that is, to gain some of the benefits of middle-class, white-and-male-dominated life and to be recognized and rewarded. But I fear we have achieved more integration than equality, more tolerance than justice, and more freedom for the middle-class than shared power and resources for those who live on the margins of society. In every movement I have worked in, class and our failure to address economic injustice—more than any other issue—have kept us from reaching our revolutionary goals.

You stated concerns about young dykes, who may or may not be feminist, who have a knowledge of injustice but who do not identify with older feminist analyses or strategies. In particular, you said that they do not identify as victims. You know, I think we created a lot of that analysis within our women's antiviolence work and, of course, within our antioppression work in general. Because there was such a glaring lack of understanding of the harm that oppressions and their attendant violence did to women, we thought we could make change by making sure that people understood the breadth and depth of that injury. The most powerful way we could find for conveying that information was through women's stories. It was wonderful work. Those stories empowered the tellers, gave us a basis for analysis and action, and bonded us together in a weave of common experience. However, the flaw in this work was that, with the accounts of injury so great, people tended to bond around victimization

*Barbara Smith, ed., *Home Girls: A Black Feminist Anthology*, p. 272.

rather than power. In the beginning, we were naive enough to think that education would lead good-hearted people to make change so that women would no longer suffer injustice. Imagine our surprise when we encountered a granite mountain of resistance. By the time we got clear on what was happening, there was already a market for talk shows that traded on victims' stories.

It is difficult to figure out how to keep a focus on hope and action and powerful change when people do experience such great injury. For example, in the women's antiviolence movement we have worked every strategy imaginable from direct action to police training to batterers' groups to legislative work, and yet thousands upon thousands of women and girls experience domestic and sexual violence every day. I'm with those young dykes: I don't want to spend all of our time talking about victimization and oppression; I, too, want to take action and raise hell. However, I want to be accountable and provide acknowledgement and safety and assistance to those whose lives are harmed while I work to create our collective power in making change. The central question for me still remains: What is the inclusive road to shared power?

Catherine, you observe that there may not be divisions between generations but competing notions about what lesbian and feminist politics should look like. I think I have a somewhat stronger sense of the politics of feminism than of lesbianism these days. At its best, feminism to me has always meant broad humanitarianism. Therefore, there has been no issue that is not ours. We feminists have been as concerned about military buildup and environmental destruction as about affordable child care and equal pay. To advance equality and justice for women and children meant that we had to work with men and in community. Feminism has always been multi-issued for me. Where we have failed is on the question of equality: Who gets to be equal to whom and on whose terms? Our most critical failure has been along the lines of race and class.

As far as lesbian politics are concerned, I am much less certain in my beliefs. For one thing, I am no longer sure what the definition of a lesbian is. Is it, as some say, a woman-born-woman? Is it someone who has been sexually attracted only to women in her lifetime? Is it a bisexual woman

when she is with a woman? Is it a woman who identifies emotionally with women and who has sex with men? Is it the woman who called herself a lesbian for years, now is in a relationship with a man, and still calls herself a lesbian? Is it the female-to-male transsexual who was once a lesbian and now has sex with women? Is it the male-to-female transsexual who has sex with women and calls herself a lesbian? Is a lesbian a dyke? Is lesbian the same as gay? Is it the woman who was happily married for thirty years and now is in a relationship with a woman? Is there still such a person as a "political lesbian," such as those in the '70s who did not have sexual relationships with women but identified themselves as lesbians? Is lesbian just one vague stripe of queer?

I don't know the answer to these questions and have little interest these days in finding the perfectly apt label for my own women-loving self. It has always been clear that being a lesbian was not my most compelling and central issue, and I have not been attracted to organizing that focuses on lesbian issues as separate from women's issues in general. I want to integrate the issues of my queer life with those of race, gender, and in particular, economics: They all weigh in the same and are critical to the vision of the world I want to live in.

However, some of the most exciting thinking for me today is that concerning gender: gender bending, gender transgression, gender changes, the potential elimination of gender roles and classifications. It gives me hope that we will move toward more complexity in our analyses and our strategies. Though feminists in the '70s did great work attacking gender roles, I think the leadership today comes from young queers. I embrace that leadership and look forward to more conversations and strategies about how the struggle around gender can change power. In particular, this time around, I want to see how we figure out the ways to make sure no one gets left out.

Gender seems one place of entry for busting up power and redistributing it. However, it alone does not cover enough territory. I still seek a comprehensive progressive movement that combines all of the issues that promote the well-being of people and nature, putting them before profits;

and that demands human rights (safety, housing, food, clothing, education, health, and employment) and justice and equality for every person.

I guess it all boils down to this, Catherine: I want the world to be a lot like your bookstore—warm and welcoming, accessible for everyone, and filled with great conversations, beauty, fun, music, and opportunities everywhere one turns.

For our work together,
Suzanne

In an Interracial World, Is Choosing a White Partner Denying Your Heritage?

Marie Lee and Elaine Kim

Dear Elaine,

I remember the day in 1991 when you left a message on my answering machine: "Marie, this is Elaine Kim. Call me."

You didn't explain who you were, and I didn't need an explanation. I had read your book, *Asian-American Literature,* and your numerous articles. As a writer, a scholar of Asian-American literature, and a community activist, you loomed large in my vision. I was already so familiar with your work that I felt I knew you.

You were calling because my first novel, *Finding My Voice,* had been brought to your attention by a colleague. You liked it, and it was your job to keep abreast of new authors in the wonderful world of Asian-American literature, so we finally connected to talk . . . and talk . . . and talk. My novel was a Korean-American coming-of-age story, and I wondered if, as a fellow Korean-American, you might have personal as well as professional interest in it. I didn't ask, though. I was just grateful that someone of your stature was interested in my work. I was also pleased that the person on the phone resembled the straightforward, honest person on the page.

We started seeing each other at conferences, and a Korean-American students' conference at Smith College was particularly memorable. I was on a panel about fighting racism, and at one point I said that in fighting racism, we have to also face up to prejudices—against blacks, against

whites, for instance—that exist in our own community. Suddenly, several people, including a fellow panelist, accused me of being "whitewashed" and a "white lover" and of supporting a racist white power structure (strangely enough, I found out later, the panelist had a white husband).

For the rest of the discussion—as well as the conference altogether—the other panelists conspicuously shunned me. I wondered if the people in the packed auditorium agreed with them, too. But that night, you came up to me and said you stood by me, and we sat down and had dinner together. That gesture meant a lot. I think it was at this point, breaking bread with you after a long day of stress and disillusionment, that I believe we crossed the line from being colleagues to being friends. How should I describe our relationship as it has evolved over years, projects, and many meals? I think it's easier for me to just define what you are to me: mentor, *unni* (older sister), trailblazer, icon-buster, friend. We are both writers, teachers of Asian-American literature, as well as children of Korean immigrants. But because of the two-decade span in our age and experience, we have a curiously one-sided relationship, much to my advantage. You are my crystal ball: I look at you and see some version of my future; that is, if I am to grow older as an independent woman proud of my heritage and all the love/hate complexities it entails. You've let me ask you anything: Should I get married? Should I have kids? Your answers sometimes surprise me, but they always contain the honesty I crave.

You've always answered whenever I've asked, and I ask things often. The map of your life contains so many strange signs and pictures and symbols—it is a Rosetta stone against which I place my own life. Is there anything I shouldn't ask? Any subject where I should fear to tread?

How about our marriages (mine impending) to white men? Having grown up in a sea of Nordic whiteness in Minnesota, I spent most of my childhood wishing I had blond hair and a milk-white complexion, and it's only recently that I've begun appreciating my heritage—and I am making up for lost time. So I find that having a white husband seems to be the biggest contradiction in my life: If I revere my culture so highly, why would I choose as a partner someone who does not share it? And as a

scholar of literature, with all its metaphors, signifiers, tropes, I am only all too aware of what "marrying out" could represent: colonization, exoticism, a lack of self-love.

Okay, maybe I'm being a little dramatic here, but I have felt these emotions from time to time, and even more—other people have also subtly or not so subtly suggested that there may be something hypocritical about being an advocate for the Korean-American community's issues while being married to a white man. Of course, intellectually I realize that marrying whom I please suggests a broadening rather than a closing of my mind and heart. I should add that racist antimiscegenation laws existed as recently as a few decades ago. Somewhat ironically, the pressure not to "mix" now comes from within the community, not from without.

So how have you dealt with it, especially the cutting remark that marrying a white man is turning your back on Korean men and therefore your culture and heritage? Does it get easier with time and experience to chart your own course? Or do you have regrets about the way things were or might have been? It's shameful to me, but I sometimes think that if I had a Korean (or at least Asian-American) husband, I would, to all outward appearances, be the "good" Asian-American woman that the community expects of me. And I find that I sometimes long for this approval. I would almost substitute an unnamed Asian-American male to replace the white man who has been my partner for more than a decade and whose whiteness is no fault of his own, any more than my Asian-ness is under my control.

And how Asian/Korean am I? You and I, both born in America, purposely went back to the land of our ancestors, hoping to reconnect somehow. What a surprise to me, then, to find there was little for me to "re"-connect to. Can I tell you how disappointing it was, having grown up with people constantly calling me "chink" and telling me, "Go back to where you came from," and then going to Korea and feeling ostracized? I was a freak there because I don't speak Korean well, have a very American sensibility, and I also don't look "classically" Korean, with my reddish hair and dark complexion. I've come to realize that in forging an identity there are no easy answers, no absolutes. Korea was not the magic mother-

land I hoped it would be, but it's still the land of my parents and their ancestors, so in that way, it's a part of me. At the same time, I have chosen to call America—not Korea—home, and am happy with that choice.

So when it comes to choosing a partner, I don't feel a need to make apologies for my choice. Color and culture matter, but intellectual engagement and passion matter more, and I want to stand up for my belief that color and culture do not supersede, substitute for, or stand in for integrity and love. Facile generalizations about people based on the white color of their skin are no more justifiable than such based on red, black, or brown coloring.

But belief in a vacuum is easy. For instance, my Asian-American students often look to me as a role model of sorts, someone who defied parental pressures to become a doctor to venture into the wild uncharted waters of art. Yet at the same time I used to worry that students might see me with Karl on campus and think no, I'm not a perfect role model, I'm still an Asian-American woman with a white man and therefore burdened by the ghost of Suzy Wong and all the other political shit that comes with it. But none of my students has shown the least disapproval, and much of the pressure is internal—but like a psychosomatic illness, it is still there.

My hope is that with age (or wisdom, or both) that such external prejudices will matter less. That I will focus on my work more rather than worrying about the opinions of people I don't care about. Is this true?

Being on the cusp of marriage has also made me realize that I am very different from my mother in many ways. For her, marrying a non-Korean was not a possibility. Coming to America was not a choice, either. My mother followed Korean society's maxims and followed her husband across the ocean and devoted the better part of her life to raising her children. I'm still astounded when I see pictures of her with her young family: She was only in her twenties, yet there's something about her, a kind of competence, a bearing of responsibility that emanates from her face.

I know I cannot follow the path my mother did because my sensibilities have been shaped in a different country, a different generation. Yet, there's much I've learned from her: how to be tenacious, how to carve out

a space and a voice when society won't offer you one, how to find strength from other women. I have so many more options and freedoms, and to not listen to this hard-won wisdom would be a waste.

So, as always, I'm here asking for advice. There are more barriers to break, more prejudices to be overthrown. But I realize how blessed I am, having choices my mother never had—and perhaps ones you didn't, either. What can you tell me about the history you've lived through that might make me even more aware of these blessings? What can you tell me from the life experience you've gained about what might prepare me for the road ahead?

Yours,

Marie

◆ ◆ ◆

Dear Marie,

It was Florence Hongo of the Asian-American Curriculum Project (AACP) who told me about *Finding My Voice.* "You must read this book," she urged. The AACP is a northern California–based clearinghouse for Asian-American books and tapes, and for more than two decades Florence had been collecting Asian-American materials of all kinds and filling orders for them from across the country. She said that there was a critical need for Asian-American books for young readers, books that provide something more than the adventures of the blond, blue-eyed cheerleading twins in the Sweet Valley High series, but that don't rely on race stereotypes or present versions of traditional Asian folk tales. "We've been needing this book for such a long time," she exclaimed.

I called to tell you what Flo Hongo said. I figured that, as a young writer who had just published her first book, you should be told when people like your work. I also called because I was curious about you. Believing in the importance of good, nonracist books for young Asian-American readers, I wanted to find out who you were and what motivated and interested you. The book jacket said that you were Korean-American like me. I wondered if we might be "Seoul sisters." *Finding My Voice* was about a girl grappling with being the only Asian in her Minnesota high school. Having been the

only Asian-American girl in my Maryland high school class in the late 1950s, I marveled at some of the parallels between my experiences and hers, decades later. I wondered about your experiences.

After we talked, I read everything I could find written by you. In essays and op-ed pieces as well as in fiction, you wrote very frankly about your views on controversial issues, mostly having to do with race and racialization. You wrote about problems between African-American customers and Korean shopkeepers, about how you as a Korean-American writer are often expected to "speak for" the group, about your feelings about contradictory criticisms of your work in the Korean-American community, about interracial adoptions and interracial marriage. I was impressed by your spunk and honesty, not to mention your writing skill. It takes courage to say what you think instead of only what you think people will want to hear, and it takes talent and hard work to say it well.

If I've become your *unni,* your "big sister," you must be my *tongsaeng,* my "little sister." You think of me as your crystal ball showing you a version of your possible self as you "grow older as an independent woman proud of [your] heritage and all the love/hate complexities it entails." I think of you as my crystal ball because you are the future. The choices you make, the courage you exhibit, and the principles you uphold will give me a glimpse into what is likely to happen long after the people of my generation are gone.

You have asked me many personal questions, especially as you grapple with your life decisions. Now you ask about the seeming paradox of being deeply interested in your Korean heritage while planning marriage to a man who is not just non-Korean—he's white. You fear that some in the Korean-American community will think that you are a victim of racial self-hatred and that he is one of those men who wants an exotic Asian woman to walk on his back.

As you correctly point out, times have changed. You are indeed blessed, living as you do in an era when old ideas about who can be American are giving way to possibilities for new American identities, due in great part to many people repeatedly challenging race and sex discrimination over the decades. It was African-Americans who first showed me that

I could be American and a person of color at the same time. Thanks to the African-American–led civil rights movement that began in the 1960s, the "good old days" of direct apartheid are gone. And thanks to the American women's movement that has grown since the 1970s, gender discrimination has been repeatedly challenged and people's general awareness of sexism has increased significantly.

Neither your mother nor I had the choices that face you as the new century approaches. Your mother grew up in Korea in the 1940s, during an era when her life could not have remained unaffected by political upheaval and intense economic hardship: That was the fiercest period of exploitation during the decades of Japanese colonial rule in Korea, when worldwide economic depression and the Second World War brought intense suffering to the Korean people, only to be intensified in the 1950s by the devastating Korean War and its ruinous aftermath. The major responsibility for middle-class Korean women of your mother's generation was to take care of their husbands and raise strong, successful children. I grew up in the American 1950s, at a time when an unmarried woman was generally viewed as a social failure. I belong to a generation of women who were encouraged to feel that they had to choose between family and "career." Most of them were born too long before the American women's movement of the 1970s to derive much benefit from it. Many of my classmates never worked outside the home, never had a chance to test their talents the way their husbands could. Your mother and I, then, are products of a time when options were often limited for women, just because we were women.

But what you and I have in common is the experience of growing up as Korean-Americans in a society that is obsessed with race but refuses, paradoxically, to admit to its obsession, pretending instead to be "color-blind." We have been faced with the nonchoice of being different and inferior on the one hand and "just like us" but invisible on the other. But unlike you, your mother, and most of my classmates, my childhood and young adult experiences were poisoned and disfigured by the kind of apartheid life Asian-Americans on the East Coast often had before the civil rights movement of the 1960s. Those were the "good old days" about which so many Americans wax nostalgic, a time when life was simpler and

more abundant and people were wholesome and honest, before the idyll started being disrupted by uppity, demanding black folks and messy waves of brown and yellow immigrants.

For me, those were the "bad old days." When I was in primary school, if a classmate invited me to her home after school, her mother would kick me out because I was Asian. Kids used to hold the corners of their eyes up and say "ching chong Chinaman" or "Japanee" when I walked by. Adults invariably asked me where I was from and when I was "going back." Everyone marveled that I could speak English. I felt that I didn't belong in this country, where I had always lived, and that everyone would be more comfortable if I would return to Asia, where I had never been.

When I was in high school, no one asked me for a date, even though I was "exceptional, for an Oriental." I was not only a student government officer but also a cheerleader—no mean feat for an Asian-American student in the blond and blue-eyed 1950s, when even Jewish girls were not chosen because of de facto discrimination. I sat at the lunch table with the other cheerleaders, but I was only a mascot, like a little dog allowed near the table. Even they would ask me about what to order at Chinese restaurants. Looking into the mirror, I thought I was beyond ugliness, rather like a creature from another planet. When you are too young to know better, you start to become what people make of you.

Not having had access to books like *Finding My Voice,* I was motivated only by a desire to be accepted by the Sweet Valley High type crowd. Like Alice in your book, *If It Hadn't Been for Yoon Jun,* I would have been mortified to be lumped together in my classmates' minds with a newly-arrived foreign student from Korea. Not having seen very many Koreans or Asians besides Fu Manchu, Charlie Chan, and Mr. Moto, all played by white actors with Scotch tape on their eyelids, I thought Asian men were singularly unappealing and dreamed only about Robert Wagner, Tab Hunter, James Dean, and other such movie stars. It was not until I visited Korea and, later, moved to California, that I really began to experience Asians and Asian-Americans as human beings.

Apprehensive about Korean community disapproval of "outmarriage" and about what might lie ahead for you in an interracial marriage, you ask

how I feel now about my brief marriage, many years ago, to a white man. My circumstances were quite different from yours. True, I was the first and last person on both sides of my family, including up to my sixth cousins, ever to marry someone who wasn't Korean. But if there had been a synod of disapproving ancestors, they probably would have been more concerned about us marrying our "colonizers"—Japanese or Americans—than about race per se. Having grown up at a time and in a place where both immigrant and American-born Koreans and Asians were very rare and always the objects of overt race discrimination, I knew that my family members could not really blame me for not being able to find a Korean husband, and there was no Korean-American community to speak of that could express its approbation very strongly.

My problem was that I was already married when I began to understand—thanks to the civil rights movement as I knew it in Washington, D.C., in the mid-1960s and to the ethnic-consciousness movement I witnessed in California in the late 1960s—how white racism had distorted my ideas about myself and the world. Through my blossoming political consciousness, I became so different from the person my husband had married that our marriage could not endure.

Even though my divorce was more than twenty years ago, it has taken me many years to "kill" the white man inside my head—the standard that ruled Asians and other people of color as inferior and everything white as superior. There have been many years when I could barely speak with white people, and I would never keep company with a white man, as if even contact with one would rivet me back into the paroxysms of self-hate that racism had engendered. I had to be careful, so as not to be reinfected. I had to develop antibodies. Gradually I have been able to relax my vigilance and open my heart, but it has been difficult, and it has taken a long time.

For me, the bright side is that I have been fortunate enough to live in a multiracial locale where it was possible to establish strong relations with other Korean-Americans, other Asian-Americans, and other people of color while I was struggling with the white demons inside my head. Somehow being made aware of the diversity and complexity of these communi-

ties has helped me question the false notion of monolithic white homogeneity.

Although we are faced today with different manifestations of social inequality, it is certainly true that there are many more options for American women and for American people of color today, and hopefully in the future our children won't experience the kinds of psychic and material damage we faced back then. Among the teenagers and twentysomethings I encounter in my racially diverse environment, I have noticed increasing acceptance of multiplicity, hybridity, heterogeneity and less interest in congealed, mandated identities and communities of taste than in the past.

I don't agree with the people who disapprove of Korean-American women marrying white men. I oppose the tendency among some Korean-Americans to try to mandate and regulate Korean-American identity. I agree with you that "color and culture" should never be prioritized over "integrity and love." But because I experienced those "good old days," I think I understand why some people feel so defensive about interracial marriage—no, not just interracial marriage, but Asian-white intermarriage. But their life is not yours, and in the end they can't really know what you as a person need and want, let alone why you need and want these things. And in fact they don't really care. It's important, then, for you to keep being courageous and outspoken and for you to keep saying and doing what you believe in. In the future, you will be the mainstream of the Korean-American community. Whether the would-be arbiters of Korean-American identity like it or not, Korean-Americans will undoubtedly be marrying people from many different backgrounds in the twenty-first century—not just whites, but Latinos, African-Americans, other Asians, people of various mixed heritages. I expect that they will be busy creating more and more ways to be Korean-American, and you will be right there in the middle of it, writing stories that will keep on opening doors and minds and creating new choices and new spaces for the young readers following in your wake. They will write to you as their *unni,* their big sister, for advice. And you will be there to cheer them on.

Affectionately,

Elaine *unni*

GRRRRRLS KICK ASS!

Women Prove Themselves on Male Turf

Jennifer Gonnerman and Susan Faludi

Sara Hammel and Arie Taylor

Emily Jenkins and Mariah Burton Nelson

◆ The military, print journalism, and sports are just a few arenas in which women have broken new ground and gained visibility. We may celebrate that a head of a hospital, traffic cop or CEO is a woman, but is that enough? These letters take a closer look at women's success, questioning the way in which women handle power when they enter "men's worlds." Is it a feminist success for women to be accepted into institutions like the United States military, a traditionally patriarchal domain? How does the military change by admitting women? Should feminism be about a woman's right to choose whatever she wants to be, even if it means she perpetuates sexist institutions?

Perhaps the more pertinent issue is what women consider success in the first place rather than simply accepting the brass rings that society holds out to us. Should we promote, for example, a physical sport at which women excel over men? How should feminist investigative journalists bring their agenda to their field? Is it enough just to hold your own on male turf, or do we need to bring new values to sexist playing fields?

How Do We Respond to Pseudo Feminists Trashing the Feminist Movement?

Jennifer Gonnerman and Susan Faludi

Dear Susan,

I was still in college at the time your book, *Backlash: The Undeclared War Against American Women,* was climbing the best-seller list. The Clarence Thomas–Anita Hill saga had captured the nation's attention, and a feeling of despair and frustration was sweeping across my liberal campus. Then *Backlash* came along and armed young feminists like me with a litany of facts and numbers to help us articulate our anger, battle sexism, and change minds. (I even gave a copy of the book as a Christmas present to my Republican grandmother. She liked it.)

Packed with years of in-depth reporting, *Backlash* also helped change my perception of the journalism industry. Maybe, I thought, reporting was not just the province of balding white guys like the ones you see spouting forth on Sunday morning political talk shows. Maybe feminist journalists could fix some social problems and perhaps even jump-start a revolution.

When I was in college, the idea of writing for the school newspaper both daunted and intrigued me. I wound up spending my junior year at Cambridge University in England and, without much else to do, joined the staff of the school's weekly paper. Only a few months passed before a huge story landed in my lap. Within weeks, I got a crash course in the power of the media—and the fury that could be unleashed when it fell into feminist hands.

I had heard through the rumor mill that female students at Cambridge got fewer top scores on their final exams than their male counterparts. So when everyone else was away on vacation, I convinced the school's registrar to hand over recent exam scores broken down by gender. Since Cambridge professors do not give grades, all that really matters are the scores students get on the exams they take at the end of their undergraduate years. Tallying the numbers I got, I realized male students were getting twice as many top scores as female students.

Chaos broke out on campus after we printed our findings in the school paper. Everyone had theories about why women did not do as well as men, ranging from the fact that most of the professors were male to the charge that the exam graders were biased against feminine handwriting. The school's top administrators promised to investigate, and national newspapers like *The Times* and *The Daily Telegraph* picked up our exposé. It was pretty heady stuff for an undergraduate. I was hooked. Now, three years out of college, I am a staff writer at *The Village Voice.* I have also written for other left-wing publications like *The Nation* and *Ms.,* as well as mainstream magazines, including *Spin, Glamour,* and *Vibe.* Often I report on feminist issues like domestic violence, employment discrimination, and sexual assault.

In some ways, it's an exciting time to be a feminist in the media world. It's so satisfying to plow through a column by Barbara Ehrenreich in *Time* and know that her feisty feminist ideas are sitting on millions of living-room coffee tables. And it's inspiring to think about all the women who have managed to convince their (mostly male) bosses to let them write an opinion column and then used that position to bring attention to feminist concerns often neglected in the rest of the paper. Molly Ivins, Anna Quindlen, Barbara Reynolds, and Ellen Goodman are just a few of the women I would put in this category. But in recent years both the media and the face of feminism have changed, creating a slew of new issues for the next generation of feminist journalists.

Thanks to the battles waged by previous generations, there are now more women, and more feminists, working in the media industry than ever before. But sometimes, I'm not too proud of what my own genera-

tion has accomplished. When Katie Roiphe seized the media spotlight in 1993, I felt that I was getting a painful reminder that men are still the ones who decide which feminist voices will get heard.

In *The Morning After: Sex, Fear, and Feminism,* Roiphe claimed that campus date rape was not a big deal and then ridiculed young feminists for wallowing in their own victimization. In return, Roiphe, then twenty-five, got more attention than most authors get in a lifetime. The lesson to young feminists like me was clear: If you want to get noticed and make some money, write a book bashing other feminists. I wonder, Susan, if this is the message you got when you were in your twenties. How did publishers respond when you first approached them with the your idea for *Backlash?* Were young feminist writers then considered a marketable commodity? Did you ever imagine that *Backlash* would sell so well?

I feel like journalism's pecking order has flipped in recent years, perhaps in the time since you started your career. Now television rules. Young people like me used to be encouraged to report and write at newspapers for decades in order to learn the craft. Now the message sent by our older counterparts is completely opposite: Mold yourself into a pundit, get on television, and spew opinions on subjects about which you may or may not know anything.

We've both written about antifeminist women who have exploited this recent media trend, promoting their message while bashing as many feminists as possible along the way. It has been so frustrating to watch a small group of antifeminists get hundreds of opportunities to slam feminists on political talk shows and the op-ed pages of major newspapers—while major feminist organizations seem unable to mount a coordinated counterattack.

In this crazy climate, what's a young feminist journalist to do? How can feminists like me have the most impact? Sometimes I worry that we print journalists do not have nearly the power of persuasion that our older counterparts possess. Only about fifteen percent of people under thirty years old read newspapers or vote. Invigorating our peers through traditional media is going to be, in some ways, harder than ever before. So, Susan, what would you advise my generation to do? Should we pressure

media outlets to hire more feminist reporters, editors, and producers? Should we set up our own public relations machine, get ourselves invited on television, and trade barbs with the antifeminists?

When I am at my computer, writing a story for *The Village Voice,* I always imagine that my audience is a young woman who does not follow the news or care much about politics and who may or may not call herself a feminist. I think it's my job to grab her attention and show her why she should be interested in whatever social issue I'm exploring, whether it's the plight of women in prison or the challenges of being a female labor organizer. But even if I keep her attention long enough so that she finishes my article, I sometimes worry that I am preaching to the converted. Most *Voice* readers consider themselves liberal. They are usually not the people who most need a strong dose of feminism.

Who are the readers you are trying to reach? Do you think you are able to spark more social change when you write for alternative publications—like *Ms.* and *The Nation*—or when you write for a mainstream magazine? I noticed that you have recently been writing for men's magazines—including *Esquire* and *Details*—and I wonder if this is how you decided you are able to have the most impact. The world of book and magazine writing seems in some ways an ideal place for a feminist writer. Would you advise younger feminist journalists to follow your own career path? Did you have any older female mentors advising you along the way? Are you happier now that you no longer work at *The Wall Street Journal*—freed from the shackles of corporate America, writing only about what you want, free to be as feminist as you wish?

Besides floating a few questions, I wanted to apologize for something I failed to do when I bumped into you at a party during the 1996 Republican convention in San Diego. We were surrounded by clean-cut conservatives in dark suits and were talking to the only other liberals who had bothered to show up. Suddenly, a young, burly Republican guy started shouting at you. He was loud and obnoxious and accused you of not having the correct press credentials. Grabbing you by the arm, he hustled you out the door. I remember wanting to scream, "Do you know who this

woman is?!" But instead, I kept my mouth shut and later kicked myself for days.

Now I wanted to apologize for not sticking up for you and to let you know how much I and other young women, in and out of the media world, admire your work. Thanks for being such an inspiration—for putting a feminist-friendly face on a historically male profession, for encouraging my generation to keep fighting, and for showing how much strong journalistic skills can contribute to furthering the feminist cause.

Susan, I'm looking forward to hearing what you think about all of this and to reading your next book. Take care.

Best,

Jennifer

❖ ❖ ❖

Dear Jennifer,

The kindness and concern so warmly conveyed in your letter reminded me of feminism's most attractive—though most unsung and, these days, somewhat frayed—quality: the affectionate community it can create around its adherents. That you should be agonizing, years later, about a rude remark directed at me by a boorish young Republican and that you should be chastising yourself for not having stepped in—what other political movement has as its deepest current such feelings of personal and sisterly responsibility? Your letter echoes with the correspondence of centuries of feminist women, worrying over each other's particular burdens as much as over the abstract cause. I must urge you not to give that incidence of Republican thuggery another thought. If truth be told, I was more amused than disturbed to be shown the door and, suspecting that an overcrowded Planet Hollywood party made for a slim reporting opportunity, half-relieved for an excuse to leave. But to read that this incident troubled you and stayed with you touched me greatly and made me feel cared for.

Your caring also brought into relief something more painful: I'm not sure that the women's "movement," if you can call its remnants that, is as

effective as it once was at providing a sheltering and supportive arm. While your letter reminded me of feminism's rich potential to provide that steadying and connective union called sisterhood, it also reminded me of its comparative lack. So often I yearn, and I wonder if you do as well, to hitch my feminist impulses to some larger and sturdier piling; yet most of the time I feel, as a feminist, unmoored. I envy our feminist forbears who, for all the horrors they faced, had a bondedness that seems so elusive today. The forums and "networks" where feminists gather now so often seem to be staged, airless events in which everyone is terribly upbeat and congratulatory and no one really knows one another. There is much public convening under the klieg lights but little in the way of that continual private association that produces real inspiration, ideas, and structure for authentic political action. It is hard to have an earnest conversation at a PR event, and it seems as if there are fewer and fewer feminist assemblies that are not infected with that modern disease.

No one in particular is to blame, though won't Camille Paglia hate it if we don't blame her! I suppose feminism is simply suffering from the same atomization that has fragmented the rest of society; we don't feel we "belong" to a "movement" because belonging and social movements have little place in a world that recognizes only star turns and solo performance. Celebrity culture seems to be a kind of virulent inverted weed killer that burns away the grass roots but turns the random dandelion into a towering orchid.

Your keen observation about the way journalism's pecking order has flipped—television pundits with no knowledge trump print investigative writers with a devotion to research—got me thinking about how this cultural change has been doubly devastating to those of us who aspire to feminist journalism. The tradition of feminist writing is to make change in the present and future by shedding light on the past, by uncovering buried history, by showing how individual women's stories connect to a larger picture, by demonstrating, in the words of Mary Beard's classic title, how women have been and continue to be a "force in history." You and I both write out of the same terribly old-fashioned conviction that these larger

truths can be excavated; that if you take readers through the historical record and appeal to their rational powers instead of their bloodlust for sensation, they will eventually come around. By looking back, we transform the present.

But for our skills to bear fruit we must write in a culture that places some premium on social history and accumulated knowledge. And journalism is now a profession utterly fixed on promoting an immediate present and a near-future disconnected from the past—which is probably as good a definition as any for entertainment news. Matters of who is "in" and "out" and who joins the top ten next fall are the primary preoccupations. Women are "celebrated" in the media only one by one, as rising lone stars who, a year hence, will be flung on the slag heap. How can we shine our patient beam in such a strobe-lit profession? Feminist journalism creates meaning out of individual stories by backing up to reveal their place in the greater patterns of social and political history. But the new "journalism" dollies in for close-ups that erase all historical context.

Where does this leave us? You ask a question that is a constant plague to me, too, and for which I have no good answer: How can we have an effect in a media that showcases antifeminists masquerading as feminists on TV talk shows every day? How do we convey our perspective in a media that won't recognize an idea until it gets trotted out to be "debated" on MSNBC or *Crossfire,* at which point it gets quickly reduced to a meaningless bit of fluff underfoot? You and I and many others have talked about creating some sort of counterpart to the antifeminist "feminist" think tanks that have produced the likes of the leopard-miniskirted Laura Ingraham and the omnipresent Christina Hoff Sommers and all their sister chatterboxes dominating current-affairs programming on feminism. Such a project would be, at the very least, a great comfort: It would bring together isolated feminist writers who are otherwise floating disconnectedly on the media sea. And even if its effects were minimal, it might well spark other initiatives, lead to other things. Nonetheless, I can't help but suspect that in the short run, it would serve only as an unfortunate casting agency for TV news shows, supplying the counter to their point, the Hal-

loween cat in their staged feline hissing match. Better to let the Ingrahams and Sommerses yowl alone and find our own way. What that way will be, I don't know, but I can't convince myself that exchanging sound bites with people who have only their own promotional advancement in mind can serve to salvage a movement.

So, to get back to the questions you asked, "In this crazy climate, what's a young feminist journalist to do? How can feminists like me have the most impact?" Maybe where we are really stuck is with the question itself: What do we mean by making an "impact"? You and I both have heard a variant of the question raised more generally at every feminist assembly: "What do we do now?" What that query usually implies is, how do we advance the "battle," how do we prevail in a confrontation? But is that the right question to be asking—especially at a time when we are engaged in no single struggle? This is not the era of suffrage; we are not rallied around one banner—and so to talk of wins and losses is not to come to terms with the times we live in.

In the long haul, feminism will prevail—women's place in the world is resolutely in the ascendancy, albeit a rise of fits and starts. Mary Wollstonecraft's voice will be heard long after Ingraham's and Paglia's have vanished. Yet we sense feminism is facing a crisis in our time, and we want to take action, we want to fight whatever it is that is creating this sense of dread and decline. Maybe the question we should ask ourselves is why we think we are having an "impact" only when we are locked in confrontation. We feel we are losing our hold, slipping back, and we think the answer must lie in triumphing over every antifeminist babbler on television. Such battles can be important. But the media victories can also be Pyrrhic. Even when we manage to talk our way past the gatekeepers and take our spot in the media pit, we find there isn't anything meaningful to confront. We swing and we hit air—generally hot air. Meanwhile, we feed the celebrity culture that is our real problem, because that culture loves the reflexive combat on hot-button issues as a replacement for complex thought.

Our crisis isn't feminism's lack of "popularity," but the dearth of opportunities for substantive and subtle disagreements in a public arena—

the kind of searching and honest discussions out of which feminism was first born. We are not so much undercovered as we are undernourished. The media provide less and less of an outlet for real thought—and we are at a loss for another outlet. The dialogue is stunted, and so our spirits and our cause.

How do we create realms of discussion that will give feminism the fertile turf it needs to prosper and evolve—just as any science or body of thought grows only with further research and intellectual argument? This is our "battle," I think, and it is a long and internal one. It is not likely to get worked out before the cameras. In fighting this battle, you and I can be most effective by sticking to our knitting, resisting the urge to devote ourselves to gladiatorial exercises in the talk-show ring out of a misplaced sense of responsibility or guilt. In spite of all the trends and forecasts to the contrary about "new media," I still believe that our best hope as feminist journalists lies in pursuing what we know and care about most—the words on the page. Your meticulous and nuanced reporting and passionate writing is an important and lasting part of the bulwark against the flood of media prattle, so much of which is temporal. The nineteenth-century press put out a lot of drivel, too, and all of it has burned off in the slow bake of time. What remains powerful and enduring about our writing is that it does endure, that it has a life long after the television lights have gone off. God knows that's been the saving grace of women's writing, written and shelved and "lost"—and salvaged centuries later.

In the context of history, where we write—whether it is in *The Village Voice* or *The New York Times*—may matter less than what we write. Past feminists have written in tiny newsletters, private letters, or the privacy of their own diaries, and yet their thoughts are with us now because they committed them to paper. (The disappearance of correspondence in the modern age may be a far greater setback to feminism's historical record than we realize.) In the shorter term, though, the question remains how best to reach an audience—and what audience? To some degree this becomes less an issue with the rise of media monopolies; perhaps the one upside of the press consolidating is that to write for one publication is to write for a dozen. Even *The Village Voice* is busy gobbling up regional al-

ternative weeklies. Nonetheless, there's a big difference between reaching the converted in *Ms.* magazine and the recalcitrant in *Esquire*. I'm afraid my reasons for writing for men's magazines these days are rather mundane: I'm working on a book on masculinity, and the reporting lends itself to articles that interest men's magazines. But one outcome has been exposing a readership with many misconceptions about the women's movement to a feminist voice that doesn't fit its prejudices. Repeated exposure might help them develop some immunities to the stereotyped swill about feminists that bombards them in the popular culture. On the other hand, these glossy magazines aren't read in a particularly serious fashion—they are meant to be leafed through with the greatest pauses at the ads—and there is a desperate need for rigorous feminist reporting and writing in publications aimed at people who do read.

What troubles me most is the lack of investigative articles on women's rights issues. So much of what gets published these days under the banner of feminist writing is unresearched and self-absorbed. Your reporting is a blessed rare exception. In the end, I don't think we should worry too much about choosing to write in one forum or another; it is more important that we write for a variety of outlets and that our journalism is searching, our analysis unstinting and honest.

I didn't, to answer your question, have the slightest clue that *Backlash* would garner as large a readership as it did. But I wrote it for the same reason I suspect you write, to answer questions that hound and to work out complicated ideas that seem apprehensible only on paper. Those were questions and ideas, it turned out, that weighed on many, many other women's minds as well. Which goes back to what I was struggling to say in the beginning about sisterhood. So many of us labor in our mentally imposed, isolated garrets, utterly unaware that our thoughts are shared by multitudes of women. All the vaunted global communications systems have not served to draw us together in that way—they have only encouraged people to behave as passive consumers of the same half-dozen corporate-sponsored pseudoideas. But independent writing, in some mysterious and paradoxical way, does seem to have that power to form a

collective. It is, at any rate, the one place where I have found that sturdy piling, that sense of attachment to something larger than myself.

Receiving your letter made me feel more connected to a larger feminist world than any of the televised "debates" about feminism's future I've participated in. Maybe this will be just the first in a long correspondence. I hope so.

In sisterhood,

Susan

Why Would a Woman Want to Serve in the Military, Anyway?

Sara Hammel and Arie Taylor

Dear Arie,

As you know, in the last few years, civilians have absorbed a continuous flow of bad news about what women in the military endure daily. The Tailhook scandal, Shannon Faulkner's battle with The Citadel, Kelly Flinn's sex life in the Air Force, and reports of rampant sexual assault at Aberdeen Proving Ground are just a few of the stories dissected relentlessly in every form of media. The hardships these women face makes me wonder what draws them to the military in the first place.

The more I read about women's struggles to carve out a space in the military, the more I appreciate the barriers you and others of your generation broke down during the '50s—a time when racial and gender integration were practically nonexistent. You were the first Black woman to lead basic training in the Air Force years ago when it was astronomically tough for women and African-Americans to be in even the lowest rungs of the military. And you're still speaking out on the need for gender equality, dedicating time and energy to help nurture WANDAS (Women Active in our Nation's Defense, their Advocates and Supporters), a fledgling group that lobbies Congress and the Department of Defense on behalf of, and provides legal support for, military women.

Although I haven't chosen to be in the military, I developed an emotional tie to the issues that surround it after my experience on an army

base two years ago in Massachusetts, when I joined more than thirty other civilian women in an army study of women's strength. The study's aim was to see if, given the right training regimen, women could become strong enough to perform military tasks usually assigned to men. For ninety minutes a day, five days a week over a period of seven months, we struggled to run miles over rocks and roots carrying a seventy-five-pound backpack, sprinted while carrying heavy sandbags, and ran as fast as we could dragging a 110-pound trailer behind us. With each new challenge we became physically—and, as a result, mentally—stronger. I was in agony sometimes, my lungs burning and my back throbbing as I struggled to lift heavy boxes to simulate loading an army truck. Through it all, I was surrounded by unwavering support and inspiration from the other women, the two army scientists and our two trainers (all men) who cheered me on and told me to keep going, to make sure I finished as quickly as I could.

I used to wonder, before, during, and after I'd make those treks or lift those boxes, what it would be like to have someone yelling at me to give up, that I wasn't good enough, that I might as well just stop. Or worse, to have no one yelling at me at all, just ignoring me and hoping, knowing, I'd fail. Or perhaps even lowering physical standards for me before giving me a shot at succeeding under the norm. In the end, our study proved women could be trained to do the toughest military jobs. Most of us could heft the required weight and run the required speed loaded down with whatever our trainers piled on. The report on our success might be sitting on an officer's desk right now, ready to be used as evidence of a woman's physical potential, or maybe it's already been filed away with thousands of other military studies. No matter where it is, though, it provides solid ammunition to use against anyone who questions a person's ability to kick ass just because she happens to be a woman.

It makes me wonder how you did it at a time when women were appreciated more for their secretarial skills than for their wits and strength. Why did you enlist, knowing you would be one of the first Black women to barrel in and take on a predominantly white, male-dominated fraternity? Why would any woman want to serve under such a traditionally patriarchal in-

stitution, one for which she might eventually sacrifice her life or put her dignity on the line, like Kelly Flinn?

I know that you joined the Air Force for the opportunities—especially educational ones—it offered you. But the military is an optimal place to learn life lessons, too, and I wonder if you think that's a major reason a lot of women these days enlist or, at least, decide to stay. If a woman is having trouble climbing a rope for the first time, she'll often surpass her own limitations to reach the top. If she is marching, sweating, thirsty, blistered, and loaded down with supplies, she discovers she can work through the pain and keep with the group until it's time to stop. These lessons apply to anything in life—being a single mom, scraping your way up the ranks in a company, dealing with racists or sexists every day. There are many days when I wish I had another chance to push myself as I did during the study; maybe I'd be even stronger now, have more insight to offer.

Despite all the discomfort I voluntarily endured in the name of women's strength, I was not defending nor preparing to defend my country. And that, unarguably, is the military's job. Combat readiness is its mandate. But with the pool of interested good men dwindling and a stream of good women pouring into the ranks, there is change in the air and disagreement about how that change should occur. Some say the problems with integrating women into the military lie with women's inherent inability to serve on submarines and in hand-to-hand ground combat, the two assignments that still exclude us. Pat excuses aren't hard to come by. A common one is that we can't carry a 220-pound injured man out of harm's way during a battle, an important skill that saves lives. But a lot of men couldn't do that, either. Women who can carry or drag the large injured soldier should be allowed to do it.

Other detractors say pregnancy weakens a unit because a female soldier must leave to give birth. But men leave, too, and for less noble reasons. Statistics show that in the military men have the majority of substance abuse problems and commit the violent crimes. So who really threatens a unit's readiness? Others say women can't be in combat because "male bonding" is such a vital key to national security. Well, I challenge anyone to say the women in my study didn't bond as tightly as humanly possible.

And, more importantly, I challenge anyone to give any of the fittest, strongest women in our study a job in any section of the military.

Arie, how have you responded to people who say women can't be a formidable force in the military? As a neophyte newspaper reporter aspiring to bring to the public's attention issues I saw as important, I joined the Army study to see just how far other women and I could go physically, to help make the study a success, and to write about it. The latter, I thought, could make a difference in readers' and especially in women's lives by possibly opening doors for those who harbor dreams of reaching the military's upper ranks. For me, though, that was a seven-month stint, not a life choice. Being both a feminist and a military-watcher has given me some unusual perspective on the issue, a perspective which makes me deeply admire your choice to go for what you wanted and make yourself a success. I support any woman who sees herself as military material—she should go as far as her talent takes her. But as I close this letter, the most perplexing question for me still remains: Why, even if given carte blanche to do so, would any woman want to be in one of the last male havens in the military, "hand-to-hand" combat? Arie, I can't wait to read your answers. The tougher the better!

Warmest regards,

Sara Hammel

❖ ❖ ❖

My Dear Sara,

When I endured basic training at Lackland Air Force Base in Texas over forty-five years ago, I never carried that seventy-five-pound pack which you and other courageous women labored with to prove that women can physically perform in today's military. I did learn that no matter what a woman can endure physically, there will always be those who will simply insist that we do not belong in the military. So the load we must bear is much greater than any pack or physical chore. The day I enlisted in the military was the day I consciously rejected the American vision of what my role as a woman who was born black in America was supposed to be.

I was the oldest daughter in a poor family from Ohio. I had four broth-

ers and five sisters. My mother was an LPN and was busy having babies. My father was a Methodist minister who was at the mercy of a bishop who didn't like my father and made him build churches. I decided to have an attitude like the bishop instead of my father and become a leader, not a follower. I graduated from Bedford High School and attended Miami University of Ohio for one year since I only had a one-year scholarship. (I had forgone a four-year scholarship to Wilberforce College, an all-black institution, since I did not want to attend a segregated school.) With no money of my own, I could not continue my education, so I enrolled in Western Reserve as a part-time student working for Jean Capers, a Cleveland city councilwoman. (This marked the beginning of my interest in pursuing a political career.) But I did not see myself progressing there so I enlisted in the Air Force in 1951 knowing that I could complete my college education with the GI bill.

I took to the military very well because I had already served as household squad leader to my nine brothers and sisters after my mother died when I was twelve. When I was fourteen, I worked in a meat packing company to help support my family. By the time I got in the military basic training was challenging, but not too much so because hard work had become a way of life for me. I scored high on my military aptitude tests for clerical positions, and they wanted to send me to a military clerical training facility in Wyoming. But I refused to be buttonholed into a secretarial role. I asked why there were no black classroom instructors at Lackland, and a female colonel informed me that the "time was not right" for us.

This same colonel was fielding quite a talented group of female athletes. I was a star softball player and all-around athlete. She wanted to keep me for my athletic abilities and offered me a position as a base orderly with secretarial functions. I did not want to be a secretary, but because the colonel wanted to build a good softball team and could not do so if she lost her home-run-hitting orderly, I was made a classroom instructor, and history was in the making. I successfully completed supervisory and instructor training and went on to become the first black woman to teach military law, customs, and courtesies in the Air Force! I also won

a lot of blue-and-white luggage for softball victories in addition to playing field hockey, basketball, and volleyball. My brothers had taught me well.

Sara, when I went into the Air Force, there was big-time gender segregation—men and women had separate training, drills, and chains of command. We marched separately. (The irony is that over four decades later, a female-headed civilian panel is now recommending single-sex boot camps. So what's new?) Being a woman in the military was difficult enough but being a *black* woman in the military in the '50s was a double hazard. So, yes, there were racist elements I had to contend with, but I was a good soldier who received commendations. When I was an instructor I encountered no resistance from trainees. I would say to them on day one, "Yours is not to question why. Yours is to do or die. If I say, 'Jump!' you say, 'How high?'" It worked because, ultimately, a soldier, male or female, is trained to kill or die for the nation, quite literally.

My problems were with other instructors and supervisors. Once a white female sergeant, the noncommissioned officer (NCO) in charge of Women's Air Force (WAF) training, accompanied by the female NCO in charge of math instruction, came to my classroom to chastise me—for nothing. The sergeant called me "a worthless black nigger." The NCO in charge of math instruction then told her she was wrong for calling me names. I knew that if I lashed back at the sergeant, I would be court martialed. So I called attorney Jean Capers in Cleveland and told her to get ready because I was going to whip the NCO's ass. Capers and the math NCO cautioned me not to hit the racist sergeant. Even though it took all the discipline I could muster, their good advice prevailed. The racist NCO was eventually demoted from tech sergeant to corporal for her actions. Quite a fall for a person who was at the time in charge of all WAF training—a position I was to assume before my Air Force career was over.

It is worth noting that doing the right thing in the military in my day had nothing to do with political correctness. The lieutenant and the math instructor who brought charges against the NCO were actually friends of hers. Military discipline took precedence over personal relationships. In some ways this was because women were under intense scrutiny from the

men, who were looking for any excuse to come down on them. The men in charge could review women's actions and hold them to a higher standard which they would not have been subjected to themselves, no matter how racist they were themselves. To this day, I don't know what set that female tech sergeant off. I guess she was just tired. The real tragedy is that racism was a divisive factor for those of us who should have been natural allies.

My military advancement was strictly based on my classroom accomplishments. I made buck sergeant after ten months. I eventually became staff sergeant and tech sergeant. (To put this in context, a sergeant can rank from an E-3 to an E-9. A staff sergeant being level E-6, a tech sergeant E-7, and sergeant major E-9.) I was the highest ranking NCO WAF classroom instructor of males and females, and I served a total of only four years. I was in charge of all WAF training after three years and was ready for new challenges. In 1954, the same year of the landmark *Brown v. Board of Education* case, I scored highest on the recruiting exam for the Eighty-fifth Army Area. I was to leave at 5 A.M. for West Virginia to serve as an Air Force recruiter. Instead, the colonel called me in from my farewell party to say that my orders had been rescinded by the Pentagon, basically because "whites did not want a black woman recruiting their little West Virginia daughters."

This treatment was a major factor in my decision to leave the Air Force. I even considered getting pregnant to take advantage of the sexist policy that penalized women for having babies (probably because it's something men can't do). I did not get pregnant but instead took an early out, despite the colonel's protest. I had just been named "airman" of the month, but I decided I couldn't fight the prejudices in the Air Force wearing a uniform. I did not reenlist.

Racism and sexism took their cumulative toll on me. I was fed up and knew things would not get much better for me in the military. I didn't want to set myself up for a crucifixion, and so I moved on. Women in the military during my era of service did not have the external support from women and other progressives outside the military to challenge racist and sexist practices. Today there is a "supporting cast." That is one reason I encourage women who are up to it to enlist in the military.

In answer to your question, I think what attracts women to the military today are the same things which motivated me over forty-five years ago and which motivate men then and now: good training, education, and benefits. How do I respond to those who say women can't be a formidable force in the military, especially in hand-to-hand combat? Look at Israel: Women can do anything men can do, including engage in hand-to-hand combat. We do it every day in the neighborhoods of America. That's how we have survived rape attempts for generations. Proper military training coupled with physical conditioning will result in a woman's being every bit as capable as her male counterparts in a combat situation.

Sara, you must understand that the lives of black women have always been endangered. For too many reasons that defy logic and civility, the beating and killing of women of color (and many poor white women) has been condoned with approved nods and a "she deserved it" mentality. The dangers I faced in the military were no more than those I would have had to confront had I made a commitment to share my life with the wrong man.

And about the issue of sex in the military. You can't take boys and girls (these are kids, we must understand that—they will be attracted to each other), put them in proximity, and not expect nature to take over. Proper military discipline will certainly minimize nonconsensual activities. But the sex issue obscures the real issue: What can a given individual contribute to the defense of our nation? Fly a plane, shoot a gun, operate radar, be a medic, work on a nuclear sub, etc. The sex ploy is used to keep women in their place—subservient to men and unarmed. Quality-of-training issues must be addressed by today's military. A well-trained, disciplined soldier is a national asset, irrespective of gender. Gender must not be an obstacle to military opportunities and advancement.

Sara, all the sociological analysis cannot obscure the ugly reality that male-dominated military culture has perpetuated the myth that only men are capable of bearing arms and waging war. It is civilians who are basically freaked out at the very notion of women in the military, because we have been conditioned to accept the reality of GI Joe, not Josephine. Cer-

tainly the United States military has been in the vanguard of that un-
healthy mentality. Sexist stereotypes shape the mind-set of too many civil-
ians who buy into the crap that the military is for males only and we are to
be "protected" by our men. Surely if history has shown us anything it has
demonstrated that the defense of our nation is too important to leave in
the hands of men.

My experience taught me a clear lesson. If men had their way, not one
woman would wear a uniform, because of the male mentality that there is
only one role for a woman: flat on her back having babies. That is wrong,
but that will never change. War and preparation for war are hard. Men re-
sent the fact that women can at least do one thing they can't do (bear
children), and men want to reserve fighting for themselves. That's just
part of macho bullshit.

Just as black Americans immediately understood that we could not be
full citizens unless we shed blood for this nation so, too, must women deal
with this unstated requirement for full American citizenship and the op-
portunity to fully participate in controlling the destiny of our nation.
When men restrict who can fight and die for America, they restrict who
can run America. There is no greater leverage in the quest to participate in
a nation's decision-making process than that gained when people serve
their nation and make the ultimate sacrifice of life itself. Of course, there
were black Americans like Muhammad Ali who made the courageous de-
cision not to fight in the Vietnam War. But I feel that we served so that Ali
and others might exercise their rights to refuse to serve.

Sara, you and your generation must be unrelenting in our common
goal of insuring gender balance in all phases in life in this nation—includ-
ing military service.

Your friend,
Arie Parks Taylor

Are There Sports in Which Women Beat Men Every Time?

Emily Jenkins and Mariah Burton Nelson

Dear Mariah,

I must confess, I defaced a library copy of *Are We Winning Yet?* by scribbling notes in the margins. Later I was contrite enough to buy my own copy of *The Stronger Women Get, the More Men Love Football,* which I read in two days. Your books have shown me what a tangled mess of athletic urges I am.

I want to talk sports talk, I really do. I want to follow the Knicks. I'd like to watch hockey. I think it would be fun to drink beer and yell obscenities at the TV or argue ferociously over the merits of a recent trade. Only I get bored. When I have a chance—that is, when my boyfriend's friends come over to watch a game or the subject of the playoffs comes up at dinner—I realize with a shock that repeats itself each time this happens that I have no idea what people are worked up about. I don't know the rules of the games or the names of any of the players. They blur together, the male sports stars, forming a fuzzy expanse of muscled bodies punctuated only by Dennis Rodman and Carl Lewis. And suddenly, as I write this, I see what Rodman and Lewis have in common—why they, among dozens of other stellar male athletes, have a place in my memory when everyone else fades into obscurity. They are the only two I have ever seen in women's clothes.

In an advertisement a few years ago, Lewis posed, hunched down at

the starting block, wearing red spike heels. More recently, Rodman wore gaudy, glittery drag to book signings on a publicity tour for *Bad As I Wanna Be*. These feminized images of male athletes have given me a strange point of contact with the sports Americans watch. I remember Lewis, swell with sympathetic pride when he makes the Olympic team for the third time, and watch the papers for his times during the games. I find Rodman's dirty leer appealing and cheer for him the few times a year I find myself watching basketball. Why? Lewis and Rodman—unlike the armored football stars, the thick-set batters, the padded goalies—have made themselves like me. If only for a moment. It is amazing how vulnerable a nearly superhuman man can seem in ladies' clothes.

So it is obvious why I'm bored with sports talk. It is talk about a planet with no one like me on it. A planet I can't inhabit. A planet with a language I don't know. The question is, why do I want to speak that language? Why do I want to go to that planet at all?

If I try to tell you the answer, all I can come up with are three memories from my childhood. One, I used to be a biter. I unfailingly attempted to cannibalize any children who ever hit me, drooling and chomping and holding onto their wrists like a demented pit bull. It never occurred to me to defend myself by hitting back, because that kind of full-out physical aggression felt unnatural to me. It was impossible to propel my fist outward, away from myself, with force. Biting was more contained. It was the only form of violence that wouldn't involve my whole body moving in a large and obvious way, and it was the only form of violence that eluded the definition of fighting as I had learned it—kicking and hitting and pushing. When I bit people, I remember feeling pride. My victims would be shocked at my raw animal power, and lack of fear.

Two, I was mildly traumatized in the outfield during sixth-grade gym class. The softball came at me. I followed after it with my mitt and scooped it up. Then I stopped. I didn't know what was supposed to happen next. I felt a surge of pride at having got the ball and a surge of mortification: Who was on my team? Which direction should I throw it? What was I trying to accomplish? The teacher who put me in the outfield had assumed we all knew the rules, but I had never seen a baseball game. I

gave up and tossed the ball to a loud boy standing next to me in the out-field, and he threw it wherever it was supposed to go.

Three, when I was a senior in high school the boys in my class proposed a drag race. One of them owned a Camaro, another a BMW, another a red Porsche. I had a 1964 Volvo with a push-button starter and was not invited to race. Neither were any of the other girls, even those who owned fast cars. The race was supposed to involve a good amount of beer bought with Metal Dave's fake ID, and it was to go about seventy miles out of town to someone's country house where more beer would be drunk and the winner would rule. It never occurred. The speed racers drifted into school plays, rock bands, and necking sessions with sophomore girls, and their Evel Knievel fantasies lost their pungency. What is important is that my friend Kelly and I insisted that we would race, too. We called ourselves "Team Turtle." We would show the boys what we were made of. And what was that, when it really came down to it? Something slow, something curvy, something unthreatening—like my Volvo.

What the anecdotes show is that a sense of physical proficiency—of being fluent in the codes of physical aggression and domination, even in the rough play of the schoolyard or the adolescent posturings of the senior tables in the refectory—is important to me. But I have never been able to participate in it fully, only from the edges. I would bite because I couldn't hit, toss the ball to someone else, drive like a turtle so I could join the race without being a threat. I didn't care about winning the drag race, or preventing a home run, or taking revenge on Biffy Smith, who pushed me down in the schoolyard. I cared about participating in that fearless, aggressive mode of being, whether it was talk or action.

I have to admit that the way I've told these stories makes me sound tougher than I was, because tough is what I wanted, and still want, to be. Nine times out of ten I just cried and told the teacher when someone pushed me down, and I very often thought about eye shadow colors in the outfield rather than watching for the ball. I was voted worst driver in my senior class by a large margin, so there probably wouldn't have been much hope for me even if I owned a Ferrari. I am thin-skinned and awkward in the driver's seat and the playing field. My body is irritatingly frail. I fanta-

size about playing hockey, skidding across the ice, taking a beating, and bouncing up to dish out some punishment myself. But truthfully, I am timid at the rink and tell myself that lessons cost too much. Even when it's just a matter of talking sports talk, I am still standing at the edge of the rink, watching the boys circle round each other. I only know about Rodman and Lewis, with their tenuous link to my own experience, and I cannot quite get myself onto that unknown planet. And I will never play with the big boys unless I do.

Your books politicized sports for me and made me examine my own tentative, sideways embrace of athletics more closely. You showed me why I wanted to talk the talk and play the games and also why I have never done either: largely because "baseball and other manly sports are more than games. They constitute a culture—the dominant culture in America today." Sports talk, as you say, bonds people together over a team and connects them vicariously to masculine strength. Fluency in it is fluency with the master's tools, tools which Naomi Wolf argues are the only way to dismantle the master's house. Thus many women are embracing athletics as a means to self-empowerment.

In a way, you have convinced me that participation in both competitive and recreational sports—despite the sexism of sports culture—can and does open doors for women. In a society where "muscles represent strength, privilege and competence," female sports participation can, as you've argued, foster comfort with competition, a sense of unity with members of a team, confidence with physical risk, a feeling of accomplishment—all of which engender very real personal and political changes.

But on the other hand it seems to me that we need an alternative paradigm. You've argued that women are changing sportsmanship to reflect a "partnership model," where competing players see each other as comrades rather than enemies and in which power is understood not as dominance but as competence. I'll bet this is true, but it's not enough for me. I think women need sports and games that are not based on skills men will probably always beat us at. You yourself wrote in *The Stronger Women Get* that sports which depend on men's superior upper body strength bolster the myth of male physical supremacy. I would extend that argu-

ment—because much as I hate to say it, they also beat us at speed, height, and lower-body strength. And as long as we are high jumping, running, and swimming against a clock, or thrusting the ball through the waiting hole of the hoop, we are trying to do sports designed on a male model, sports which demand height, muscle, and an impulse to penetration. Even in sports which are thought of as women's sports, such as gymnastics and skating, men do higher jumps and more rotations in the air. Are they all, in some way, men's games?

Some of these sports have been around for only a hundred years or so. As we approach the twenty-first century, I wonder if you see a different sort of athletics emerging out of the women's movement in the next one hundred years. I don't mean noncompetitive sports, because we have plenty of those. Aerobics made me an athlete when I could never have brought myself to compete at anything. I didn't have to worry about winning or knowing the rules or talking about aerobics heroes at parties. Recreational sports are great, but they aren't enough. I wonder instead if there isn't a way to foster women's competitive urges under a new flag. Might there be another way to teach physical education? Might there be other games to play, ones that stress women's physical superiorities? (What are those superiorities, anyway? You've mentioned flexibility, efficient sweating, longer life span, resistance to stress, and a low center of gravity, but I would trade them all for speed. Or a strong right hook. None of them gives me a sense of possibility, perhaps because there are so few sports in which they are really advantages.) What might those other games be? What do you think the future is, Mariah?

Yours,
Emily Jenkins

❖ ❖ ❖

Dear Emily,

When I was a seventeen-year-old high school junior, the teacher who was molesting me wouldn't let me participate in his annual Thanksgiving football game, known as the Turkey Bowl. Several other male teachers played. Some of my male classmates played. The legendary

Bob Dylan (Jakob Dylan's father) was even rumored to have played one year. I wanted to play. Why not? I was a star basketball player, volleyball player, lacrosse player, and swimmer—and could throw a mean spiral. I argued my case, but the teacher insisted the Turkey Bowl was "a male thing."

His refusal to let me play served as a "click"—a feminist awakening—that helped me extricate myself from the abusive situation. "Since I can't play football with you," I told him, "I am never, ever having sex with you again." His exploitation ended that day.

So I commiserated with your exclusion from the drag race, though I liked your spunky insistence on entering Team Turtle. What I saw in your story was not so much an acquiescence to slowness and curvaceousness as a gentle parody of the boys and their fast cars. The statement you and Kelly made was, "We girls are going to team up and enter your race, regardless of what you boys say, and we're going to do it our way." The purpose of all-male events is to exclude women. You didn't let that happen. Good for you.

I suspect your uninvited entry might even have contributed to the race's demise. Maybe the boys were uncomfortable at the prospect of you two poking along in your Volvo, laughing and having entirely too much fun. Or maybe they feared you would win. Surely they knew of Aesop's fable about the tortoise and the hare!

Nowadays you're again trying to visit a planet where you're not welcome. I don't blame you. When men spend all afternoon watching television and screaming obscenities, they're busy not doing some things that women usually take care of: laundry and groceries and diapers. Plus they look like they're having fun. How pleasant to be included in the jovial sports talk that pervades the living room, the dinner table, the workplace.

But there are reasons why you can't speak that language. While watching what I call manly sports (football, baseball, basketball, hockey, and boxing), men identify with big, strong, aggressive men (who serve as heroes), while small, busty, smiling women (who serve as decoration and titillation) remain on the sidelines, dancing and showing off their underwear. If you're female, the best you can hope for is acceptance as

"one of the guys." Yet that alleged compliment denigrates your own gender. So you can't win that one, and I suggest you turn your attention elsewhere. Fortunately, there are many other ways to be sporting.

If you seize control of the remote (or simply share it) and change the channel, you can visit whole planets where you won't need Dennis Rodman or Carl Lewis to demonstrate what "athletic and female" might mean. On all the networks plus several cable channels you can now watch fabulous female athletes engage in basketball, softball, soccer, swimming, volleyball, tennis, track, bowling, and golf for starters, plus the usual skating and gymnastics, plus offbeat sports like barrel racing. You'll have to hunt for some of these treasures—only about five percent of all sports coverage is of women—but because televised sports are increasingly ubiquitous, most days you can find some women to watch. Your boyfriend and his pals might not join you on the sofa, but then again, they might: The millions of men who are flocking to women's college and pro basketball games (and women's pro tennis and golf) are catching on to the fact that great athletes can be glorious, regardless of their gender.

Personally, I've always been more interested in playing than watching, and I sense that's your urge too. Yet your body is "irritatingly frail," you say. Well, no wonder. Until you discovered aerobics, you didn't receive any athletic training (apparently). Those ice hockey players you admire— the ones who can "take a beating and bounce back to dish out some punishment" themselves—weren't born that way. Whether male or female, they've spent hours developing strength, coordination, flexibility, resilience, and, yes, toughness.

Given your passion for sport, I'm not sure why your school teams and youth leagues failed you. One in three high school girls plays sports now, as compared to one in twenty-seven in 1970. That's not enough—boys still get twice as many opportunities, which is illegal as well as immoral— but there are now millions of chances for girls (and not just the most gifted ones) to develop the fearlessness, aggressiveness, and physical proficiency you desire.

Maybe your parents expected you to come home after school and take care of younger siblings—as is the case with many girls but far fewer boys.

Maybe your early humiliation on the softball field (which was not your fault, I hope you realize; you should have been told the rules, and you should have been forgiven for mistakes) so unnerved you that you avoided sports after that.

My guess is that internalized sexism (which all of us suffer from) did you in: You seem to believe that women should be nonviolent, even when violently attacked; that we should try not to threaten male egos, even when men are cruel to us; and that what men do and how they play is more important than what women do and how we play. You (and many women of all ages) seem to suffer from a sense that it's not right (not feminine?) to get your "whole body moving in a large and obvious way."

Emily, I encourage you to get that body moving. You say you crave speed. What's keeping you from acquiring it? Surely not your estrogen or your XX chromosomes. You tell yourself that "lessons cost too much," but if you remain timid throughout your life, what will that cost you? Find a coach or a friend who knows more about ice hockey or running or skiing or rowing or cycling or auto racing than you do, and go get fast. Are you still frail? Lift weights to build strength. With training and discipline, I bet you can get pretty fast.

Maybe it's that qualifier, "pretty," that irks you. You seem to want to be the very fastest. Or you want women in general, or some particularly swift women, to be the fastest of all, faster than all the men.

I can relate. I cheered when Billie Jean King beat Bobby Riggs in 1973; when Ann Trason beat all the men in a twenty-four-hour national championship run in 1989; when Susan Butcher beat all the men in the Iditarod Trail Sled Dog Race for four of the five years between 1986 and 1990; and again in 1994 when the Colorado Silver Bullets won their first baseball game against men.

As you know from my books, women and men often compete equally in rifle shooting, yacht racing, auto racing, equestrian events, horse racing, and some other sports. Even in marathon running races, in which the overall winner is usually (but not always) male, the best female is usually faster than about ninety-five percent of the men. So the truth is, men are

not better athletes than women. Some exceptionally skilled men are better in some sports, that's all.

But you're seeking sports "that stress women's physical superiorities," you say. How about the balance beam and synchronized swimming? Do these not count as "real" sports because men don't participate in them (and laugh at them)? Would men outshine women if they tried them?

I suspect you want to use sports to prove that our gender is superior the way men have used sports to prove that their gender is superior. Let's imagine what might happen if we invented one of those sports. Let's call it ice swimming: traveling long distances, fast, in frigid water. Now we can stop imagining and draw on facts, because Lynne Cox holds the overall record for swimming the Bering Strait, and she's the only person to have swum across Siberia's Lake Baikal. Her female body fat—along with her human strength and training and technique—surely help her thrash through waters that dip to thirty-eight degrees. So we could say that women are superior at ice swimming, and we could encourage women to do this. Then what? Would we discourage men, just to be sure that none of them surpasses us, the way men have created legal and cultural and educational barriers to women's sport participation? Many men have said to me: "Women could never play pro football." Would we now say to men, in that same derisive tone: "Men could never be professional ice swimmers?"

I don't want to play that game. I'm too familiar with the damage done (to all of us) by the myths of male superiority, white superiority, heterosexual superiority. I don't believe women (or people of color or gay people) are inferior. Nor do I believe that men (or white people or straight people) are inferior.

Yes, all games are men's games, in a way, but the same could be said of most educational, political, and religious institutions. All games become women's games when we play them, and our very participation changes women, men, and the games themselves. So if you want to reinvent sports, Emily, go ahead. It's happening all the time: mountain biking, snow boarding, sky surfing, in-line skating, bungee jumping, base jumping, and many other sports were born after you were born. That's what extreme

sports are about: an effort to think differently about how we can take risks, have fun, and compete. But I also urge women to sign up for drag races and Turkey Bowls and professional football coaching jobs and whatever else appeals to us. We need to refuse, steadfastly and repeatedly, to remain on the sidelines.

I foresee that in the future, children will be introduced to a myriad of sports and encouraged to compete honorably with other girls and boys. After puberty, in certain Olympic, professional, and college sports where gender differences matter, men and women will still compete separately. But most people will play sports in ways that make gender irrelevant, training and competing based on their skills, size, and interest.

Fortunately, this is already happening. In masters swimming, for example (my current favorite sport), we segregate according to gender and age for meets, but for daily workouts we group ourselves only according to speed. I train in a middle-speed lane with Julie, George, Ruth, Patrick, Sue, and Hank. Most days, Julie's the fastest and Hank's the slowest—not because of gender but because of talent and conditioning. During most practices, my lanemates and I compete with each other—not to prove any points about men, women, and supremacy but just because competing challenges and amuses us. The fastest and slowest lanes also include both men and women, aged twenty-one to ninety, and several world champions. Two of our fastest swimmers are named Bambi and Rose.

I cherish this mixed-gender, mixed-age, mixed-race, mixed-sexual orientation camaraderie. In particular, I cherish the fact that men and women are working out and competing and laughing together as equals. I think it helps all of us transcend the culture's pervasive battle-of-the-sexes mentality. I know that for me it's healing. It offers me hope that there are men in the world (and in my very own swimming lane) who truly respect women as peers.

So the future is now, in a way, but I'm also impatient for that day when no one falls for the myth of male superiority anymore. I yearn for the day when all girls are taught to throw that "strong right hook" but no girls need to use it. I look forward to a time when women routinely trust our abilities and assert our rights, regardless of what men can do and regard-

less of what men might say. I believe that sport—because it builds strong bodies and minds and egos and because it shows everyone, on a daily basis, that lots of women are as skilled and speedy as men or more so—can help us get there.

I admire your passion and honesty, Emily, and your writing. It's risky to commit stories and questions and ideas to print. That's what athletes do: take risks. So you're on your way to athletic success, if that's what you want. It's not too late. You've got the courage. Now go get yourself some of that speed. I was named for the wind, and I like to think I'll be the wind at your back, supporting you and also pushing you, gently, to excel.

In sisterhood,

Mariah Burton Nelson

OFF THE PEDESTAL:

Younger Generations Take Their Foremothers to Task

Eisa Nefertari Ulen and Angela Y. Davis

Liza Featherstone and Dr. Phyllis Chesler

Nisha Ganatra and Christine Choy

Lisa Springer and Betty Millard

◆ Women are supposedly the communicative, cooperative gender. Most of the time this works to our advantage, but it may drive underground some necessary and even useful confrontation. Women from the first and second waves of feminism share offices and projects with their younger counterparts, a generation which never expected *not* to work. What happens when women employees and employers hit a brick wall in their relationship?

Too many conversations between younger and older activists seem to end in "you don't get it" (coming from younger women) and "what are you doing about it?" (coming from older women). And there's intergenerational tension about the legacy that foremothers have left behind. Young women may resent the lack of guidance, mentorship, and even "social parenting," while foremothers often want young women to come up with solutions on their own.

How can we challenge each other without alienating one another? Should young women receive special treatment from older women? Do women working together sometimes replicate the worst of mother-daughter relationships?

What Happened to Your Generation's Promise of "Love and Revolution"?

Eisa Nefertari Ulen and Angela Y. Davis

Dear Ms. Davis,

You know my father. You know my mother. They know you. And your sister Fania. Daddy helped you slip through Pennsylvania when you were underground. Mommy let Fania into our home when you were caught. Fania was pregnant, I was about two, and she later named her daughter Angela Eisa Davis. Mommy kept your niece's birth announcement. It is taped, next to pictures of people sporting Afros, in my baby book: "Born of the bloodfire of struggle for the people. I honor my child with your daughter's name. May they both be strong forces of love and revolution."

Oh, the promise of those words, those pictures, these images. My soul cries out even as I turn the yellowed page. There are pictures of Daddy and Mommy. Together. And me. Lenin lines the walls, stacked beneath a poster ("Unite Contre La Represión") in our living room, where folk then in their twenties would arrive and debate through study sessions, trying to fulfill the promise in that poster, those books, bringing the images and words to life—a real life.

Of course that living room isn't ours anymore. Like so many folk in their twenties then, my parents divorced. And like so many folk in their twenties now, I was raised by my mother.

As I take full advantage of my generation's opportunity to enjoy a de-

layed adolescence—single but yearning for marriage and parenthood—I look back on my own family. I feel the lost potential—at times feel imprisoned by it. I also look around our community, feel the lost potential, and—at times—feel imprisoned by it. I think we, now, are feeling the same way, imprisoned by the past. The Black Nation's hip-hop generation has been looking back at itself.

We give '70s parties, wear '70s bell bottoms. Well beyond any good ol' days clichés, my generation is recapturing its passage from youth to young adulthood. In an era when so many young Black men have seemed unafraid of killing and dying, Generation (Malcolm) X is reliving—in the past.

A few of the best in the rap music industry can take and twist 1970s sound with 1990s image through old sampled beats and new spoken words. This aligns the modern on an ancient continuum and perpetuates the legacy of Black music; yet why do so many hot young singles go back in the day on wax? Why is Black music, our talking drum in the diaspora, sending a message of return? Why are we consuming your generation's music, your generation's love?

In the climate-controlled confines of local movie theaters, where we escape from the real world and enter the filmmaker's recreated vision, we go back to the days just before and just after Black folk in their twenties stepped into young adulthood. Something in the collective unconscious of young Black filmmakers remembers a people bumping on the dance floor, rolling with the skates at a disco ring, loving themselves enough to keep the gun unloaded in a shoebox on the closet's top shelf. From *Crooklyn* to *The Inkwell* to *Boyz N the Hood* to *Dead Presidents* to *Jason's Lyric* to *Panther* to *Set it Off,* we revisit.

The release of rites-of-passage films heavy with Pro-Keds–era iconography moves us to a time before AIDS (what happened to my sexual revolution?), before Reaganomics (what happened to my economic revolution?), before crack even hit Huey Newton's neighborhood, much less poisoned his body (what happened to my political revolution?). And in this slice of time before sneakers became one-hundred-dollar investments worth shooting the brother down the block over, parents called us

into the house once streetlights flickered on through the community's night. Then, just as we grew old enough to play adolescent games past sunset, the safety of the streetlights blew. Now we stand on the stoops and porches ourselves, not quite ready to call out to the neighborhood kids, no longer the ones called.

I refuse to lie back and feel good about the retro movement in young Black cultural expression. Were a hot young single you love holding her broken old Lite Brite with strength equal to 1990s P-Funk revivalist record sales, you would worry. I know it's time for young heads to work toward true illumination. But that bright glare might spotlight a positive HIV test, a lot of time between jobs, the barrel of that gun now loaded, out of the closet, the shoebox tossed. Better to focus on the dim past as we stand on the community steps, peer into a situation where the street-lights still burned bright.

Too few households have left the stoop lights on along the streets of today's Black Nation. But why? Why after the hope and uplift and strug-gle of your life—of your collective lives—why is our community standing in the dark?

My mother tells me I should write something nice. "Why don't you talk about all the good things that happened?" she asks me. Well, it does feel good to turn on my radio and hear the old school mixes, hear my favorite hip-hop artists talk about "back in the day," about "goin' back in the day." I'm listening to all the good stuff all the time. But aren't we a little young, isn't hip-hop a little young, for any of us to feel good about going back?

It was during the '70s that my peers were able to rise from where we'd been forced—undereducated, underfinanced, underground—and create the multibillion dollar industry that is called rap. But now, just as we've started to create a new generation ourselves—who mimic our words, our sounds, and our deeds—we haven't been able to build on your promises of love and revolution. What will be the substantive results of our legacy, our image? What were yours?

It's bad enough that brothers are dying but that the death seems some-times to be feeding on itself, springing out like fresh blood from within ourselves; this is just, this is just too much. I know each generation strug-

gles, Ms. Davis; but I'm asking you to help me come to terms with these losses. I know there are retro elements in any new trend, but each film looks at the moment of transition, the place where our families, our communities, our world seemed to fall apart. We mix sounds of family reunions and backyard barbecues with words of terror and pain.

I am writing from a seemingly sheltered, comfortable life, but I, too, have seen boys fall to our streets. I've seen their blood fall to our streets. I've heard young men listen to your music and say, "This is when Black people still loved each other."

I've seen girls fall to our streets. I've seen their futures fall to our streets. I've seen young women look around them and heard them say, "I'ma just go on and have his baby before he gets locked up or shot up or something." I've heard that.

Your generation's ex-husbands are replicated in my generation's babies' fathers. This is not an empowering new configuration of family that is somehow uplifting and free. Our babies' mothers are alone and tired and broke.

I can only remember a glimmer of revolutionary-type lovin', of we gonna make this happen, baby I love you this much, enough to make this happen, this is our struggle, this is our struggle, we gonna struggle together baby-type lovin'. Where are our models of strong manhood for young men? Where are our models of strong mates for young women? Where are those revolutionary, revolution-era families?

Are we supposed to get those models from our grandparents? From books? Forced further and further past strength to strain, what is left but the prison of bad choices? I see whole families imprisoned by bad choices. I see whole communities surrounded. I sometimes wonder if we were better off when we had fewer rights, but more revolution.

I'm asking because after seeing my family fall apart, seeing the Movement fall apart, I know the real revolution was at home. For a Black woman and a Black man to create new Black life, nurture it, watch it grow together, that is a revolutionary act. It is the only way we will be able to live—to remain alive.

I know the face of a real postwar syndrome. I belong to it. I have seen

the ache and the rage in my own father's eyes. But now he can see a piece of that part of himself in me. He was too young then. He was too young to see such death. I am too young now. Our death—real and metaphorical— and our prisons—real and metaphorical—have kept your generation so far away. And they have kept my generation flung backwards in time.

I am asking your peers to come forward with the full force my peers have spent in the stretch to yesterday. What formal structures (as formal as family configurations) do you have in place for us? For your grandchildren? Will you help us rebuild the extended family—the one I remember from my childhood—in our community today?

I know Tupac needed everyone who had ever been down with anything Afeni had been down with to visit him in jail, Ms. Davis. He needed that. He said that. Geronimo wasn't released until Tupac was dead, but you weren't all locked up. Or were you?

Are we going to kill each other off before your generation returns, is released, to finish leading, to finish parenting? Where are our leaders? Where are our parents?

Will you hear us? Will the new Black Radical Congress address us? Will it include us? Will it address the brilliance lost like Tupac's, brilliance lost on our community streets every night?

Ms. Davis, we are crying out to you in the dark. We have come of age without the wisdom of the earlier generation. We have your style, but we don't have your substance. Tupac was just a symbol of our murdered potential. A future so lost, so gone, that sometimes, just sometimes, Ms. Davis, it seems gone for good.

Love and Revolution, Ms. Davis. Love and Revolution.

Still yours,
Eisa Nefertari Ulen

❖ ❖ ❖

Dear Eisa,

So often when I speak on college campuses and at other venues around the country, I am confronted by young people—of your generation and younger—who ask me, essentially, "Where do we go from here?"

And my answer to them is the same answer I will give you: That is for you to decide. As an "elder," I do not presume by virtue of having lived longer in this world to be able to guide younger generations into the future. I will not shy away from the fact that I possess a certain wisdom born of experience, and I recognize that my wisdom and experiences may hold valuable lessons for you and your peers. But I also can recall my own youth, when black student activists were contesting—rather than seeking to follow—the philosophy and strategies of Martin Luther King Jr., whom we considered to be an elder. It was out of this contestation that the Student Nonviolent Coordinating Committee (SNCC) was born. And from SNCC arose the Black Power movement. And so on.

Eisa, so much of what you have expressed involves the relationship of yourself and your peers to a certain romantic idea of the past, of the '60s and '70s, an era that in the minds of many young people today is charged with dreamy notions of revolutionary fervor. You write of "trying to fulfill the promise . . . " and of being "imprisoned by the past." You write of posters and books and music and other markers of a bygone era; you evoke contemporary black films whose production and popularity are fueled in part by nostalgia. You lament that your generation has not "been able to build on the promises of love and revolution" of my generation. So much looking backward, you say—and why?

The times we live in today are far more complicated than the past, about which you write. Before desegregation, before Black Studies, before the advent of the word "multicultural," before Ward Connerly's anti–affirmative action campaign, it was far easier to develop a critical analysis—a revolutionary analysis—of the social conditions that affected our lives. On some level I think we all yearn for those simpler times, when we knew who the enemy was. The challenges we face today as we struggle to advance our multiple fights for social justice and certainly the challenges confronting young people as you try to imagine your future—these are daunting challenges, indeed. So why not harken back to the '60s and '70s, when it was so much easier to draw a line in the sand and when there was a real revolutionary movement that had real momentum? Why not delve into the past in search of inspiration for the present, a vision for the future . . . ?

Because, as you write, so many young black mothers are "alone and tired and broke," and so many young black men are "falling to our streets." Because, as you write, "whole families are imprisoned by bad choices." And watching movies, listening to music, reading books, and dreaming about the '60s and '70s are not going to turn the tide. Only a movement can make a difference now. And building a movement is hard work. But it is work that must be done, by young people like yourself who have consciousness, questions, and energy—and there are a lot of you out there; I've seen you, and I've talked to you, and I've received E-mail messages from you. You all just need to find one another. To come together on common ground. To build a movement that encompasses all of your concerns. And I have a suggestion.

You write of " . . . our prisons—real and metaphorical." Let's talk about the real ones. Let's talk about a prison-industrial complex that is threatening to devour an entire generation of young black men, that is a repository for discarded poor communities of all racial and ethnic backgrounds, and that increasingly is targeting poor women as grist for its expanding mill. Let's talk about the Thirteenth Amendment, which abolished slavery and involuntary servitude except for individuals who shall have been duly convicted of a crime. Let's talk about corporate involvement in the expansion of the prison system, of the trend toward privatization of prisons, which lays the foundation for such human-rights abuses as were brought to light in the Brazoria County Detention Center videotape that was exposed in 1997. Let's talk about the gutting of the welfare system, which will force ever larger numbers of poor women into alternative economies—drugs, prostitution, etc.—that ultimately will result in their arrest and incarceration. Let's talk about a system in which punishment equals profits, in which the most lucrative construction jobs are in prison construction, in which the Corrections Corporation of America performs phenomenally on the stock exchange and has a global presence in the private-prison industry.

The fractured families you mourn, the individuals about whom you rightfully are concerned, the communities you witness falling apart—all are victims of a complex web of vicious social conditions in an era of

global capital that includes a rapidly expanding prison-industrial complex. And justifying the expansion of the prison system in the United States is a socially constructed fear of crime—and of "the criminal"—that is perpetuated by politicians and popular media alike. Political campaigns are won and public and private funds are allotted for further prison construction on the basis of a publicly perceived need for a "war on crime." But what— or, more specifically, who—is evoked when most people think about crime? What does the face of "the criminal" look like in our mind's eye? Do we see a white business man in a three-piece suit who misappropriates millions (or billions) of dollars? A corrupt politician? A corporation that is destroying the environment? Or do we see a young black man in baggy jeans with a beeper and a baseball cap?

During the era of the Cold War, communism was constructed as our national enemy. Exorbitant quantities of money, manpower, and military machinery were mobilized against the Soviet Union and other communist-bloc countries in Eastern Europe, and domestic witch-hunts persecuted radical individuals and organizations who identified themselves as socialist or communist. But with the relatively recent dismantling of socialism (with the exception of Cuba), which occasioned the close of the Cold War, has come the need for new national enemies, new public enemies. And those enemies are crime, immigration, and welfare. In a sense the war against communism has mutated into a war against crime, in which poor people on the streets are the primary targets. Young black and Latino men are public enemies, women from the same communities are their accomplices, and poverty itself is a crime. And "lock 'em up and throw away the key" has become the order of the day.

I can remember that more than thirty years ago, when I first became active in the struggle for prisoners' rights, there were fewer than two hundred thousand people in prison in the United States, and that was an enormous number. But it's nothing compared to the nearly two million people who are locked up today. Nearly two million people are incarcerated in prisons and jails in the United States in 1998. Fully one-third of all young black men between the ages of eighteen and twenty-nine are in jail or prison or on probation or parole. We are in crisis. And this crisis ex-

tends beyond boundaries of race and gender. While women comprise a very small percentage of the entire incarcerated population in this country, the rate of increase in the arrest and incarceration of women is almost twice the rate of increase in the arrest and incarceration of men. There is just one boundary that is respected by the contemporary prison crisis: If you are not poor, you probably are not affected.

On the other hand, how many black people can honestly say that they do not have either a family member or a friend in prison right now? And we need to start talking about this publicly. We need to shed the shame that shrouds our feelings about our imprisoned sisters and brothers, sons and daughters, fathers, mothers, and friends. We need to speak out, to call this crisis what it is, and to mobilize against it. Because this is the closest thing we have seen to an organized campaign of genocide against black people since the era of slavery.

So, Eisa, when you write of your generation that "We have come of age without the wisdom of the earlier generation," I want to ask you to think about the times and about the differences that separate the 1990s from the 1960s and the 1970s. Racism is alive and well, yes; poverty remains endemic among people of color, yes; truly equal access to education remains a goal for the future, yes; but things are far more complicated today. There are nearly two million people incarcerated in the United States, and no wisdom that we possessed in the '60s and '70s could have prepared us— let alone you—for that staggering reality. We ourselves, your elders, are at a momentary loss when confronted with the situation that exists now. We are grappling with the challenge of reassembling a united progressive/radical movement; our efforts are manifest in formations like the Black Radical Congress, the Institute for Multiracial Justice, the Committees of Correspondence, and in the Fall 1998 conference and strategy session, "Critical Resistance: Beyond the Prison Industrial Complex."

So when you ask of my generation, "What formal structures do you have in place for us," my answer takes a similar form: What formal structures do you envision successfully moving all of us into the future, your future? As I stated previously, I believe that only a movement can make a difference now. And I place the challenge of constructing and propelling

that movement into the hands of you and your peers. There are plenty of issues around which mobilization is urgently needed. I offer the crisis of the prison-industrial complex as a starting point—will you take up this crisis and wage a fierce battle against it so that you can defend and reclaim your sisters and brothers, your communities, your families? You possess your own wisdom. And you will make your own revolution. In twenty-five years, I want you to write me another letter telling me all you have learned in the process of bringing about your own radical social transformations, in the process of changing your world.

In solidarity,

Angela Y. Davis

Why Is There So Much Tension Between Feminist Bosses and Their Female Assistants?

Liza Featherstone and Dr. Phyllis Chesler

Dear Phyllis Chesler,

I remember exactly where I was standing when you came into my life—in front of my parents' refrigerator in Michigan, where my father had left a scrawled message with your name and phone number. I knew your name, of course; I had quoted you in my recent article in *Lies of Our Times,* a left-wing media criticism journal. I admired your work greatly; I was in awe of your ability to bring a truly scholarly analysis to popular subjects—Baby M or Aileen Wuornos—to write lucidly and with feminist passion, to express rage and argue rationally at the same time.

I must have misquoted her, I thought. Who am I to write, to publish; this is what happens, people get mad, they call and complain. The next day, before I had the nerve to call you back, your bookkeeper, Pat, called on your behalf. "Phyllis was very impressed with your article on Aileen Wuornos, and she'd like to talk to you about it. She's looking for a research assistant."

I was twenty-three and living in Michigan with my parents, getting ready to move back to Brooklyn. It was springtime; the previous fall I had been an intern at a progressive national magazine in New York, work that made me feel smart, political, part of something large. Now I was learning

to drive, working part time, saving up money, getting over and into love affairs that made no sense and trying to map my life's next turn.

I was restless being away from work I loved, an intoxicating city, and new friends, but going back was a scary prospect. What would I do? How would I make enough money to live in that expensive city? How would I hold my own among all those smart, driven, confident intellectuals? I wondered above all: Would I ever do satisfying, useful, and political work again, or had that fall just been a postcollege mirage, the kind of trick the work world played to lure you into thinking it had something to offer?

After your call my heart raced; I was dizzy for days. I went to see my new lover in Chicago that weekend; we couldn't stop talking about your phone call. She was so proud; I was so happy to impress her. Then you called back. In our conversation, I wasn't at all sure I came across as smart enough, together enough, to work for you; but it seemed I had a series of coincidences on my side. You lived in Brooklyn, in the same neighborhood I was moving back to. You were writing a book on the very subject of my article—Aileen Wuornos, the Florida prostitute who killed seven men but was—you and I thought—not a serial killer in any typical sense. You needed a researcher, I needed a job. Fate was bringing us together, you said. I thought so, too.

All the details seemed to fit, but that wasn't all. Your phone call was the greatest, most generous gift anyone could have given me at that moment in my life. You, one of the world's leading feminist writers, thinkers, and activists, were telling me that something I had written mattered and made sense. You were letting me know that I had a place in the feminist movement, as a writer and thinker. And you invited me right in. I will never forget it.

What happened next is not so dreamy. I moved to Brooklyn and began work with you in your office, in the basement of your Park Slope brownstone, before I'd even unpacked. However, our working relationship just didn't "work": I felt criticized; you felt frustrated with me. I quickly realized that we were not a match, and I quit. I moved on to pursue a freelance writing career, admiring the work of my foremothers from afar and relying upon my peers for support.

Over the years, I've seen how badly women need an inter-generational discussion about the work relationships between older and younger feminists. I've worked with many feminists of varying ages, at *Ms.* magazine and elsewhere, and I've talked to numerous young women whose stories about feminist bosses echo the confusion about authority and expectations that you and I encountered. I know a Famous Feminist, a brilliant writer whose colleagues warn young women not to work with her. Another, one of the best-known leaders of the second-wave feminist movement, is so tyrannical that several of her younger colleagues have reported waking up feeling physically sick every morning before work and ending nearly every day in tears. Another, a best-selling author, has shamelessly taken credit for her assistant's work. A prominent reproductive-rights activist is flatly unable to delegate any of her organization's meaningful work to her younger employees, no matter how experienced they are. Many older feminists, young women complain, work better with men than with women. Many don't speak respectfully to their younger assistants, they expect unreasonable sacrifices of time and money, and they don't appreciate a job well done. "How can she be a feminist and treat me this way?" young women wonder. "Why doesn't she clean her own house while she's changing the world?"

Women who have led a movement against hierarchies and inequalities of all kinds may be ambivalent about their authority. As women we already have a somewhat uneasy relationship to our own power, but feminism sometimes adds a bit of moral guilt to the mix (one of our movement's least attractive legacies!).

Perhaps, too, veteran feminists feel themselves undervalued, since their social contribution, considering how great it is, is appreciated by a relatively small group of people. It may be hard for them to acknowledge young women's efforts when their own have been so undermined. The financial and institutional rewards for being a Famous Feminist can be paltry, compared with being a Famous anything else. Do you think older women may resent young women's need for respect and appreciation? Or feel that the young women should, for their own good, get over it?

Feminists have not yet rethought managerial relations, and I think perhaps it's time we did. Political work has to get done, we have to work to-

gether to do it, and we all have rent to pay in the meantime; we have to find ways to negotiate these realities that take account of our humanity, of our politics, and of our movement's needs.

Younger women need the support, invitation, and approval of older feminists. When you asked me to come work with you, Phyllis, you were in effect saying, "You are not just some hysterical, outraged chick with hysterical, outraged friends. You are part of a movement that continues to change the very fabric of human life." Older feminists represent history to us, the history we want to be a part of. Without you and that history, we're not a movement, just girls who know in our guts that something's still amiss. We need to learn from—and build on—the existing ideas, institutions, movement debates, and coalitions that older feminists have set up; there's no need to completely reinvent the wheel. There's plenty to work with—if we can work together.

It's somewhat less clear to me what you need from us. Many of us are willing to work for low wages, and obviously that's attractive. And our political passion, our eagerness to please, our respect for history, and our need for role models sometimes—though not always—make us pretty hard workers. But don't you also need partners from the younger generation who can tell you what's going on in the under-thirty-five world, who can offer fresh perspective? Older feminists will find such partners only when they learn to negotiate their authority more ethically, that is, by finding more democratic ways to employ young women. This may be difficult—work in this society is based on someone getting more out of someone than they give back.

Of course, younger feminists can do better, too. Do you have ideas about this? How do you and others your age experience us? Do we as workers have unrealistic expectations of a feminist work situation? Do we unfairly expect feminist bosses to tolerate our bad work habits just because our ideals are in the right place?

I've definitely noticed that too many of us sabotage relationships with older feminists by overidealizing them and being too easily disillusioned when they fall short. I know what you meant when you said young women often have these expectations you can't meet—no one could live up to

the images we sometimes have of feminist foremothers, the courage we imagine you have, the stamina, the flawless feminist ethics. While older feminists need to learn to treat the young women who work for them as human beings, we must learn to acknowledge that they, too are, just that, human beings—not goddesses.

I think much of the ideological strain between older and younger feminists (often played out in debates over issues like pornography or sexual identity) has its roots in these fundamentally unequal work relationships in which we too often meet; classic worker-boss stuff, which, in a sad irony, is exacerbated by radical idealism. I've noticed that outside of the economic relationship, it is much easier to see each other's worth. In the brief moments before I became your employee, for instance, you gave me the respect and affirmation every young writer needs. That was encouragement that I've carried with me throughout my career and always will.

And last year, when you tapped me on the shoulder in Cousin John's, the neighborhood café, I was stunned. It was the first time I'd seen you since that terrible month in 1992, and you not only remembered me but seemed genuinely pleased to see me. I could barely speak, I was so startled, but I asked after your health. And you asked about . . . my writing! And you said to send me something I'd written; I couldn't have felt more respected and pleased. We were right back to the promising beginning of our relationship.

So here it is—something I've written.

Sincerely,

Liza Featherstone

❖ ❖ ❖

Dear Liza,

Thank you for writing to me.

Recently, I attended a gathering of second-wave feminists. So many of my sisters looked and, in speech after speech, sounded as if they still lived in the past, at the moment when History kissed us all awake. While many of us cried with delight to be together, too many of us looked sad and terribly tired but not tired enough to forgo the all-too-familiar ordeal of too

many speakers. (Feminists have so much to say, so few places in patriarchy to say it in; we also believe that a feminist space "owes" each and every woman a platform and a captive, if not spellbound, audience.) With some few exceptions, most speakers were unable to take us all in: themselves, the rest of us, too. Finally, after fifteen speeches, we each began to slip away. And still the feminists of my generation kept talking: hungry for the microphone, desperate to be "heard," hungry for acknowledgment, wounded by its daily, lifetime, absence.

So understand that I know something about what you and your friends say you have encountered among my generation: where you sought guidance and kindness and tending, perhaps. Pioneers are not always able to both clear that miraculous path and form a gracious, unscarred, welcoming committee for the coming generations.

Walk the path, lengthen it, find comfort where comfort resides, don't expect too much more or the wrong thing from those who have cleared that path.

Like you, over the years, I have heard stories about abusive feminist coworkers as well as employers, who are rigid and authoritarian (like men, only worse, because posturing), or who manipulate, "back-stab," divide and conquer, and who enjoy humiliating and destroying other women— as if this made them mighty.

I would guess that the feminist "bosses" to whom you refer but whom you dare not/are kind enough not to name are not veteran feminist speakers. These feminists are not corporate sharks nor are they high-profile politicians. Few run financial empires, few ever had the money to ever hire someone else. Most are, themselves, unemployed or only marginally employed, retired, or living on disability. Perhaps your abusive feminist employers are under incredible strain, with double the work load and half the support of their male counterparts and bosses. Perhaps they have been sabotaged one too many times by other women. Perhaps their jobs as tokens reside precisely in their ability and willingness to guard against all other female comers. Perhaps your abusive feminist employers are themselves desperate, drowning women who, like abusive parents every-

where, repeat what was done to them: literally, without being able to see how it hurts the next woman.

This does not justify abusive behavior. Women—feminists especially—should, ideally, refuse to break the spirits of the next female generation. Free choice, transcendence, is what happens when we choose not to do unto others what was done to us by abusive men or women: genital mutilation, psychological disfigurement.

However, a feminist boss who occasionally yells or who criticizes real errors is not breaking your spirit. Women tend to experience everything "personally." The slightest criticism is often experienced as a devastating blow. Women, including feminists, might step back, emulate some of the virtues of competitive team sports such as fighting hard as a team, then, letting it all go afterwards, breaking bread.

I have been privileged to have had some extraordinarily devoted students and some skilled feminist employees. Still, for nearly thirty years, most (younger) feminists of any age have, more often than not, tended to approach older feminists, including employers, with their "hands out." Could we be their pro bono lawyers, therapists, editors, publicists, agents, social workers, publishers, social facilitators, do a benefit for their cause, and/or employ them, full-time, for at least fifteen to twenty-five dollars an hour—good benefits, mind you, but please understand that on Mondays they'd have to leave mid-day for a standing therapy appointment and on Tuesdays for an advanced yoga class; on Wednesdays they could only start working in the afternoon because they'd enrolled in a graduate course—a feminist employer couldn't be against that, could she? Thursdays—now that's a day they could work, they'd come by no later than 11 A.M.—unless they weren't feeling well or had been up all night making love or had a sick child; now Fridays—Fridays might be difficult. After all, they, too, had movement commitments; they, too, had creative lives, unplanned-for crises, a round of health care appointments—surely, the feminist employer understood that, and while they couldn't really type as fast or as accurately as they said they could, surely, since feminism had drawn them here, the feminist employer would be

willing to pay them while they improved—wasn't the employer in favor of helping women?

But let me be clear: You are right. There are feminists who have Bad Characters, who are evil, cruel, crazy, difficult, power-mad, megalomaniacal. Just like their male or antifeminist counterparts who exist in every generation: yours, too. Apparently, neither feminist philosophy nor organized patriarchal religion has the power to abolish such Bad Behavior. My advice? Watch what a leader or employer does, not just what she says. If she's demeaning you, no matter how tempting the affiliation or the money might be—leave. You owe that to yourself.

In my day, I saw many a good feminist also act out: Some saw enemies everywhere, even when they weren't there; some acted as if they were God's personal prophets; some experienced themselves as "helpless" victims rather than as avenging dominatrixes. We're flawed, human, just as antifeminists are. It is important to understand that otherwise extraordinary leaders and comrades can also be extremely fragile, limited, wounded, mad, evil, overbearing, oversensitive—simply too interpersonally challenged to work with or befriend. Therefore, one must try not to confuse their behavior with their inspiring ideas.

Young feminists should not work, full time, for love or money, in family or "cult-like" environments in which they are verbally or physically abused, where there are no boundaries, no job description, no wages, little wages. Young feminists should not remain in a feminist environment in which they are humiliated or forced to babysit or do housework for their employers—unless that is their precise job. Nor should they be expected to sleep with The Boss, or listen to all his (or her) problems. However, these remain the standard working conditions for most women in patriarchy.

Today, so many young feminists appear confident, energetic, spectacular in sports and science, forthrightly ambitious, as if they're members of a future species. And yet, some young women, including feminists, are also unable and unwilling to work. Too dreamy, too impatient, too hyper, too wonderfully anarchic to follow instructions. Some young women, feminists included, are, sadly, too unsure of themselves, ambivalent about working with any (female) authority figure—not to mention a Major

Mentor. They may need to strike out on their own. Misguidedly, they may strike out, first, at their chosen feminist mentors. Some may be looking for a mother (with whom to continue That Old Business), not an employer; a therapist, not an employer; an instant, total, community—not a series of difficult, dull, or demanding tasks; a series of sexual and social opportunities—not the mission of a lifetime.

Feminists of my generation did this, too.

I understand what you are saying about some Older Feminists, but this problem doesn't disappear simply because one is young. Have the feminists of your generation already begun the difficult task of being an ideal Older Sister to younger feminists, or has your generation, like mine, been the absolute center of your universe?

I have seen young feminists in their twenties and thirties exhibit boldness, "badness," a readiness to perform street theater, an eagerness to demonstrate—but often only once, for each issue or case, and in the hope of making the evening news, not the local jail.

Many feminists of my generation did the same thing, but I have since come to understand that we cannot free a single battered woman who is behind bars, often for life, for having killed in self-defense, by grandstanding. That requires many, many years of grungy, unheralded, unsexy, unpaid work. Few young feminists want to spend ten or twenty years for no money campaigning for just one woman's freedom. Many believe that they can "have it all"—a career, a revolution, love, children, happiness—when this is not possible.

Perspective is important. While there definitely are feminist employers who yell at their feminist employees—there are probably more antifeminist employers who yell at—and, in addition, sexually harass, underpay, refuse to pay, bad mouth, rape, and fire their feminist employees, too. Also, there is a high turnover in business and in all social justice movements. This is not specific to feminist enterprises or employers. Everyone—not only young feminists—manages to lose some idealism along the way; otherwise, we gain no wisdom. Most high-powered, perfectionist—not only feminist—employers expect their employees to perform well or to sacrifice everything for the task at hand. As they themselves do. Often

young employees really want to be taken into some imaginary, better family—one that does not yet exist. When this doesn't happen, there is sometimes a sense of betrayal, disappointment.

Once, like you, I expected so much of other feminists—we all did—that the most ordinary disappointments were often experienced as major betrayals. We expected less of men and forgave them, more than once, when they failed us. We expected far more of other women, who, paradoxically, had less (power) to share than men did. We held grudges against other women in ways we dared not do against men. We were not always aware of this.

Be aware of such unspoken double standards. Try and behave more even-handedly than we did.

I disagree with you on one point. I do not think that feminist boss-worker problems are mainly due to the "fundamentally unequal work relationships." This painful, often unacknowledged problem exists among many women: within the same generation, across time, and among many feminists of my generation. The problem exists with and without money changing hands. It exists among antifeminist, patriarchal women too.

I think this problem "without a name" may be best approached—at least by me—psychologically. My feminist generation psychologically arose one morning, or so it seemed, right out of the primordial "frontlash." Like the goddess Athena, newly hatched from her father Zeus's brow, we, too, wanted to experience ourselves as motherless "daughters." We were a sibling horde of "sisters." Although we were many different ages psychologically, we lived in a universe of same-age peers. We knew of no other way to break with the past. There were no living "mothers" moving among us. Of course, in real life, some of us were mothers, some of us even loved our real mothers, but when we stepped out onto the stage of history we did so primarily as motherless daughters/sisters/sibling rivals.

Psychologically, we had committed matricide—the equivalent of what Freud said that sons do to fathers. Of course, Freud had it wrong; it's the other way round: Fathers "kill" sons, despite which sons still continue to hunger for their fathers' love and to scapegoat their mothers for its absence. Most feminist daughters did not notice what we'd done or why.

Many of us rather hotly denied that this was so. To this day, some of the most brilliant voices of my feminist generation continue to speak in the voice of The Daughter Risen and not that of The Mother-Teacher.

Like other powerless groups, my generation of feminists found it easier to verbally confront and humiliate other feminists than to physically confront patriarchal power in male form. Just because we were feminists didn't mean we had gotten beyond the gender code. Please remember to always create safe spaces to discuss how feminists also internalize patriarchy. Doing feminist work is not a way of getting your every psychological or economic need met. Movements cannot flourish if their members are there mainly for therapeutic or career reasons. You have a responsibility to see that your wounded selves do not get in the way of your warrior selves.

Ah, Liza. You want kindness. Fairness. Guidance. A helping hand. From older feminists. I understand. I wanted that, too—but I dared expect it only from same-age peers. We did not think it possible to receive that from living, older women. In our time, it may have been impossible. Today, perhaps, some mothers (and fathers) are nurturing heroic rebel daughters; that was rare in my time. What you're after is a legitimate but also a revolutionary desire. It is not a given. There are exceptions, but most of our mothers did not—could not—treat their daughters this way. Understand: You want nurturing from older feminists, most of whom have, at least psychologically, themselves committed matricide. Like the mythic Electra, who helped kill her mother Clytemnestra, they may be especially wary of daughters and daughter-figures as potentially matricidal. Which, traditionally, many younger women are toward older women. Feminists included. Older women, who are now in their sixties, seventies, even eighties, tell me that they feel resentful of those younger women who only turn to them as if they were serving-girls, there to dress, adorn, compliment, "listen" to the Young Princess talk about the Ball she alone is about to attend. Older women tell me that they have been used (and used up) in this way and now want to be approached only as peers, not as Fairy Godmothers or Listening Posts.

If a young feminist today wants a feminist mentor—if s/he actually

wishes to be paid by one and not have to pay for the apprenticeship, then, in my view, s/he must come ready to serve the work, in humility, respectful, not as a groupie but as an heir. S/he must bring all her best skills, whole heart, undivided attention—at least for a period of time. S/he must arrive with clarity and calmness and with no need that needs satisfying other than the need to be involved in the work itself.

What we have is hard work which we must do together. My generation cannot keep going without the next generations joining us, not competing with us, for the right to fight. Fighting back is something we need each other to do. In my view, a mentor or foremother is not an all-powerful Goddess. She is not the final authority, you are not the lowly peon. What you bring to her (or him) is also crucial. Reciprocity is everything.

In solidarity,
Phyllis

Do You Feel Responsible for Opening Doors for Young Women in Film?

Nisha Ganatra and Christine Choy

Dear Chris,

I am writing to you about something that you have probably long since forgotten but which made a lasting impression on me. It was the summer after my first grueling year at NYU's Graduate Institute of Film, and I was coming to terms with the faculty's harsh critique of my technical skills, the political content of my work, and the overall tenuous position of women in the graduate film program. I had had reservations about coming to NYU, knowing its reputation as an old-boys' club. I decided to attend despite this, largely because I knew you would be the new chair my first year. You were going to be a progressive breath of fresh air. A documentarian. A political activist who merged the worlds of film and politics. A woman who would shatter the old-boys' club and push a new agenda in the halls of NYU. When I arrived, the faculty were all white men (save for one white woman and you), so I clung to the hope that your position as chair gave me.

I was told that my class was the first to be fifty percent female. NYU was being generous and openminded. This statistic was constantly quoted at us with an air of self-congratulation. We were made to feel as though we should make offerings to some affirmative action god (or goddess). Later, I found out that had the department admitted only the top-ranked appli-

cants that year, we would have had an all-female class. But that was before you had the power to affect admissions.

I respect how quickly you made changes in the department. You hired women professors and professors of color and admitted more women and students of color. In the three years since I've been at NYU a lot has certainly changed. But there's still work to be done. My first film, a short, not-very-well-directed piece on domestic violence, was destroyed at evaluations by six male professors, who called the piece "propaganda." But you did not speak up at the review; you addressed my piece privately in your office days later. To this day I wonder why. I left the review feeling ineffective, naive, and unskilled. Also, I was disturbed on a philosophical level; how does one integrate political content without being didactic? I looked to you for support because you have managed to build a career in film without losing your political content. I needed your guidance in putting theory into action and onto celluloid.

The summer after that first difficult year, I felt I had no business being in film—it was a privileged field and I had made a bad decision. I felt isolated and confused, filled with idealistic thoughts a long way from ever being realized. Then I came to your office and found out you were beginning work on a project for commercial television about "inspirational women." I felt that fate was pushing me in the right direction, telling me not to give up hope. You invited me to work on the project, knowing my "feminist background and concerns." I was excited to work with you on a project that would fuse feminism and film.

I immediately dove into my role as research assistant, compiling data on these "inspirational women," preparing information sheets and videos, screening hours of footage for usable shots and ideas for the piece, and suggesting new names to be added to the list. I was told that I would be hired to work on the interview shoots and maybe make money as a production person. Most importantly I would be gaining a professional credit, an essential part of starting a film career in New York. You took me to meetings and introduced me to the producers as your young, hip research assistant. I wrote proposals for several segments. The atmosphere was electric. You knew so many amazing women. Your Rolodex was filled

with names of people I had been reading about for years. I was working with Christine Choy, my mentor, a role model. You were a viable alternative to what I feared all employers were in this industry.

For one month, I did research for the film and worked as a temp on alternate days to make ends meet. The producers had approved the budget, and you included a line item for my research work, but for some reason the money was not coming to me. I didn't know how to ask for it and felt I shouldn't for the greater good of the project. So I started temping more frequently. Working with you, with other women in film, on a project produced totally by women, was helping me in a deeper manner than you probably realized. Despite the financial strain, I decided to stick with the project.

The next thing I knew, the interviews were being filmed, but I had been neither informed of nor invited to them, even though I had been promised as much. I was dying to meet these women, especially since I had been compiling information on them for so long. Then I started to worry that you felt I was not committed to the project because I was temping so often. After I made repeated attempts to reach you, your new producer finally contacted me. She asked me to help on one interview as a production assistant. But she talked to me as though I had no prior involvement with the film. Communication with you dropped to almost nothing. You were busy flying around conducting interviews, I was told. I asked your producer about helping with the editing so I could at least watch the interviews and hear these women speak. But I found out you had given almost all the paid positions to experienced men. When the film aired I saw that only you (and maybe your producer?) were given credits. There was no acknowledgment of the work I had done. I was left with a lesson I had already learned from my days working for male employers in the industry: Women shouldn't expect to get hired for top positions or get credit for the work they do. I was disappointed, I thought you would be different.

Still, despite that incident, you and I have maintained our mentor-mentee relationship, mostly because I respect your outlaw behavior and unflagging ambition to continue making films. You are always breaking the

rules and always making a film (over fifty at last count)! Plus, you have been the only person in the film industry who, when I've said I wanted to make a feature-length film, said "do it," instead of "don't bother." Chris, you did what it took to make it without a map in the film world. You and I both have experienced being "outsiders" in this industry, and I look to you as proof that a woman, and a person of color, has a space to work in.

But my experience with you that summer instilled in me more fear about the position of women in the film industry. Being in a position of power, you could help so many women gain access to the professional arena by hiring them even when they have little experience. I worry that in your determination to make films, you refuse to take the time to think about "feminist ideals" when hiring your crew. I guess I can understand that to a certain extent. When you're under the gun trying to shoot a film, spending other people's money, who has time to hire a less experienced grip just because she's a woman? But was the solution for you to join the boys' club and act in the same manner?

Maybe I have the privilege of being critical of the way women achieve success because I've inherited what you have struggled to attain. Still, I know that when I become more established in film, I plan to help bring as many women as possible in with me. I believe we can give each other that first break, that professional credit—I believe we have the power to perpetuate work within the industry for each other. So I guess what I'm asking is, do you feel responsible for opening the door for young women in film, knowing how difficult your entrance has been? My hope is that you want to pass on your spirit and drive to those of us struggling to break ground in this male-dominated field.

When you reflect on our relationship, how does it look to you, Chris? What happened during that shoot—why did I become invisible to you? I remember being with you once when you referred to a time "back when we thought the women's movement would do something." I wonder now what exactly that "something" was and why you no longer feel responsible for doing it. You have enormous influence, and you have opened the door to many young women filmmakers like me. But even though the door is open, we still need your guidance, and more importantly we need to trust in you.

After that incident, I felt betrayed. Help me understand your disillusionment with the women's movement, because I remain hopeful about feminism and also determined to be a successful, groundbreaking filmmaker.

Nisha Ganatra

❖ ❖ ❖

Dear Nisha,

Thank you for your letter. I shed two kinds of tears while reading it: tears of anger over your accusations but also tears of empathy for you and the situation you are facing. Still, ruthlessly righteous person that I am, I am going to be quite objective in telling you how you seriously misread that incident. I am also going to be subjective in telling you some deeply personal things about my history and where I've come from. Perhaps by walking a mile in my shoes you will be able to walk a little longer in yours without tripping.

I always hated it when I was younger and my elders would say, "When you get to be my age, you'll understand . . . " or, "You don't have it half as bad as I did when I was your age." Well, I'm old enough now to say that they were right. When I came to the United States in 1967 at the age of fourteen, I did not speak English. Chinatown in Manhattan was only four blocks square, surrounded by a Latino and Jewish community in the Lower East Side, Italians to the north, and Bowery winos to the east. In those days, the relationship between the United States and the People's Republic of China was nonexistent: China was literally viewed as the source of the "Yellow Peril" that would overwhelm truth, justice, and the white American way.

You, Nisha, are able to stand where you are today because my generation fought for you even before you were born. All of the movements for diversity and affirmative action that you take for granted today were just beginning then. In the late 1960s, the Vietnam War was raging, as was the antiwar movement. The civil rights movement was a great moral crusade that was commanding the attention of millions of Americans. The terms "gay" and "lesbian" didn't even enter the popular vocabulary until the 1970s.

So there I was, thrown into the midst of the United States of America.

I felt like a true outsider: nonwhite, Asian, a native of Communist China, the most feared and despised nation on earth. But even in Asia, I was part of a despised minority. I was considered a foreigner because my father was Korean. In Korea, I was considered a foreigner because my mother was Chinese. In Japan, it was even worse: Chinese were considered the "enemy" during the 1930s and 1940s; Korea was for many years a colony of Japan. To this day, Koreans in Japan are subject to oppression and discrimination.

I became a filmmaker in order to live out the personal-is-political struggle in the only way I knew how. With my given background, as part of an invisible minority wherever I went, I needed to express how I felt about my people, about who I was, and about my observations of the new world into which I had been catapulted. It was a different era then: There was a great impatience in the air—far greater than what is there today—in which the aesthetics, content, and means of production in filmmaking were direct outgrowths of the deep frustration many of us felt about not being recognized and accepted. In those days, Asians were portrayed as "Orientals"—the men sinister and the women submissive. It was either Fu Manchu or Suzie Wong, take it or leave it.

Even though we are two decades apart in age, I can still share a great deal of your frustration, Nisha. Everyone has a desire and a need to be recognized, whether filmmaker or scholar, shoemaker or cook. However, you are luckier than me in that you came on the scene after twenty or thirty years of struggle by women who have redefined our role in society, whether in academics or in the home. Use this knowledge to reflect on, criticize, and improve your present condition. You have chosen me as a role model, yet I did not have the luxury of a role model in filmmaking. My role models were from all sectors of society: welfare mothers, women's righters, shopkeepers, waitresses, barmaids. This assemblage of characters and their collective memories provided me inspiration and strength along with despair and pain. It is this kind of collective politics that kept me going in such a totally male-dominated industry. I made commitments twenty years ago to make and distribute films dealing with Third World issues, women's issues, people-of-color issues,

voiceless-individual issues. To my astonishment, many women I worked with have supported me but also sabotaged me. I have asked myself why over and over again.

Why have women sabotaged me? Maybe talking about this will help you resolve some of the issues raised in your letter. What I am going to say is not going to win me points with many feminists, but I am going to say it anyway: Women in general were never trained to voice their opinions logically. We are much more emotional, so we tend to have a selective memory about things, just as you had a selective memory about the television project.

You wrote that only two women were included in the credits. That is not true. Eleven of the seventeen people, including myself, are women. Why were your credits not listed? For two reasons. One, according to my producer, you were busy with your own priorities. You did not follow up on some particular tasks that you were asked to complete. You didn't return phone calls. In short, I was not happy with what I would call the lack of professionalism.

Facts can be disputed, obviously, but it was your responsibility to investigate all facets of a situation before arriving at a sole opinion. Perhaps some women of your generation displace your anger or rage by pointing a finger at a single target without seriously looking inward in self-criticism.

I, too, was not entirely happy with that project. I will admit that out of my enthusiasm for doing a pro-women project, I got myself into a restrictive situation. Unfamiliar with the strict hierarchies and contractual system of commercial television, I had to bear the brunt of a lot of bruised egos. I was told by the producer that I was incompetent, that I jeopardized their budget, that I should share directorial credits with my editors, two of whom had secretly made an alliance with the executive producer to claim those titles. It got ugly. But I swallowed my personal pride and tried to analyze what happened objectively. I refused to shirk my responsibilities by choosing an easy target. But I really lacked an understanding of the intended commercial audience. My style was too PBS.

I also didn't have the power to protect your position when you were asked not to participate in the project any longer. I was angry, believe me,

but I took it as learning a lesson. It made me think twice about undertaking a project of such magnitude without being clear about such matters. It began with all the right kind of idealism, fused with enthusiasm and high hopes. But it is so very easy to lose focus. True collaboration comes from mutual respect, but that respect does not come about overnight. It is a respect that comes from paying one's dues, suffering failures, and opening one's vision to input from others.

This brings me to another point raised in your letter. You claimed that I did not defend your student film against charges of "propaganda" from the male faculty. When I sat through your first-year evaluation, I was in my first year as department chair, not your teacher. Though there were six men in the room who labeled your film as "propaganda," I would not have invested that incident with the sexist nuances that you do. In your position, I would have smiled and defended my effort against this kind of attack. Why did you let that word so devastate you? There's nothing wrong with making a propagandistic film if you have a message to get across, if the message is skillfully delivered, if you're able to move people into acting beyond their own self-interest. If that's the case, it's good propaganda.

In this case, I respected the opinion of the other faculty members. I may have disagreed with them, but there is such a thing as academic freedom within an educational institution. My decision not to come to your defense was not directed against you personally: I applied that same principle to every one of your classmates, male or female, white, black, Asian, whatever. If I was your teacher instead of the department chair, I would have been in the different position of evaluating the progress you were making along the way instead of just critiquing the final product. My criticism as a teacher would have been much more holistic, complete, and productive for you.

Once upon a time, Nisha, I was very much into "isms." It was really rather simplistic: Feminism was good, racism was bad. Now, as I get older, with two sons and a daughter, two of them grown, and with fifty-some films to my credit, I have decided to reject the whole culture of "ismism." "Isms" are hazardous to your health. They prevent you from broadening your mind to examine things critically, to receive new ideas. By embracing

"isms," you lock yourself into a preconceived ideology that brands nuances as subversive. But it is in the nuances of life, in the gray areas, that we meet people as they really are, in all their complexity and grandeur. Just like plants need water and sun, I need the embrace of new things in order to grow. If I allow "ismism" to prevail, I will only be caught up in my own narrow world and turn into even more of a paranoid, insecure, isolated individual. That I cannot stomach. So contrary to your belief I am not a member of an old-boy's network—or an old-girl's network or an old-mom's network. Just an "old-me" network, maybe.

It may sound like heresy to feminists, Nisha, but I believe my responsibility is not opening up jobs for women only. My responsibility is to encourage and work with good human beings regardless of gender and nationality. At this point in my life, I am trying to be a student again, learning from global cultural perspectives that were just not available to me as a scared teenager in the 1960s. I am way too incompetent to be a role model, too subjective to be objective. I have had too many bad experiences working with women to make a conscious decision to work with women only. When there are films that address women's issues, I will make every effort to collaborate with women. When there are films that address men's issues, I will collaborate with men. If the film has historical material, I will do my research from the perspective of both men and women historians. Is there anything wrong with that?

One thing I have learned over the years is that there is no such thing as absolute truth. The interpretation of truth comes from many levels of association. I think this is a healthy discovery, and I will continue to explore this dimension as long as I am placed within a multicultural, multivocal environment.

Christine Choy

Why Aren't You Angrier About Homophobia?

Lisa Springer and Betty Millard

Dear Betty,

How many hundreds of hours have we spent discussing your life as a lesbian and my life as a lesbian? Three years have gone zooming by as you have told me fascinating stories about seducing women in the '30s and '40s. I love our talks because they connect me to an unwritten history. We discuss butch and femme and the question of whether it is important to know if being gay is genetic or not. Our arguments are playful and yet serious, for they touch on a very important part of our lives. And last night, when we talked once again about anger, I'll admit that I felt frustrated and sad. I woke up continuing the discussion in my mind, arguing with you while I was alone in the silence of my apartment. And so I decided to take all the passion that I feel about this topic and explore it in a letter. The truth is, I would like to convince you that I am right.

Here is our fundamental difference: You are not angry at homophobia and I am. I notice homophobia every day of my life and I come to you with tales of injustice, both large and small, that fill me with rage. Last night I brought you the story of my close friend telling me her husband thinks homosexuality is a disease. I explained to you that it was her ease in presenting this point of view (as if it were valid) that upset me. She never stopped to consider that I might be hurt. You told me that she is probably doing the best she can. You explained that she and her husband grew up

thinking that homosexuality is wrong and that many others share their point of view. I know all of this, but it does nothing to prevent me from being hurt. In your attempt to be fair, I feel that you are taking the side of the homophobes, while you think I am wrong to be so angry. You plead with me to have perspective.

I know we see things differently in large part because you are eighty-five and I am forty. After all, I went to college in the mid '70s when women were angry and blacks were angry and those who protested the United States government's involvement in Vietnam were angry. Your generation was committed to social change, although perhaps in a less angry, more genteel way. I think about how much harder being a lesbian was in the '30s and '40s and '50s and '60s than it has been in the '70s and '80s and '90s, and I try to be understanding of our differences. Yet I find myself confused by your apparent lack of anger. During dinner, as we argued, I felt that we slipped close to agreeing with each other every once in awhile. But in the end, I believed in the value of anger and you still advocated for understanding. Hence this letter.

Let's look at your own life, a biography that could exist only in a homophobic society. After a period of loving women in your twenties, you spent some fifteen years in your thirties and forties trying to go straight. You did this because you thought you would be happier if you were heterosexual. Of course in a world that treats gay people badly, this is true. Eventually, in defeat, realizing this conversion wasn't possible, you lived with a woman in total secrecy for some fifteen years. You must have felt very unsafe to live such a hidden life. It is only now, in your mid-eighties, that you are coming out. It is only now that you are telling close friends that you are a lesbian, a fact that has been central to your entire life.

Last night, I called all of this "tragic." I admit that I said this melodramatically. (I often exaggerate to draw out your own anger, which I tell myself must be buried somewhere inside you.) I pretended to speak with vehemence and outrage, although in truth I am angry for you, angry for myself, angry at all the homophobia that every gay person suffers. Toward the end of my impassioned, somewhat theatrical speech, I thought I saw tears in your eyes and I felt hopeful that we could share the pain of

our exclusion from the predominantly straight world. Did I just imagine that I had touched you, that we really do stand together against a common enemy?

I'll admit you came close to convincing me that we should be grateful for the gains we have made. You pointed out, as you have many times, that change comes slowly. You told me that in your lifetime an extraordinary amount has been accomplished in the area of gay rights. I do respect your age and greater experience. I can only imagine how happy you must be to have witnessed the world becoming more tolerant of women loving women. You gave me evidence: "Look at the numbers of people marching in the gay pride parade. Consider the very existence of this parade. Watch the male couples and female couples holding hands as they walk down the street. Read the articles on gay life in *The New York Times,* a totally mainstream newspaper."

For a moment, I was lulled by your arguments into applauding the new freedoms enjoyed by lesbians and gay men. Of course all these changes are positive. But no sooner did I find myself sharing your happiness than I became enraged that we are being thankful for such tiny crumbs. I don't want to be grateful that I sometimes feel safe holding my girlfriend's hand in public. We should be able to take such a pleasure for granted. Don't you see how far we are from total acceptance?

I wonder why you don't feel the same anger I do. I'm confused. You have faced so many more difficulties because of homophobia than I have. The stumbling blocks you have encountered, compared to the relative ease of my own experiences in the gay world (post-Stonewall), would lead me to predict that it would be I who would be optimistic and you who would be enraged. And yet the very opposite is true. Last night I paced in the dining room of your apartment complaining about the injustices that gay men and lesbians suffer daily while you spoke about how wonderful it is that we can all be more open these days. Now how does this make any sense?

Why the difference? Am I just a cranky person who looks at the state of the world with rancor, while you see the glass half-full? I consider this possibility, and then I remember that you were a card-carrying active communist for many years. I know that you feel outrage about the unfair dis-

tribution of economic resources. I know that you don't think everything is the best it can be in the best of all possible worlds.

Perhaps I come to anger more easily because it is a privilege of my generation of lesbians. Political activism has made me angrier, not more complacent. Each year on St. Patrick's Day when I step onto Fifth Avenue and get arrested for protesting the exclusion of the Irish Lesbian and Gay Organization (ILGO) from the parade, I become angry. Or rather, looking at the hundreds of policemen lined up to prevent ILGO from even expressing our anger at being excluded, I become aware of how angry I already am. As I feel the oppressive pressure of the New York City police, the on-the-street representatives of our government and the homophobic world's desire to silence us, I know just how powerful and important it is to hold on to my anger. You may have experienced this same feeling when you fought for change as a communist. Didn't the fight itself fuel your passion, making you more aware of injustice? Why does the fight against homophobia feel like a less worthy cause to you?

I think about all the things you have to be angry about. The lovers who told you their relationship with you would end when they met the right man and got married. The therapist who told you he would help you change. I think of the difficulty of finding a lover when no one is out. I think of you falling in love in your twenties and thirties and forties and later feeling that you could not tell a single friend about this joyous experience. And what about the heartbreak you could not share? I think of the world telling you that you loving women is wrong and guess what I feel?

Anger seems like the only possible response to these experiences. And yet you do not feel it. You tell me you have survived with no bitterness. You watch younger gay people enjoying privileges you never had and you don't feel envy. You are unfailingly generous towards those who have hurt you, understanding their limitations. And while I find all of this mysterious, I know that this attitude is one you are committed to. You cling to your point of view as to a life raft, and it occurs to me that being accepting of the way the world has treated you is essential to your very survival. If you were to get angry at this point in your life, would you feel too much regret? Suspecting that you have good reasons for your position, why do I want to rob

you of these feelings? Why is it so important to me that you feel the anger that I do?

When I left your apartment last night, having failed once again to convince you to be angry, I felt lonely. In the years since I have been a lesbian, I have been surprised to find that while overt homophobia wounds me, it is not responding to those attacks that fill me with despair.

I had been out for about a year when I was walking in Greenwich Village with my girlfriend. A teenage boy turned to us and asked in a jeering voice, "Do you suck each other's tits?" A gay man passing sent the boy a look of intense, well-timed, perfect hatred. His instant understanding of the situation made me feel part of a community. His anger transformed the horrific incident into something that was just annoying. I left the scene shaken but feeling visible. I learned more about the experience of being a lesbian from the gay man's response than from the teenager's hurtful words.

Anger is a powerful form of protection. I want you to be angry because I love you, and I want to protect you myself and to know that you can protect yourself. I want to be sending looks of hatred at various homophobes through many decades in your life. I want to transform horror into annoyance. I want our anger to put us in charge.

And while it's true that I want to be your knight in shining armor, I also want *you* to protect *me*. Believe it or not, I need safety from the storm. I know that I sound tough and sure, but often I am not nearly angry enough about my own life. I listen to a homophobic joke and realize days later that I have been insulted. I spend an entire weekend with my girlfriend's family during which her grandfather succeeds in not saying a single word to me. As she and I are travelling home together, I feel badly for him rather than myself. I think of how terrified he must have been in order to turn away from me when I held out my hand to introduce myself to him. A shocking thought passes through my head: "He's of another generation, and he's doing the best that he can." You see, I can fall prey to the same defense of the enemy.

I must admit I am terrified of my own tendency to complacency. Perhaps that's why I'm so hard on you. While I know that excusing homophobia may be your way of making sense of an irrational hatred, this

response makes me feel very alone, in danger of annihilation, and, most importantly, afraid I will not be able to count even on myself for safety. You see, your arguments do almost convince me and sway me away from my own anger. When I speak to you about the importance of anger, I am lecturing myself. I am searching for a way to hold onto my own anger without faltering.

I believe that if we see homophobia wherever it is, in both its subtle and obvious manifestations, and we get angry about it, we will not feel alone. We will not feel invisible. We may not feel at ease, but this seems a small thing to give up. In the hundreds of hours of conversation that you and I will have about our lives in the next three years and beyond, I know that I will continue to try to convince you to be angry. I can't help it. It feels necessary for my survival.

With much love,
Lisa Springer

❖ ❖ ❖

Dear Lisa,

In response to your letter I want to tell you a story from the winter of 1931, when I was a student at the London School of Economics. During that time, I heard about Radclyffe Hall and her book *The Well of Loneliness,* which had been banned in England. I got hold of a contraband copy, read it, and was stunned. The book was a long roll of thunder. It held the message that electrified countless lesbians in the '30s: We were not alone.

I had to do something with my wonderful new knowledge. I called Hall's publisher and learned that she lived in Rye. I considered writing her a letter but instead found myself on a train to Rye several days later. It was one of those terribly polluted, foggy London mornings when I felt I had to escape the city in order to breathe. I don't know what I intended to do in Hall's hometown; I just wanted to be near her.

I found her house with no difficulty—a thatched cottage on a cobblestoned street. I shivered in the damp weather and walked by the house several times trying to muster the courage to knock on her door. When I finally did, a woman answered. Looking back, I think it might have been Radclyffe

Hall herself. However, she told me that Hall had gone up to London for the day. I returned to London disappointed yet exhilarated by my adventure.

Why do tears come to my eyes now when I remember that day? I think they are for Hall's life, but perhaps they are for mine.

That same winter I met a member of the British Labour Party who introduced me to the principles of socialism. When I returned to America, I brought my new political knowledge with me and became a communist activist. Though we weren't fighting for homosexual rights, I must tell you, Lisa, that we were not genteel, as you imply. We too lay down on the streets to make a political point, just like today's activists. We went on endless protest pilgrimages to Washington; we wrote articles that got us fired or imprisoned. When I was a communist I was definitely angry—at war, at racism, and at the oppression of women. But at homophobia?

Well, homophobia was different. I felt it could wait or that it would change along with everything else. As a radical, I did not believe in a "human nature" but rather believed behaviors and traits to be culturally based. I believed everything could change.

And I'm still not angry about homophobia. I admit it! And I should be—you are absolutely right. But my question is: At what or whom should I direct my anger? History? The Bible? The Torah? All human societies have embedded women under rock-piles of contempt. The patriarchs, the rednecks of history, have always been angry at us for asserting our personhood. For thousands of years they have proclaimed our inferiority. Only now have women begun to reach for the economic power that has to be the basis for social power. And lesbians' struggle for freedom and power is even more complex than that of heterosexual women. Of course I am angry at homophobia itself, just as I'm angry at war and racism. And I definitely have contempt for homophobes. But not rage. My equanimity is not disturbed by ignorant people repeating ignorant notions—I choose to shame or educate them into thinking differently.

You list a few things I should be angry at. But how can I be angry at a therapist who believed, as I did, that it was possible and desirable for me to change my sexual orientation? In fact, we discovered together that this change was not possible, and he helped me in many other important re-

spects. How can I be angry at a previous lover who said from the beginning that she wanted to marry and have children and that our relationship was not permanent? It was then my choice to accept or not accept her terms. And in truth she wanted more than a child (she could have had that while "married" to me). She also wanted respectability and acceptance by the mainstream. I know because I wanted the same thing, despite my radical politics. She and I took pleasure in feeling like we belonged to a secret club. It was exciting! (Not to mention safer than being out and angry.)

You talk about anger as a form of protection. By that do you mean to imply that I am defenseless without my anger? I feel that my pride and self-respect are my defenses. I don't want you to think of me as cowering in a corner in the face of homophobia. However, you also mention fear of your own complacency, and I think it is me not you who had surrendered to complacency. I used to feel responsible for all the exploited, unhappy people of the world. "If I could just explain to them why they should be angry," I used to think to myself, "then we could change the world!" I saw myself as strong and in charge. Ironically, when the revelations about Stalin appeared, though I was shocked, I also felt that a great weight had been lifted from my shoulders. I no longer felt responsible for the whole world. I think it was then that I learned of my own ability to be complacent.

Lisa, I am glad you feel angry. You should. It's your energy that propels history forward. My role is to be wise and full of years and say things like "change comes slowly" or "take the long view." Your role is to run out into the streets and get your head cracked by a cop's nightstick. Then in fifty years, you too can be temperate when you pass on your wisdom to other eager young sprouts of forty.

Your letter has made me reevaluate my life. Maybe my anger about homophobia is simply buried so deep that I cannot dredge it up. It's wonderful to be forced to open to the winds. It's wonderful that you are my friend and that you're angry on my behalf. You are a kind, beautiful person. And even though you may come on like gangbusters, I hope you never change.

Love,
Betty

Part Four

BODIES AND SELVES:

The Politics of Health, Healing, and Spirituality

Anna Bondoc and Annemarie Colbin

Lisa Tiger and Wilma Mankiller

Meg Daly and Sandra Butler

Jennifer Hunter and Starhawk

Karin Cook to her mother, Joan Carpenter Cook, who died of
 breast cancer

◆ So often women's bodies are symbolic of something else: sex, nur-
turance, weakness, beauty. When will all women's bodies just be bodies,
strong and free? Our bodies have also been the site of many political bat-
tles such as those over reproductive health, childbearing and rearing, and
breast cancer. Then there's the problem of our youth-obsessed culture
which encourages women to dread growing older, rather than embrace
the wisdom and strength that comes with age.

Our health and well-being cannot be taken for granted. While we are
busy running for office, running laps, or plain old running errands, it's
easy to forget to care for and love our bodies, and discover our spiritual
selves. In order to become whole women, we must accept, nourish and re-
plenish the corporeal vehicles that transport us daily towards our goals.

What kinds of foods, for example, should we eat to nurture ourselves? How is breast cancer related to our environment? What are women's strategies for healing their bodies and spirits while coping with disease, whether it be AIDS or an eating disorder? How do we maintain traditional spiritual practices in a crazy-making world? These letters explore the ways in which women's physical, emotional and spiritual health go hand in hand with our social and political aspirations.

Why Do So Many Women Have Unhealthy Relationships with Their Bodies?

Anna Bondoc and Annemarie Colbin

Dear Annemarie,

For the past year and a half, I've been enrolled as a chef's apprentice at the school you founded, the Natural Gourmet Institute for Food and Health. I've prepared numerous pots of brown rice, steamed hundreds of leafy greens, discovered the joys of tempeh, made delicious sugar-free desserts, and discovered how to eat for both pleasure and health in a conscious, informed way. All this time, a question for you has been brewing at the back of my head, and it just presented itself clearly to me this past March, while I was sitting in your "Food and Consciousness" class. It struck me that of the twenty-six students, all were women. Since the class was billed as a course to discuss how "what we eat affects how we feel every day," I couldn't help wondering why men weren't attracted to the class. After all, there's usually a sprinkling of men in the "hands-on" cooking classes. But I also remembered that the majority of your staff, teachers, and students were women. Maybe it's because women are still the primary at-home food preparers. But I also have a sneaking suspicion that it has something to do with the fact that women, not men, are the ones with food issues. We are the ones starving ourselves, bingeing then feeling guilty, buying up books about fad diets, joining Weight Watchers, and taking miracle diet pills—sometimes throughout entire lifetimes.

Up until recently, difficult times and food issues went hand in hand for

me. At age three I came to the United States, and my mother tells me I barely had an appetite and couldn't keep things down. It wasn't surprising. I had been born in the Philippines and raised by my maternal grandparents while my parents and older sister established a home in Cincinnati, Ohio. Then, boom: I was transported with disconcerting speed via airplane from a tropical climate and my grandparents to Cincinnati in mid-November cold. I had a brand-new family, and I didn't speak a lick of English, to boot. All I remember is sitting for hours behind the couch sucking my thumb. When I would eat, I was so slow that my family got tired of waiting for me to clean my plate, and I'd be left alone at the dinner table. A neighbor who looked after me some afternoons says I barely spoke at all, only to ask for the same lunch day after day: a fried egg over white rice with ketchup.

When I was nine, the ground shifted under my feet once more and my reaction to eating was the barometer of my ability to cope. Mom announced that she was pregnant, and I was thrilled at the prospect of having a brother and not being the youngest anymore. Shortly after the announcement, my grandmother was diagnosed with breast cancer and my mother went back to the Philippines, leaving my sister and me in the care of our father for the first time. Easter weekend my grandmother died, my grandfather followed unexpectedly fifteen minutes later (Mom says of a broken heart), and my father put his index and middle fingers of his right hand into the blades of the lawn mower. I was the one who heard banging and shouting and opened the garage door to discover his gruesome mishap. While I ached for my mother's calming presence, worried about my father, and pondered the loss of the grandparents who helped raise me, the strangest thing during a surreal weekend was what I focused on: the unfamiliar food I was eating. Neighbors and friends brought over potato chip–topped casseroles and fried chicken made with 7Up and bread crumbs. We reheated and ate them for days on end. I had been spoiled by waking up daily to Mom's oatmeal, eating the tuna sandwiches she packed in my lunch, and coming home to a predinner snack. So when I had to pack my own lunch for the first time, I felt like a grown-up, but a reluctant one.

As an adolescent, I turned to food as an outlet for academic stress and the confusion of puberty. I was unusually neurotic about my grades—a state I later found to be common among second-generation Asian immigrant kids. GPA's, honor rolls, and college applications were the suns that I revolved around. To complicate matters, my maturing body and the onset of hormones threw me into a whirlwind of insecurity about sexuality, independence from my parents, and becoming a woman. We "GenX" women came of age during the 1980s' hyperawareness of women's bodies, for better and for worse. We learned that our parts and pieces were more complicated than our male counterparts' by reading books like Judy Blume's *Are You There God? It's Me, Margaret* and studying Playtex tampon brochures. The fitness craze swept America just as we started wearing training bras and filling out at the hips. Photographs in *Seventeen* and *Vogue* insinuated that we could be sexy if we were skinny (and blond), but the articles warned us that our bodies could attract trouble.

My response to all this? First, I put on leg warmers and worked out with Jane Fonda's videotapes. Then I ran track. Other friends played soccer. We got called tomboys sometimes, but at least we had an outlet for our teenage turmoil. Then I read *The Best Little Girl in the World,* a book about a teenage girl who was bulimic. It was probably written as a deterrent to the binge-purge syndrome, but I read it as a how-to book. How to get attention. How to control the one thing in my life I could make decisions about. How to express frustration and anger at wanting and hating the very thing I craved: independence. I was bulimic for the first two years of high school. On a nightly basis, I'd eat a regular dinner then consume all the things I wasn't supposed to until it hurt: a row of Oreo cookies, several Kit Kats, and a couple of Health ice cream bars. Afterward, I'd disappear into the bathroom for half an hour. What scares me now is how typical my behavior was for a woman that age.

Countless magazines articles, factoids, and testimonials I've read all reach the same depressing conclusion: A large number of girls and young women are plagued by self-destructive eating habits. I wonder sometimes what would have been different if I had screamed and yelled (or danced, written, or sung) my way through the angry parts of adolescence, instead

of telling myself everything would be OK as long as I was pretty and smart and had a date for the prom. Not that I'd wish it on anyone, but why can't I picture a teenage boy weighing himself every day or eating a box of Oreos when he's stressed out like I did? Annemarie, you have worked with women of all ages and generations. Have women moved any closer to a world where we aren't taking anger out on ourselves and our bodies?

I've been fortunate. With the help of books like yours, *Food and Healing,* and the wisdom of chef instructors I've worked alongside (not to mention the support of good friends and a loving husband), I've moved beyond dieting and am committed to a career in food as nutrition, sustenance, and pleasure. One of my greatest joys is making a healthy, delicious meal and consuming it with friends. The irony of it all is that as a teenager when I was begging for attention, eating a cookie and milk for lunch, ice cream for dinner, and four cups of coffee in between, no one asked what was wrong. I get more attention now that I've cut refined sugar, caffeine, processed foods, and red meat out of my diet. If I say no to a piece of cake, a hamburger, or coffee, a lot of people look at me like I have an eating disorder. Sometimes intrigued, sometimes suspicious, people ask why my diet is filled with whole grains, fruits and vegetables, legumes and why I eat leafy greens and sea vegetables for calcium instead of drinking milk. I've been called everything from health-conscious and admirable to obsessive and a food nazi (along with its lovely counterpart, "feminazi"). Other favorites include "austere," "weird," "repressed," "neurotic," and "controlling." When I explain that I eat this way because I have more energy, fewer mood swings, headaches, and pimples, I get unsolicited confessions and rationalizations. "You're being so good. I'm so bad." "C'mon, it's a party. Ease up a little." "I'm so busy I don't have time to think about what I eat." "My grandmother lived to eighty-five eating meat and potatoes every night of her life."

This leads me to an annoying hypothesis (and I hope you'll tell me I'm wrong): It's socially acceptable or at least expected for women to have screwed-up relationships with food. For women, eating issues don't stop at adolescence. It's women, not men, I overhear in the deli counting fat grams. I saw a woman the other day with a considerable pile of Hostess

treats confessing to her assistant, "I'm not hungry, I'm frustrated." First I want to blame those radio and television commercials that portray women ordering Diet Cokes with their chocolate cake. Then I want to blame *Vogue* and *Elle* and *Sports Illustrated.* But women make their own choices. We know what we're doing. I've watched too many women say, "I'm being so bad," down a pint of "mocha chip," then wonder why they're slipping into a food coma after dinner. I've done it myself. Women have paid you to consult on their health and nutrition, Annemarie. Is it true that we, not men, are the ones eating out of guilt, frustration, and the need for comfort or control? Why?

I have my own theories. When women get insecure, at best they cry, call friends, buy something, or work out. Too much of the time, especially when it means having to confront someone, we get quiet, internalizing anger because we've been taught it's unseemly to shout or be bitchy. So we go home after a frustrating day at the office and eat a chocolate bar instead. Adjunct to this is the superwoman theory. Superwoman has to fly around the world attending board meetings and making sure the kids get to the pediatrician. So she subsists on four hours of sleep, lots of caffeine, and reheated slices of pizza. She has migraines and her Pap smear is irregular, but she doesn't have time to sit down to a good meal or ask her domestic partner to make her one.

Then there's the confusion the 1990s health info-glut causes. On the one hand, we're finally abandoning the tired four-food-groups model with its overemphasis on protein and dairy. My friends are more likely to buy cookbooks like *Almost Vegetarian* instead of our foremothers' *Joy of Cooking* (when I flipped through the latter recently, I found the words "butter," "sugar," and "heavy cream" on every page I randomly stopped at!). But we're being fed a lot of misguided or incomplete information. My favorite example is the milk ads urging women to get calcium (and sex appeal) like Ivana Trump and Naomi Campbell. In your "Principles of Balance" class you opened our eyes to the fact that we First-World, dairy-consuming countries still have the highest incidence of osteoporosis. You explained that most Americans get excess protein from milk and red meat, which causes all sorts of health problems, including excess acidity. The body

then balances this by leaching a readily available base, calcium, from the bones. We're terrified of our bodies' frailties but unequipped to take action. It's no wonder there's a health "industry", capital H, that targets women's fears, selling us *the* one right way to eat. Or ways to eat our cake without guilt. And it's no surprise that we wait for doctors to ride in on their white horses at the eleventh hour with their drugs, surgery, and I-told-you-so's.

Your teaching, delicious recipes, and writing have inspired me not only to eat better but to want a career writing about, teaching, and cooking foods that allow people to live the best-quality lives. One of the things I admire most about your teaching style is that you don't scare or bully your students into eating well. But here's the thing: When I told you I get frustrated by people who complain about sluggishness, headaches, or mood swings but refuse to give up caffeine and sugar, you said, "Sometimes people need you to be a mother figure; other times, a bartender. Both are useful." You added that we shouldn't tell someone what she should eat. Better to wait until she "opens herself spiritually to you." While I agree with you and admire your accepting manner, I have to admit that some part of me was saying, "Isn't that just being resigned? How will things ever change? Why do we want to be in this field, anyway?" I left the class wondering if you've always been able to respond this calmly. If not, how did you lose the impatience I find so hard to shake?

It's not that I think food is a panacea. I mean, let's face it, as the bumper sticker says, Shit Happens. We can't be immune to everything. Food to me is only a potential catalyst for boundless energy, disease prevention, and, yes, the sensual pleasure we want and deserve. But it's a powerful catalyst, in my experience. It's just that I think we tend to use food too much for satisfaction and sensual pleasure when we can't find it from our work, our lovers, our friends, or our self-worth. And people don't usually eat green vegetables and brown rice when they're upset. A lot of us have fought for the right to make decisions about our bodies, Annemarie, but why do we keep making the wrong ones?

Respectfully,
Anna Bondoc

❖ ❖ ❖

Dear Anna,

You send some provocative questions my way, and I will do my best to explore the issues. Food is such a profoundly fascinating subject to me, and finding out how we deal with it in our time of plenty keeps me endlessly entertained. I say our time of plenty, because issues of what to eat and when only show up in a society such as ours where there is such a vast choice and variety of foods. Last I heard, supermarkets carry between five thousand and seven thousand different food items. Learning how to choose what is good and right for each of us to eat takes some serious study. It's not the way it was in simpler times, when we ate what we could catch or forage and bulimia would have been an unthinkable waste. With the types of foods most young people eat today, the packaged, refined, colored, flavored, and altogether fake foods everywhere, getting rid of what was ingested sometimes may be the lesser of two evils for the body's well-being. The solution for that conundrum, I believe, is not in forcing oneself to stop the behavior but to change the types of foods one eats, choosing whole foods, whole grains, beans, vegetables, some animal protein, all truly delicious, so that the body would be naturally reluctant to give them up. You yourself have found such a way, after many detours, to be joyful and satisfying.

You ask why men don't come to some of my classes, such as "Food and Consciousness." They do, sometimes, but you are right, our students are mostly women. I believe there are two reasons. First the simplest one: Men seem to come in a higher proportion to classes taught by male chefs or teachers. I guess that is because they prefer to be taught by other men, not by women. A question of identification, I guess: "If that guy can do this kind of cooking, then so can I." Perhaps they're afraid that being concerned about health, short of under the threat of a deadly disease, is somehow sissy stuff. I caution you against making any kind of issue out of this. That's just how many men are, and there is nothing wrong with it.

Why are women the ones with food issues? I believe that is because women are, by their deepest nature, concerned with feeding their families

and tribes. A woman's body is designed to provide a newborn's first food. This is how we have been programmed by evolution throughout history in every corner of the globe. Only during the twentieth century has that changed for millions of mothers and babies, with the advent of bottle feeding. I consider this change in infant feeding habits to be one of the most profoundly dramatic changes in human history, a vast experiment forced on entire populations with no assurance that it would be healthier, and no studies on long-term—that is, lifetime—health consequences. Bottle feeding completely changes the dynamic between mother and child. For the mother, it separates her from her child, gives others power over the baby, and thereby disempowers her as a nurturer. As we have the imprinting of thousands of generations of women before us who breast-fed their children, not doing it creates a deep, subconscious sense of something missing, something left undone. In some cases, it could even give a woman the subconscious impression that her baby is dead because it's not nursing; this can be a major cause for postpartum depression. I had such an experience after I had an ectopic pregnancy, for which I had to have an operation. As my body had been preparing for a pregnancy that suddenly disappeared and my breasts deflated, I went through a week of depression, which I recognized as mourning the absence of the child I had lost. I assume that the same thing can happen easily to some women although not to all if the baby is bottle-fed. Many mothers like the idea of bottle-feeding because it gave them "freedom." But everything comes at its price: I will never forget the story of a successful physician who spent the early years of her children's lives doing her residency and left them bottle-fed with babysitters all the time. In her fifties she had to undergo extensive psychotherapy to deal with her belated depression over not having nurtured and spent time with her children when they were little.

For the child, prepared by evolution to nurse at its mother's breast, hearing her heartbeat, and getting its perfect food, surely there must be a shock and an adjustment to being given a rubber nipple and a liquid that tastes and smells quite different from expected. It always seems miraculous to me that the strength of the human spirit allows us to overcome such a poor beginning. In fact, at the beginning of the 1900s in the early

times of bottle-feeding, before the "scientists" had found the proper for-
mulations, babies died by the thousands from diarrhea and dehydration
caused by bottle feeding.

There are psychological consequences as well. For the male child, it
may mean that his mother is not willing to give him what he needs, and he
may grow up with an anger against women that, although not "reason-
able," nevertheless may color his dealings with all of them. Could this
early disappointment be part of what lies behind the way some men sexu-
ally and physically abuse women? And don't think I'm "blaming" the
mother. Most mothers, whether bottle- or breast-feeding, love their chil-
dren and do everything they can for them. My point is that if there is not
the frequent body contact that is the natural corollary of breast feeding,
the subconscious message is that Mother is not there, not taking care of
me. Regardless of the mother's actual loving feelings, they may not get
through because of lack of physical contact, and so the child draws con-
clusions and inferences that may be damaging both for himself and for his
family and relationships.

For the female child, being bottle-fed means not only that her mother
isn't giving her what she needs, she is also showing her how to be a woman
in a new way, which is to be separate and disconnected from her child.
This is completely contrary to the expectations that evolution has im-
printed in the young female and causes a painful inner conflict, which is
what becomes manifest in eating disorders. Without exception, all the
women that I have seen who have eating disorders or a love-hate relation-
ship with food, or who have trouble choosing healthful food for them-
selves had been either bottle-fed or separated from their mother early on,
such as yourself. They didn't get the nurturing or the nourishment that
they needed and had to make do. Some may decide that Mother has de-
termined they're not worthy of being fed, yet the impulse to live is too
strong to accept that sentence of death, and then they defy the mother's
apparent directive in order to live. But that is another problem: Evolution
has prepared us to expect that our mother will teach us how to eat and live
and protect us from danger, so that we naturally tend to listen to her. Do
you see the problem? Mother doesn't feed us right, we defy her lack of

food, and our defiance is as life-affirming in reality as it is life-denying psychologically. That is why we are "taking out our anger on ourselves and our bodies," as you put it.

In a society where the majority of the young women have been bottle-fed, and maybe some of their mothers as well, the "norm" is to be different from what evolution had prepared us for. Therefore, the "norm" is to have a screwed-up relationship with food, as you put it. That doesn't mean it is what evolution "normally" would have us do. And because we didn't get it right at the beginning, we keep flapping around and eating out of guilt, frustration, and the need for both comfort and control until, after many years and many tries, we begin to find the way to eat that works for us. In essence, what we need is real, natural, nourishing, delicious food, not fake, colored, and imitation food that fools our eyes and palate but not our bodies.

And here is the main reason, I believe, for unhealthy cravings. Nature provides us with whole foods, that is, foods with all their edible parts: fruits, vegetables, nuts, whole grains, beans. When consuming animal foods, traditional societies will use all the parts of the animal, including organs, and use bones and feet for stock or soup. In our society we have split the foods, by extracting various parts: white flour (missing the bran and germ), sugar (missing the rest of the sugar cane), vitamin supplements. Whenever we eat nutrients separated from their source, our bodies know it and will crave the missing parts to make balance once again. Eating these fragmented foods, especially refined carbohydrates, will create a deep and profound hunger for "something missing," and so we keep eating and eating looking for the missing nutrients. More often then not, this is considered a psychological problem; I believe firmly it is physiological, because I have seen it resolved so swiftly with a change in diet. Women with severe "carbohydrate cravings" lose them instantaneously once they eat just one properly balanced meal, with enough good-quality protein, carbohydrates and fats, balanced also by nutrients, color, flavor, texture, and energetics.

Perhaps having had such a confused relationship with food helps us understand both food and ourselves better. I believe that going through

difficulties and working our way out of them helps us in our quest for ever increasing awareness, consciousness, and spiritual growth. Learning and accepting that we deserve to be fed and to be fed well, and learning to choose nourishing food for ourselves, is part of our growing up in our own right. Part and parcel of this growing is the shedding of old selves, a painful but inevitable process. The superwoman business executive and mom who feeds everyone else but lives on pizza and caffeine hasn't learned yet the importance of nourishing herself, because she hasn't been taught this as a child. If she accepts the fact that she deserves to be well fed when she's tired from work and unable to muster up the energy to feed herself, instead of a candy bar she might get a balanced cooked meal from a restaurant, deli or take-out place. If she has the means, she might hire someone to cook for her weekly, if not daily. And why not? Paying for help is a reasonable way to delegate the many chores we need to fulfill. This is a concept that is generally not popular in our society—at home we're supposed to do everything ourselves—but it should be.

I notice you mention that superwoman also has to make sure "the kids get to the pediatrician." Do you know that there was no medical category of "pediatrician" until the 1920s, when women started to give up their knowledge of healing to the "experts"? Women have, all throughout history, taken care of the health of their families. Now not only do they abdicate their power to the pediatrician, the system is also set up so that whatever women report, see, or suggest about their own or their families' health is often dismissed or ignored. Women themselves don't believe what they know unless the doctor agrees. When the doctor doesn't, women often just bow their heads and follow orders. Those that don't submit have to keep going from doctor to doctor to alternative practitioner until they find someone who understands their concerns, listens, and is effective in his/her suggestions and recommendations.

With the advent of canned, frozen, and convenience foods, women got the message that food is not very important and that the time spent preparing it is a waste and better spent "working." They also got the message that commercially prepared foods are in some ways more hygienic and appropriate for themselves and their families. But the truth is that

food turns into people, and therefore food is the most creative of substances. Cooking for oneself, for one's family, and those all around one is the most creative act we can perform, for as people eat our food it goes into creating them. Therefore, we are, in a most profound and inescapable way, the architects of our health by the quality of the materials that we use to feed the body.

Making life-affirming choices is not automatic. It is now an act of consciousness and will. Choosing healthful food is effectively a subversive act, as it means rejecting the commercial, fake, imitation, unreal food of the marketplace. Most people are neither ready nor willing to go against what the larger society, through its advertising, marketing, and promotion of foods, is telling them to eat. You wonder how I lost the impatience of wanting to change people. As well you suspect, I had plenty of impatience myself when I was in my twenties and thirties, which is when I knew just what was wrong with most people and wondered why they kept complaining instead of doing something about it. But over time I learned to respect how difficult it is to change what we eat, something so deeply ingrained in our lives. Once again, we go against evolution: If our mothers gave us the foods that the marketplace suggested—white bread, sugared pastries and ice cream, hamburgers, frozen or canned vegetables, TV dinners, pizza, potato chips, sodas, artificially sweetened colas—and we eventually decide to eat something different, we take ourselves out of the tribe. That is why people react when you refuse hamburgers, sweets, coffee, chocolate. You set yourself apart. That is interpreted as "you think you're better than we are, don't you?" Then you get reactions that are either submissive ("You're so good and I'm so bad"), hostile ("What's the matter with you, ease up a little"—or, in other words, be more like me), or, what I find more and more common, apologies and excuses ("I don't have time to think about what I eat").

We cannot change people. We can only change ourselves, and other people can only change themselves too. When people like you and me commit to teaching a new way with food, the best we can do is make sure that, when the day comes that others want to make changes, they know where to find the information. That is all I have always felt I could do for

people: make sure that they know where to go when they're ready. It has happened often that people come to class and when asked, "How did you hear about us?" they answer, "Oh, I've known about you for years." Or people take a cooking class and come back five years later and say, "Now I'm ready." In answer to my own question about "when will they ever learn," a wise Hindu teacher once said to me, "You can't rush things. In one apple tree, different apples become ripe at different times. People also become ripe at different times." Accepting that is a difficult lesson. The Book of Runes says it even more eloquently:

> Remember the farmer who was so eager to assist his crops that he went out at night and tugged on the new shoots. There is no way to push the river; equally you cannot hasten the harvest. Be mindful that patience is essential for the recognition of your own process, which in its season leads to the harvest of the self.

Learning the meaning of food is part of our growth process. Part and parcel of this growing is the shedding of old selves, a painful but inevitable process. All choices are the right choices when we simply accept their consequences. If we accept the mind-fog that comes after a pint of ice cream, no mistake has been made. But if we don't like the mind-fog and keep going for the ice cream anyway and then complain—that is foolish. When someone does that and complains to us, that is the time for the "bartender" approach, that is, noncommittal listening. Respect for the choice but no unsolicited advice. There is no sin in unhealthy food choices, only discomfort and inconvenience; therefore there is no need for guilt. If you're interested in how food affects you, then whatever you eat, consider it research.

Sharing our knowledge with others is only appropriate when it is welcomed. People are more apt to listen when we accept them at whatever stage of their own growth process they might find themselves. Is that being resigned or loving? We must be careful. Wanting to change things may be "helpful," but it is also saying "You are wrong, what you do is wrong, and I have the solutions for your problem." How do we react when anyone tells us that? I know that for me the "mule response" sets in:

On purpose I'll do the opposite. It's a fine line between helping and bullying. Rachel Naomi Remen, the author of *Kitchen Table Wisdom,* once wrote about the difference between helping ("I'm stronger, smarter, richer, etc., than you") and serving ("I am at your service should you need me")—two very different kinds of attitude, and I am still learning about them.

Food is multifaceted. We use it as fuel, as sensory delight, as emotional support, as chemical nutrition, as social bonding, as religious statement. Each of these has its time and its place. I know you will enjoy exploring all these dimensions of our nourishment.

Wishing you happy and healthy meals always,

Annemarie Colbin

Can We Regain the Traditions and Beliefs That Made Our Ancestors Strong?

Lisa Tiger and Wilma Mankiller

Dear Wilma,

It was wonderful to see you the other day; you looked strong, healthy, and beautiful. Your positive attitude never ceases to amaze me. Despite all you've been through you seem stronger than ever; you emanate determination and courage. When I heard you had been diagnosed with lymphoma, I wanted to rush to Boston and be with you, and I felt frustrated not to be able to make the trip. I wanted to return the support you gave me when I learned I was HIV-positive. I worry that I haven't been as good a friend to you.

To be honest, your diagnosis frightened me. There is a part of me that is deeply afraid of losing people I love, a fear born out of experience. As you know, in 1967 my young, vibrant father took his own life with a .22 pistol. I was only two-and-a-half years old, too young to comprehend the loss. My mother says I waited for him to come home, jumping up every time I heard a car and rushing to the window calling, "Daddy!" As I got older, I actually felt lucky, thinking that if I had to lose my father it was better to be so young. I hoped the Creator would not take another cherished person from me in my lifetime. I know now that is not how life works.

On May 9, 1990, my twenty-two-year-old brother Chris was murdered. I was twenty-five, this time adult enough to comprehend the terri-

ble pain and loss. I wish you had known Chris, Wilma. He was a beautiful person, inside and out. The two years following his death were as devastating as I had feared such a loss would be. I wondered if I would ever find peace without my brother in this world. I wasn't able to accept that he was gone until after I tested positive for HIV. Since that time, I often wonder: Do things happen for a reason? Or is life more random and what counts is how you deal with it?

I blamed alcohol for my brother's and father's deaths; both had been drinking with friends before they died. But that didn't stop me from turning to alcohol to ease the pain following the murder trial for my brother's killer. Something stood up in me, though, and told me I had to deal with it sober. I remember you telling me about your decision not to drink when you became chief of the Cherokee Nation. Alcohol has done so much damage to our people, you felt it vital that you set an example as a leader. Your example did help me, and I know it has helped others.

After Chris's death, I came to realize it is not "normal" to spend one's life obsessed with the fear of losing someone. My fear was not just based on an isolated incident but was connected to our community's large-scale losses. As a schoolchild I never learned that every United States government plan directed toward Native American Tribes had the same ultimate goal: elimination of Native peoples, by death or assimilation. I did not know that there were laws forbidding Native American religions or that Native children in boarding school were beaten for speaking tribal languages. Outnumbered, Native peoples have had essentially no say in how or where we lived. Every day now I see reminders of how we have been forgotten.

For example, the tragic bombing of the government building in Oklahoma in 1996, where 168 lives were lost, has been described as the worst terrorist act in United States history. This use of the word "worst" bothers me. I can't help but think of the massacre at Sand Creek where over three hundred Cheyenne women, children, and elderly people were mutilated and killed. The people at Sand Creek flew the American flag over their village because they were told that if they did so, they would be considered friends of the United States. I also think of the massacre at Wounded

Knee in 1890, where Bigfoot's band of Lakota were stripped of weapons and shot down. Hundreds were killed. Terrorism has a long history in the United States, and some of the most atrocious acts were committed by government soldiers upon the Native people.

I am very proud of the ancient Native American view of life as a circle where all living things are equal. I am proud to come from a people whose traditions did not allow poverty because everyone shared tribal resources. Sitting Bull once said: "These white people can create and invent anything; they just don't know how to distribute it." Native tribes shared their wealth among their people, a lesson many people could stand to learn today. I care very deeply about learning these honored values of equality and sharing of resources. When I'm on a reservation and I pick up a hollow-eyed person walking, I see the face of a once-proud nation reduced to a man or woman looking for a drink. I want us to reclaim our essential beliefs and traditions so that we might stand strong in the face of adversity.

The hard part, though, is coping with both personal pain and the pain in our communities. During my lectures, I am often asked, "How do you feel about developing AIDS and dying from it?" I answer that I don't spend much time thinking about my disease and death. Of course I am afraid. I don't want to be like my dear friend Jeffrey Penson, who went blind before he died of AIDS. I try to remain thankful for my many blessings. I keep in mind your words to me, Wilma, about "having a good mind." You have told me that long-term survivors have in common a good mind, a love of life, and a positive attitude.

When I think of the hardships of your life—the car wreck, the kidney transplant, the cancer—it shocks me that these things happened to a woman who has so much vital wisdom to offer. It seems to me that no one has dealt better with adversity than you. I wonder if you ever stop to ask yourself: "Why me?" When I ask myself that question, I laugh and say, "Why not me?" Maybe the Creator gives us what she knows we can handle.

Wilma, your wise spirit is so evident in all you do. Do you believe such a spirit lives in all of us? In me? I keep reminding myself of an old Lakota saying: "A Nation is not lost as long as the hearts of women are still high.

Only when the women's hearts are on the ground, then all is finished and the Nation dies. The women are the Life Carriers." I can promise you this, Wilma, my heart will not leave me without a fight. My greatest passion in life is to do my part in healing our Nation. I love spending time with Native youth, especially teenage women, and watching them grow more self-confident. As you know, I have custody of and plan to adopt five Lakota children. For them and for all Indian children I ask: Do you believe we can regain the traditions and beliefs that made our ancestors strong? Will our children one day be self-supporting and free?

Yours in love and struggle,

Lisa

❖ ❖ ❖

Dear Lisa,

Thank you for your thoughtful letter. Since I last saw you I have not been well. I spent ten days in the hospital and then several weeks in bed before I finally began to feel better. At the time I wondered if I would ever recover, but I am now feeling very well and the past few weeks already seem like a distant memory. I just returned from a ten-day trip to Nassau, the Bahamas, where I underwent a procedure which sometimes produces a result similar to a bone marrow transplant. I am hopeful that this will keep the lymphoma in remission and stabilize my health while I am on dialysis.

There is no need at all to apologize for not being there during my initial diagnosis and treatment. I had plenty of loving friends and family and literally hundreds of cards, flowers, and letters from friends and acquaintances. The best way you can support me is to do exactly what you are doing: educating the public about Native American history and issues, particularly as they relate to health and fitness; taking care of your wonderful children; and working to support tribal sovereignty and women's issues.

What I admire most about you is your attitude. You have taken a devastating diagnosis and lovingly turned it into a positive force for Native people. I also like the fact that you aren't just interested in abstract causes

but are willing to personally commit your time and resources to things you believe in.

You asked four questions which I will try to respond to:

"I often wonder, do things happen for a reason? Or is life more random, and what counts is how you deal with it?"

It is my belief that all things happen for a reason, that there are no co-incidences in life. Indeed, the most important thing may not be what happens to us but how we deal with it. Years ago when I first found out I would eventually have kidney failure and either face a transplant or dialysis, I spoke with a number of people about it, including elders. Through these conversations and my own reflection I came to understand that I can't always control what goes on with my physical body but I can absolutely control my spirit, my soul, and my mind. Throughout all my struggles, whether personal, political or physical, I have kept a strong spirit and a fairly positive mind. Just as you have, I have continued my life and my work, no matter what is going on with my physical body.

"I wonder if you even stop to ask yourself: 'Why me?' When I ask myself that question, I laugh and say, 'Why not me?'"

In all the years of physical and political struggle, I can only remember once when I asked myself "why me?" I believe it was when the physician discovered a spot on my lungs and thought the lymphoma had metastasized. They told me I would have to have a painful lung biopsy. I was weakened from chemotherapy, thousands of miles away from my family, and I was discouraged. After much crying, I began thinking of all the good things that had happened to me and asked the question "why me?" in a different light. I saw that I have been blessed with so much more than most people. On balance, I cannot complain.

I have had the honor and privilege of working on issues ranging from treaty rights to health care for Native people for more than twenty-five years. I was humbled by being elected three times by my own people to lead the Cherokee Nation. I have wonderful children and grandchildren. Charlie has been a strong source of support. I live on beautiful land where my grandfather and father lived. I have a home filled with art and books. What more could I ask for?

"Your wise spirit is so evident in all you do. Do you believe such spirit lives in all of us? In me?"

Absolutely. Each of us is blessed with a unique spirit. I am convinced that after we leave this life we go to a land of spirits, or as the Cherokee elders used to say, "the darkening land." Christians and others believe that place is called heaven. However one perceives that land, it is there.

In 1979 when I was in graduate school at the University of Arkansas, I was in a head-on collision with a friend. She was killed instantly, and I was severely injured. By the time they extricated me from the car, I was dying. It was the most beautiful experience of my life to date. It was like being bathed in unconditional love of a deep spiritual origin. The feeling was far more all-encompassing than childbirth or falling in love. After that, no matter what has happened to me I have had an unshaken faith in the Creator and in myself. Because I no longer feared death, I no longer feared life.

It was only after that experience that I was able to undertake the Cherokee Nation's community development efforts at Bell and other communities, as well as running for deputy chief and eventually chief.

That spirit definitely exists in you as well.

"I plan to adopt five Lakota children. For them and for all Indian children, I ask: Do you believe we can regain the traditions and beliefs that made our ancestors strong? Will our children one day be self-supporting and free?"

First let me say that I think one of the finest things you can do to support tribal culture and our future is to simply love and support children. You have my absolute respect and admiration for caring for these children. I have seen such a change in them since they've been with you; they are obviously thriving amidst your love and support.

I do believe we can regain our traditions and beliefs. In fact, I don't think that they have really been lost. Throughout the past few hundred years some of the most powerful forces in the world have tried through war, ill-advised governmental policies, racism, and greed to ensure the extinction of tribal people as culturally distinct. Yet as we approach the next millennium, not only are we surviving but in many communities we are thriving.

I never have thought our traditions and beliefs would be retained through institutional support alone. I believe they have to be preserved family by family and community by community, with support from tribal governments.

The struggle is to retain a strong sense of who we are as a Native people and interact with the society around us. There are enormous pressures for us to adopt the value system of the dominant society and abandon our own. Those pressures have been there for hundreds of years, and yet we still have a strong sense of interdependence, community, and tribe in our more traditional communities. We can only grow stronger from this point forward.

Think about it for a minute. What a privilege it is to be able to go to the ceremonial grounds to dance and hear songs that have been sung since the beginning of time. What incredible tenacity and resistance it took for the Cherokee people to be able to continue a traditional religion in the face of so much fear, superstition, and opposition to those beliefs. Every time you see Cherokee people step into the circle and dance in the old way, it is actually an act of revolution and resistance, an act of love for the old ways and culture.

In order for our children to be self-supporting and free, they most assuredly must learn to trust their own thinking, believe in themselves and their ability to articulate their own vision for the future. For so many years we had either well-meaning social workers, the United States government, or someone else making decisions about our lives. We began to stop trusting our own thinking. More and more tribal people are looking within their own value system and culture for solutions to contemporary problems. We have our own ideas, our own values, and our own dreams. In America, people are always talking about wanting a piece of the American dream. I hope our children are able to say: "We don't want the American dream. We have dreams of our own, Native dreams."

Warmest wishes,
Wilma Mankiller

What Do Young Women Need to Know and Do About Breast Cancer?

Meg Daly and Sandra Butler

Dear Sandra,

I just ducked out of the bookstore. I had to. I didn't want to lose it there, to be vulnerable among so many strangers. All it took was opening your book *Cancer in Two Voices,* a book I read several years ago, to fill my eyes with tears. How could I have known then the way your book would reflect the life of someone very dear to me? It has come to represent much more than its initial impact on me.

First I must tell you of the profound ways your book—your voice and Barbara's voice—affected my life and my dreams. In your collection of journal entries, you and your lover Barbara chronicle her journey through and eventual death from breast cancer. The exchange of journal-like voices brought me into your life and feelings. When I read it, I was twenty-three. I had recently come out. Superseding the story of illness for me was the story of your relationship with Barbara. You offered up a path to follow, images of two strong-willed women, sometimes clashing, always loving and growing. I read your book as a story of a healthy relationship— a way it could be —a balance, intensity, and compassion I could strive for in my own relationships. And having few models that I considered positive surrounding me (homosexual or otherwise), glimpses of your relationship were beacons in the fog.

I've come of age during the tumultuous "third wave" of feminism,

where the work of your generation was both heralded and dissected by headstrong women from my generation. I have learned much from my foremothers and from my peers: to love my body, to love women, to speak out against sexism and racism and injustice. Like you I have been an activist, though I think the definitions of activism has changed over the past thirty years. I worked at a rape crisis line and helped defend abortion clinics that women were founding in the '70s; I've marched for gay and lesbian rights and pride; I've counseled people living with AIDS; I've devoted my energy to a local women's bookstore. I've helped build upon the bricks laid by feminists in the '60s and '70s. However, even though I've had a few months here and there of boycotting my bras, my breasts have otherwise not been the site of my politics.

You know how you learn a new word and then you see or hear it everywhere? That's how it was after reading your book. Cancer began popping up everywhere. In November 1992, one of my favorite writers—one of many women's favorite writers—Audre Lorde, died of breast cancer, four years after Barbara. Audre Lorde is another foremother beacon to me, someone who makes me thankful I was born in her time on Earth. She died on my birthday. Like many women across the country that day, I leafed through the pages of her books, reading sections aloud, honoring her passing: "So it is better to speak / remembering / we were never meant to survive" (from "A Litany for Survival").

"Litany" reminds me of words Barbara spoke and recorded in your book, words to challenge and uplift. Only a week after Barbara's diagnosis, she had a meeting in your home with your community of friends. One of the things she said that day (and wrote in the book) has stayed with me ever since: "The trip you wanted to take but you were waiting until next year. Do it. You might not have next year. Do it now. Do it all. Live your dreams. Live them."

Live my dreams? How else could I answer from my dingy East Village apartment—my dream come true to live in New York City amid artists and writers. Despite all the struggles I had not anticipated in my dream, I was living it. And so I had to answer Barbara's challenge: Yes. I will.

In the months after reading your book, cancer began seeping more

and more into my life. My cousin was hospitalized with a brain tumor, which he has recovered from. The wife of my former stepfather developed a bizarre form of lung cancer after giving birth to their child. I started remembering stories I had pushed out of my consciousness: my grandmother's mastectomy, my father's malignant melanoma. I was tainted; I could no longer claim ignorance or unblemished health. I was forced to recognize I belonged to a culture saturated with cancer. And I was afraid.

On an early summer day in 1995 I walked into my therapist's office like always, rehearsing in my head the issues I wanted to talk about, oblivious to her life outside our sessions. I had been working with "Mary" for three years, during which time she had facilitated much growth for me and become a sort of midwife to my development as an adult. I absolutely cherished her. This particular Wednesday Mary ushered me into her office with a gray, tear-streaked face. We sat opposite one another, and she leaned forward and began speaking—something she rarely did in our sessions. Within five minutes she informed me that she had ovarian cancer, her prognosis was grave, she was going to get her affairs in order and spend time with her family. I learned more about her life in the minutes that followed than I had in three years. She had struggled through a bout of breast cancer five years prior, and it had gone into remission. If a cancer is going to recur, it will usually do so in five years. She did not beat her window of doubt. Her cancer had metastasized aggressively in her ovaries and was working its way throughout her whole body. As she put it, soon she would be joining Gilda Radner in that happy hunting ground in the sky.

Though she promised me another session the following week, it did not take place. She called beforehand and explained in a grave voice that she was too ill to see me. The rest of that brief conversation is a blur. I know I stalled. I remember the distant, cool tone of her voice. Someone already dead to me.

"I hope you have a happy life," she said.

"Thank you." Disbelief. "Goodbye."

Later, imagining the heaviness of her task telling all her clients goodbye did not outweigh my fury. Why did she turn to stone during her

farewell? When we had last seen each other there had been warmth, love. Now, emptiness, a farewell in a stranger's voice.

That time of disillusionment was when your book and others were salvation for me. You and Barbara were committed to having and feeling *all* your emotions. Barbara wrote, "To live and die consciously is what I want. This means being a vessel, porous and transparent, letting the emotions rise and fall, letting heartbreak come and letting it go, feeling the emotional pain, keeping it all moving, not blocked . . . It means living all the emotions, all the feelings. Letting them come and go. Not blocking them."

In your book you write about how, after Barbara's death, you were diagnosed with thyroid cancer. The icing on the cake, I thought. And I was so relieved that it was successfully removed and that your cervical cancer scare was *only* a scare. I had the sense of disease spiraling out of control in your and your friends' lives, and in the world. I shoved my fear away, but it nagged me like a shadow.

Cancer hit home physically for me when I was diagnosed with a malignant melanoma in 1996—the same year a dear friend's father died of lung cancer. I did not realize until the moment of my diagnosis that skin cancer could become systemic cancer; it could recur in my lungs, my brain, my breasts, my cervix. Now that my surgery is over and the scar is healing, now that I can recite to myself that there is a ninety-eight percent cure rate with surgical removal, and despite the fact I had an excellent and compassionate plastic surgeon, I still worry about that two percent. Sometimes I feel invaded and infected. Sometimes I feel out of control of my body, as if a foreign entity is still lurking within. Do you feel this way ever, Sandra?

In the book both you and Barbara make reference to political activism around cancer. I have a feeling that many women my age (mid-twenties) don't think about cancer as a reality that might affect them—to us it's a "middle-age" disease, something to reckon with down the line. But it's a myth, for I've heard of too many women in their thirties battling breast cancer. And melanoma is the leading cancer risk for light-skinned women in my age group. For all the pink ribbons and fashionable fundraisers, I still have the feeling that not every woman is as educated about the dis-

ease as she could be. Breast cancer is a "cause," like starving children have become a cause, or AIDS, or poverty. By making a very real health issue a cause to choose or choose not to support and be active in, I'm afraid that women miss a major link: the everyday awareness that our bodies are susceptible to disease and that we are connected to a larger whole—a world out of balance.

Sandra, what do young women need to know about breast cancer? What can we do to prevent it in our lives and in our friends' lives? How can young women participate in political activism about breast cancer and all cancers?

I know these are big questions. I hope you will be able to address them. Your wisdom, as a woman who has lived with a lover dying of breast cancer, is invaluable. Your perspective offers us a view from the vortex of this pervasive disease. It's important to honor the lives of people we have lost—women who have died because of "women's cancers"—by taking our private grief and turning it into public action. I want to honor my therapist in this way.

Thank you for writing *Cancer in Two Voices*. As I said before, I read it as a love story, not a loss story. And despite your great loss, you shared with each other and with your readers so much love.

Respectfully,
Meg Daly

◆　◆　◆

Dear Meg,

I am pleased to begin this correspondence, delighted that you chose me as your foremother and grateful that *Cancer in Two Voices* has been generative in your own life. I offer these words in the hopes that my work and experience might be useful as you think through the questions that are the foundation of a life of activism.

When I remember the beginnings of my participation in the women's liberation movement, I can still feel the rush of energy and readiness to change the face of the world. The male gaze. The male pronoun. The

male perspective. Patriarchy. In those heady and exhilarating beginnings, I was certain that together feminists would be able to end all the institutionally shaped forms and personally enacted expressions of sexism. In family life. In religious institutions and the media. In schools and on the street. Suddenly, it seemed, I understood that everything I had been taught about what it meant to be a woman, a wife, a mother, a daughter was untrue. Dangerously untrue. Everything had to be unlearned and re-learned. Everything. I sat in circles with other women and knew that together we could and would do whatever was necessary. Whatever it took to change the face of the world.

As my understanding of the institution and practice of sexism grew in the early 1970s, my work at the Sexual Trauma Center led to my writing *Conspiracy of Silence: The Trauma of Incest* in 1978. From that time until the moment of Barbara's diagnosis in 1985, I traveled to train and educate, organize and consult, as people began to understand more and more about the dimensions and effects of sexual abuse. As I listened to women disclosing their violations for the first time, as I saw the disbelief, blame, judgment and dismissal with which their painful experiences were met, it was clear that these astonishingly courageous women were trapped in a traditional and medical-model health structure that either diminished the traumatic effects of their sexual violation by a (usually) male family member or pathologized them for being so deeply impacted by their abuse. In those early days feminists were still unaware of the epidemic proportions of the sexual abuse of children, adolescents, and adults. There were no resources available for women and children in pain. There were no groups, no respectful therapies, no information, no medical or legal interventions or protocols. Nothing. We were required, as feminists, as lesbians, to create the world we needed to live. The feminist research, the gathering places, the newsletters, the anthologies, the pilot programs didn't exist. We needed to push the existing structures of law and medicine, psychiatry and child development, and, at the same time, create new forms to replace the corrosive effects of the traditional ones. The task was before us and we began.

During those same years lesbians and feminists created the women's health movement with the same challenges, dedication, and skill as those of us working to end violence against women. And as lesbians we were finding ways to create chosen families. Families that embraced primary partners, ex-lovers, old friends, children—all the many forms of connection and of loving.

When Barbara was diagnosed with stage-three breast cancer, my focus shifted. I turned towards her, towards the landscape of our relationship. We would make our lives public. Remove the experience of breast cancer from the private and personal realm in which it had always existed and insist it be on the page. In the world. The context of my political life shifted to a San Francisco flat filled with two women, a terminal-cancer diagnosis, a rich community, and the scaffolding of the women's liberation movement, lesbian identity, and a long history of political activism.

Having been a feminist, a lesbian, a political woman for so long, I could see the parallels between child sexual abuse and breast cancer. How sexually abused women and cancer survivors were pathologized, blamed for their presumed participation in causing their victimization. Some women who were sexually abused were blamed for staying. Others for leaving. Some women who were diagnosed with breast cancer were held accountable because of their poor diet or lack of exercise. Women were criticized for not speaking up. Or for not listening. And for each of these failed opportunities a psychological explanation was offered, a psychological cure required. If women would only act right or eat knowledgeably or exercise rigorously or communicate carefully we wouldn't get sick. Or hit. Or abused. Or die.

I could see that while sexual abuse and breast cancer needed to be treated individually, while each woman's physical and psychic wounds are indeed unique to her, individual treatment does not engage the fundamental roots of a systemic illness. In 1985 there was little information about the causes of breast cancer beyond the often-quoted hereditary factors. In 1957, during my first pregnancy, I was given DES to "hold" the baby. Now, forty years later, after cancer required the removal of my thyroid, connections are being made between the toxins in my body and the

cancer that emerged there. Now we know that much of the genesis of most cancers, including breast cancer, is invisible. Invisible in the use of insufficiently tested X rays given to women and children in the 1940s and 1950s; invisible in the air filed with DDT from pesticides that we breathe; invisible in the water that we drink, polluted with chemicals from factory waste; invisible in the food nourished by contaminated soil that we eat. But we didn't know that then. Just as we didn't know that sexual abuse was an epidemic. Formative in the lives of hundreds of thousands of girls as they negotiate the predatory violence of a sexist world. Feminist research has exposed environmental issues that were not even on the medical agenda when Barbara was diagnosed. Acid rain, pesticides sprayed on workers and food, animals raised in tortured environments and fed hormones and antibiotics, chemical dumps, environmental racism—what is now understood as "invisible violence."

My life has led me to two epidemics. Women who have been sexually abused and women with breast cancer. In both epidemics the ways in which we were individually diagnosed and treated, trivialized and pathologized has been exhausting, burdensome, depleting, and, finally, thanks to the political organizing and activism of feminists and lesbians, intolerable and enraging.

Now that I have sketched the context, Meg, let me return to your questions. "What do young women need to know about breast cancer? How can we prevent it in our lives? How can young women participate in political activism about breast cancer?" Perhaps some of my answers are embedded in a reformulation of your questions. I would ask, how is the way in which food is grown and harvested, packaged, marketed, and consumed a political process? How do the business practices of major corporations need to be accessible to and safe for consumers? How can feminist advocates and health care consumers participate in shaping the research questions, directing the funding, and publicizing the results of studies that target the cause, cure, prevention, and early detection of breast cancer? How can young women be encouraged to be proactive in their own health and insist that research and education be geared directly to their concerns?

The epidemic of breast cancer is striking the breasts and bodies of younger and younger women. The causes may have their roots in prenatal, early childhood, or adolescent exposure to environmental contaminants. A healthy lifestyle now is a necessary step, but it does not address what may have already poisoned the bodies of women of your generation. While eating a healthy diet, avoiding alcohol and tobacco, and maintaining a comfortable exercise regimen is a necessary starting place for creating optimum health, it is not enough. The urgent need to avoid chemicals and pesticides, most often from exposure we are unaware of, demands we augment our individual regimens to include the larger task of engaging the world with organizing, activism, and education. In order to educate ourselves and one another, we need to see all the ways in which the air we breathe, the water we drink, the food we eat affects the epidemic nature of breast cancer. And we need to remember how some young women have more resources. More education about nutrition and diet. More access to health care and medical coverage. Daily life where air is cleaner and pollutants hover over industrial cities hundreds of miles away. At least temporarily.

We need to ask the deepest, broadest, most comprehensive questions. Is incest the act of a single man? One who had a bad childhood? Who is suffering from misplaced love? Who is alienated, disaffected, unable to relate appropriately to peers? Or do we live in a world where vulnerability, innocence, powerlessness is sexy? Where men feel entitled to the bodies of younger, smaller, more powerless people? Is breast cancer a disease of the breast? Of the entire body? Of corporate greed? When the breast is removed is the disease removed? When the offender is confronted is the abuse healed? Is it sufficient to only engage the local site of the violation cure? Does that heal?

Working to insure a safe and habitable environment is doing breast cancer activism. Organizing to stop corporate polluters is as necessary as sitting with a newly diagnosed woman. Writing exposés on the uses of herbicides in corporate farming is doing breast cancer activism every bit as passionately as teaching the importance of physical activity to teen women. Insuring that women who don't speak English have information

on clinics, brochures, counseling in their own cultural framework and primary language is doing breast cancer activism as is doing research on health care reform. I don't think it matters where we enter. It matters that we choose to enter the struggle to create a safe and habitable world. Each of us has different and unique histories, life experiences, skills, passions, and possibilities. Each of us has to find her way to a life of passionate engagement with the world in which we live, all embedded in the acknowledgment of the political nature of daily life. It is all a part of creating a public vocabulary. Some of us will become organizers, others will provide social services or funding; some will become educators and others create organizations.

Each of us needs to take responsibility to enter her political life in the place that her heart and skills, life experiences, and passions lead her. My life experience and my love of one woman led me to political activism in the epidemics of sexual abuse and breast cancer. Yours may take you in another direction. What matters is to insist that each moment of your life be shaped by, as Barbara wrote, "the heart you bring to it, the intelligence you bring to it, by being conscious in every moment. . . . "

Meg, you enter a movement with a powerful history. Feminists have organized block by block to drive women for mammograms, done child care while they are gone, delivered meals to women who are sick, set up storefront clinics for preventive education and services, created education programs in schools and churches. We have begun to challenge the practices of multinational corporations and pharmaceutical companies, document the cumulative dangers of radiation and pesticides. We don't have to create it all from the beginning any more. Women of my generation leave you a legacy. A history. A place to begin. Take what we have begun and shape it as you need.

We cannot lose any more silent, fearful, lonely, isolated women. We have learned that being polite, well-behaved, accommodating, acquiescent, and grateful hasn't protected us from rape, abuse, loneliness or contempt, disease and death. Our commitment to other lesbians, to feminist activism places us irrevocably in life-and-death community with one another.

So, Meg, these are some of the questions and the answers I have ar-
rived at over these decades. Questions that will require your answers.
Questions that I hope will give shape and direction to your own searching.
As a young woman taking her life and all our lives seriously, passionately
and lovingly. I look forward to your reply.

 With respect,

 Sandra

How Do You Reconcile Being Pagan and Jewish?

Jennifer Hunter and Starhawk

Dear Starhawk,

I first met you the day after my senior prom. You probably don't remember me, because I was only one of a hundred people at a New York City Wicca workshop you were leading. Since then I have been a great admirer of your work and have read all your books—most recently *The Fifth Sacred Thing*. I'm pleased to have this chance to write to you, and I'd like to hear your take on some of my experiences and the way in which they have shaped who I am and where I'm going.

Growing up, I knew I was different somehow, though no one ever told me how. I had few friends through school and many enemies I didn't make. It always puzzled me how cruel the other children could be, and it never really occurred to me to fight back. So I just slipped further and further away emotionally until I was practically invisible. After middle school, the only people who spoke to me were the teachers. I wonder, did you have similar experiences? It seems to me that so many Witches were once outcasts. How do the others know we're different, even when *we* don't?

Although both my parents are Jewish, there was almost no religious or ethnic identity in my household. My mother, who raised my brother and me alone, has always had a hostile distrust of organized religion. We celebrated the major holidays simply by having dinner at my grandparents' house. For a while, we attended a Unitarian church—my mother's effort

to give us the "least offensive" kind of spirituality available—but we got bored and stopped attending. When we asked Mom if she believed in God, she said, "I believe in natural selection." End of story.

I have heard you speak about rejecting Judaism because of the limited role it offers women. Was your family religious as you were growing up? And how did that affect your spiritual outlook?

I began my own occult explorations at age eleven. For the first few years I devoured books on ESP, ghosts, handwriting analysis, tarot, fortune-telling—anything that seemed mysterious. This was something I could be good at, something to be proud of. If I seemed like a misfit, it was only a disguise: In the other worlds, I was powerful. I remember the adrenaline thrill when I got a high score on my self-test for psychic abilities. Or the pumped-up feeling when I discovered a bit of "arcane" knowledge about which my fellow seventh-graders wouldn't have the slightest clue.

When, at age fourteen, I started to read about Witchcraft—magic, energy, the old gods, the old Celtic holidays—it all made sense to me. I started doing rituals in my candlelit bedroom two years later, with a copy of your book *Spiral Dance* in one hand and my wand in the other. Practicing magic, and the Craft in general, gave me pride in myself. It placed me in a context where I mattered. I never quite bought the idea of the distant father-God, but I could feel the presence of a deity within all things. And the idea that I was an image of the Goddess gave me such strength in the turmoil of my adolescence.

However, as I grew older I came to realize I had been taking the idea of magic too literally; I had been running my life through will, thinking that if I only wanted something bad enough I could create it—including enlightenment. In the Craft, when we talk about "power trips," usually we mean people who start a coven and it becomes a cult of personality. But I was on a power trip with my whole life, thinking I was completely in charge. (And I think this is probably a common problem—no?)

Three years later, I realized the hard way that I was not in charge. Still forcing my "fairy-tale" ideas into reality, I had willed myself into an early marriage that was completely wrong for me. I disappeared into my hus-

band's shadow, believed him when he said our problems were all my fault. When I realized I had to leave, I was three months pregnant. That was my first-degree initiation. I realized I had to put my own needs first—and that meant, yes, even over the baby I had wanted as long as I could remember. I had an abortion.

Despite all the ritual and the magic and the covens and the maypoles and the "thou art Gods," I had taken none of it in. All the choices I'd made in that relationship were in gross denial of my intuition and my self-respect. My initiation was as painful as it was necessary. The Goddess had to slap me across the face. I had to learn that she is just as much the devouring Crone as she is the doting Mother.

In my little rented room, I spent the next couple of years recovering. And ironically my real-life initiation brought on the worst crisis of faith I have ever had. I read an article recently in *Connections* magazine in which someone wrote that Witches don't have crises of faith. Bullshit! When I was a teenager, I thought Witchcraft could fix anything. Visualize what you want and it will be yours. If it didn't come, it just means you didn't try hard enough. My labels, rules, and absolutes kept me feeling safe. Well, I had worked hard and followed the rules, but it wasn't enough. In my mind, I had failed. And I had to reevaluate everything. I stopped observing the sabbats, I stopped doing magic, I only consulted my tarot cards when I wanted confirmation of what I already thought. And during this time I was trying to write a book about Witchcraft. I still believe in everything I wrote, but it was walking uphill all the way.

But there is a sense to this process. During that time of confusion, I met the man who is now my life partner, and surprise, surprise, he's not Pagan—he's an observant Jew. Through talking to him, I realized that even as I love to go on about indigenous religion and tribal identity, I had forgotten that I belong to a tribe by birthright. And because I was raised in a nonobservant family, I realized I knew less about Judaism than a lot of people know about Witchcraft. As it turned out, my crisis of faith freed me up to learn about a religion and culture I had never even considered.

There was no force of will in my being Jewish: It's essentially an "accident," through two generations of secular Jews with little concern about

intermarriage, that I turned out to be one-hundred percent Jewish. That identity is a current running though my life, a gift I was given, just as much as my psychic sense and my ability to write. When I light the Sabbath candles, I feel power, in that I am picking up a thread of tradition that has been dropped—and isn't that what modern Paganism is all about?

I used to think that if you found a religion you liked and you committed to it that meant your beliefs had to remain the same forever. It's a comforting idea, but I'm learning that life doesn't work that way. As we grow, naturally our beliefs can and should change. For instance, although my ancestry is Russian/Polish, I have identified as Wiccan for ten years—a tradition of Witchcraft that is mainly Celtic in origin. But once I started to let go of that—a recent change, and a process that is still happening—I was able to start to view Witchcraft as a practice that can transcend all cultural and religious boundaries.

So how do I see Witchcraft now? I think it's about conscious transformation (on an individual, and larger, scale), through positive magic and "mundane" work, as well; about intentionally placing ourselves in the context of Gaia, or "Nature," rather than outside Her; about acknowledging the "shadow" part of ourselves—allowing ourselves to be angry, miserable, moody, harsh, and about transforming that into personal power. And especially not being afraid of change. After all, if it weren't for change and if nothing ever died, then nothing could ever be born.

As I read your novel *The Fifth Sacred Thing,* I was especially inspired by the images of people of all different religions worshipping together, on and around the mountain. It's very appealing to me, because it goes beyond the "either/or" scenario that has given me so much trouble: Now I'm a Witch, now I'm Jewish, maybe I'm nothing. Yes, all positive paths are valid. But I can't help but wonder whether pluralism strengthens us or weakens us. If I combine two religions, am I only practicing each one halfheartedly? What does it mean to commit to a path?

I'm also curious as to your take on the future of Witchcraft and Paganism in general. What do you think it has to offer? In the decade I've been practicing, I've detected a shift into more internal alchemy, rather than external—and that makes me happy. I really think people have to change

themselves before they change the world. And women like myself, who allow themselves to stay in harmful relationships, really need to look within to see how they have been participating in their own helplessness. Maybe if I had done that more effectively, I wouldn't have had to endure so much heartbreak.

I look forward to your response!

Shalom and Blessed be,

Jennifer Hunter

❖ ❖ ❖

Dear Jennifer,

Thanks for your thoughtful and honest letter. I'm happy to have this opportunity for dialogue.

You offer several definitions of spirituality. The one that comes closest to my own is "the interconnectedness of all things." I've never liked the word "spirituality," as it seems to imply a disconnection from the material world, but I often use it simply because I can't find a better word in English. But for me, spirit is embodied in nature, manifest in the cycles of birth, growth, death, decay, and regeneration within all life.

I agree that often what we humans look for in spirituality or religion is, as you say, a thread of a story that helps our lives make sense. The Goddess tradition says, "You make sense because you are part of the cycle, you have a role to play inherent in your very being, and you have a value that is inalienable, that does not have to be earned or deserved, but is yours as a birthright of the community of living beings."

While people often use magic to try to control events, for me the essence of the Goddess tradition is mystery—the understanding that the universe can never be wholly known or controlled. Our destiny can be shaped and influenced. But the excitement, the freedom we experience in life comes from the knowledge that chance and randomness are also working, and though the results will not always fit my timing or desires, that's the price we pay for living in a dynamic, ever changing cosmos.

You write about the painful feeling of being an outsider, and I feel a great deal of empathy even though my experience was somewhat differ-

ent. I remember in junior high school feeling very much that my friends and I were somehow the odd crowd. There were other groups we identified as the "in crowd," the popular kids. Years later, someone else who went to our school informed me that she always thought *we* were the "in" crowd. So I can't say that I felt like an outcast. I always had groups of friends—some from high school are still close friends today. (Although I have no friends from my college years, for some reason.) When I was in high school in the late '60s, we essentially had a social revolution. The old categories: "Surfers," "greasers," and "soshes" (socialites), which were actually very much divisions of class and sometimes race, broke down into hip and straight. My friends and I were among the hip. We were also the political activists. We had a strong antiwar group, a students' rights group, an underground newspaper all organized with no adult help. We spent our weekends piling into cars to go to demonstrations or sitting in smoke-filled rooms planning forums on the draft or listening to some of the great old blues guitarists at the Ash Grove or hitchhiking to a rock concert to hear the Jefferson Airplane or the Grateful Dead. It was all very sexy and exciting in the way things are when you're young and all of it is new. When I look back on it now, I'd have to say I had a great time in high school, even though I remember clearly feeling like I was going through hell most of the time, bored in class, fighting with my mother, breaking up with my boyfriend, and generally chafing at all the restrictions of being young.

I actually had a very strong Jewish upbringing. My grandparents were Orthodox; my parents were the generation that rebelled. My father was a communist in the '30s, and his side of the family were very political, but he died when I was five. My mother was more psychological in her orientation and not particularly observant religiously. But we lived upstairs from my grandparents for a number of years, and from an early age I went to Hebrew School and Jewish summer camps. I was bat mitzvah and continued on through Hebrew High School—an after-school program and a year of part-time course work at the University of Judaism. I was a senior in high school when I finally dropped my Jewish studies, for two reasons. The first and primary reason in my mind at the time was that my own mo-

ments of deep connection were happening in nature or in exploring my sexuality or in the ecstasy of dancing to rock and roll—not in synagogue or studying the Talmud. In fact, nothing I studied at that time even spoke of the possibilities of what I was experiencing.

The second reason I pulled away from active involvement with Judaism was out of the sense that there was no future in it for me as a woman. At that time there were no women rabbis—the possibility had yet to be raised. At best, I could hope to become a Hebrew School teacher or a rabbi's wife.

So I began exploring other spiritual paths, and in my first year of college, I met Witches who practiced what they called the Old Religion of the Goddess. At that time I was living in an old fraternity house converted into a hippie commune, and eight or nine of us were sharing one large room on the top floor. The Witches came one night and read us the Charge of the Goddess, and I said, "Yes! This is it for me—this is what I've always believed. Nature is sacred, sex is sacred, religion is meant to be ecstasy, and the divine looks something like me! Where do I sign up?"

It wasn't that I was consciously searching for female images of the sacred—frankly, the idea of a Goddess had never occurred to me. As soon as I heard the word, I liked it. As you said, it was also enormously empowering for me as a young woman to encounter a tradition which said that my body was sacred and that I could take on positions of leadership and responsibility.

Nevertheless, like you I also had a very painful early relationship. I lived with a young man from the time I was seventeen until I was twenty-two, although we never got married. When we met, we were both enjoying the try-anything drug culture of the late sixties, but as time went on, he got more deeply into hard drugs, eventually crossing the line into addiction. While in many ways those were creative years for me—I went through college, got my BA, did a year of graduate school in film, started writing, and wrote two novels (albeit unpublished)—it was also a time in which I felt I lost myself in that relationship. I was newly involved in the feminist movement, I was part of a consciousness-rasing group that became very close, I was reading Kate Millett and teaching classes at the

women's center, but none of it could counteract that deep conditioning we women get to subordinate the self.

When I left him, I was propelled into a journey that became an initiation. I spent a year travelling, with very little money. I bicycled down the Oregon coast that summer, flew east and bicycled in New England in the fall, and then spent a winter in New York trying to get established as a writer, without much success. Living in the open, dependent on my own body for transportation, removed from my circles of support, I found a new sense of my own strength and I renewed that direct connection to nature which for me has always been the heart of my spirituality.

That year led to a commitment to put my spiritual development at the center of my life and to begin writing about it. In the long run, it led to *The Spiral Dance,* which I wrote in my mid-twenties and which was published when I was twenty-eight. I often look back on it now and wonder how I thought I knew anything at that age, but evidently I did, as the book has been in print now for nearly twenty years.

I had a stormy first marriage to a man who, while loving and charismatic, was also manic-depressive. After that, I had many relationships with both men and women for most of my thirties before settling into the marriage I have now with a man who is kind, loving, and funny. He's also a Pagan—at this point in my life I would find it hard to be "family" with someone who couldn't share what is so core to my life. But I know of many sucessful "mixed marriages," so it can be done. And it's amazing how, over the years, the pain of those early relationships fades in my memory, and what remains are the good times we had.

When David and I got together, I very much wanted to have a child, but that was not to be. If you want children, I really recommend having them when you're young and not waiting until you're forty to begin trying! However, David has four wonderful daughters, who are mostly grown now and who are friends as well as stepdaughters to me. And I have a wonderful young, almost two years old, Goddess-daughter Kore, adopted by my housemates—so I have lots of young energy in my life.

My own relationship to Judaism continues to evolve. Being Jewish is, as you say, an identity, not something you choose but something you are—

at least for those of us born into the tribe. I no longer think of myself as breaking away from Judaism so much as pushing the envelope of what Jewishness is and restoring connections to the earth and to the Goddess that have always been there but have been lost or suppressed. Of course, I'm also very much aware that what I do and believe would be considered absolute heresy by many Jews. But that's not my concern. My responsibility is to live my own spiritual truth—not to make other people like it or agree with me.

I feel that I honor my ancestors by keeping the Jewish traditions that are most meaningful to me—going to High Holiday services, lighting the Chanukah candles, making a Seder. I may change the words or retell the tales in new ways, but then Jews have been doing that for five thousand years! I have also found other women who share this exploration on the edges of Jewish culture. There is a self-organized Jewish/Goddess congregation in the Bay Area, Pardes Rimonim, that does beautiful High Holiday services combining traditional prayers with invocations of Asherah and the four directions. My friends and I rewrite the Seder from year to year to play with the themes of liberation and renewal. In recent years, I have also begun teaching and lecturing in Israel.

And I also celebrate the Celtic/Pagan Wheel of the Year, the eight solar holidays of Samhain (Halloween), Winter Solstice, Brigid, Spring Equinox, Beltane, Summer Solstice, Lammas, and Fall Equinox. In my collective house in the city, we celebrate just about everything—which keeps us busy in midwinter with Pagan ritual, latkes and Chanukah lights, and a tree and gifts! With my neighbors out on the land, where I live more and more now, I also celebrate rituals that speak to our particular place and needs—for protection from fire in the summer, for celebration of the rain in late autumn.

I think your question about pluralism is a valid one. A shallow pluralism, a sort of dipping into this and that spiritual system, is not truly life changing or nourishing. True spirituality demands commitment—but in today's multicultural world that commitment may be much broader than simple devotion to one tradition. I have to honor my ancestors and the approach to the sacred that most truly expresses my own vision. I've been a Jew all my life

and a Witch long enough—close to thirty years now—that I can be fairly sure it's not just a passing phase. I also acknowledge and honor insights of Buddhism, of African and Mesoamerican and Native American traditions, although I would never lay claim to being an expert or teacher of any of these. One of the great joys of being alive at this time is that we can draw on teachings from many different cultures—if we are careful to do so with respect, with a solid grounding in our own roots, and without appropriating someone else's way. Not "practicing two religions half-heartedly"—but living out fully the whole complexity of who we each are.

What does it mean to commit to a path? It means to be accountable to and responsible for a community, to give back service as well as receiving teaching and inspiration. It means to be willing to make the phone calls and type up the minutes of the meeting as well as dancing ecstatically or singing joyfully.

Most of my time now is spent either writing, teaching about the Goddess tradition, speaking, or organizing. In between, I garden fanatically and take long walks on the land to maintain my own direct connection with nature. I'm a lucky person in that I'm able to make my living doing what I love.

For me, Witchcraft is not about manipulating the world through magic but about acknowledging our place in the natural world, honoring the cycles of birth, growth, death, decay, and regeneration around us and within us, and learning to move with those cycles. Nature is our teacher and our sacred text, and we need to learn to "read" her. We also need a strong commitment to protect and preserve both the ecosystems and the social systems that foster diversity and freedom. So being a Witch naturally leads into political activism, which is also something that occupies a great deal of my time.

In the past years, Paganism has been growing. Reclaiming, the group I work with, has grown from a small Bay Area collective to a tradition of the Craft that runs training programs in eight or nine communities in the United States, Canada, Europe, and Central America. Our newsletter is now a quarterly magazine, and our Halloween ritual regularly attracts over a thousand people. The challenges we now face are how to organize

on a larger scale without becoming institutionalized, how to pass on what we've created to a new generation, how to transform personal power and healing into power to affect what goes on in the world and to change those conditions that create our pain. My hope for the Goddess tradition is that it will spawn a thousand linked but unique traditions rooted in community and that, even beyond those who practice it directly, it will help change consciousness and be a force for the empowerment of women and the healing of the earth.

Thank you again for writing to me. And blessed be,

Starhawk

What Did You Wish for Me?

Karin Cook to her mother, Joan Carpenter Cook,
who died of breast cancer

Dear Mom,

What time was I born?
When did I walk?
What was my first word?

My body has begun to look like yours. Suddenly I can see you in me. I
have so many questions. I look for answers in the air. Listen for your
voice. Anticipate. Find meaning in the example of your life. I imagine
what you might have said or done. Sometimes I hear answers in the echo
of your absence. The notion of mentor is always a little empty for me.
Holding out for the hope of you. My identity has taken shape in spite of
that absence. There are women I go to for advice. But advice comes from
the outside. Knowing, from within. There is so much I don't know.

What were your secrets?
What was your greatest source of strength?
When did you know you were dying?

I wish I had paid closer attention. The things that really matter you
gave me early on—a way of being and loving and imagining. It's the stuff
of daily life that is often more challenging. I step unsure into a world of
rules and etiquette, not knowing what is expected in many situations. I

am lacking a certain kind of confidence. Decisions and departures are difficult. As are dinner parties. Celebrations and ceremony. Any kind of change. Small things become symbolic. Every object matters—that moth-eaten sweater, those photos. Suddenly I care about your silverware. My memory is an album of missed opportunities. The loss of you lingers.

> Did you like yourself?
> Who was your greatest love?
> What did you fear most?

In the weeks before your death, I knew to ask questions. At nineteen, I needed to hear your hopes for me. On your deathbed, you said that you understood my love for women, just as you suggested you would have fought against it. In your absence, I have had to imagine your acceptance.

There are choices I have made that would not have been yours. Somehow that knowledge is harder for me than if I had you to fight with. My motions lack forcefulness. I back into decisions rather than forge ahead. This hesitancy leaves me wondering:

> Did you ever doubt me?
> Would you have accepted me?
> What did you wish for me?

I know that my political and personal choices threatened you. Your way was to keep things looking good on the outside, deny certain feelings, erase unpleasant actions. Since your death, I have exposed many of the things that you would have liked to keep hidden. I can no longer hold the family secrets for you.

I search for information about your life. Each scrapbook, letter, anecdote I come across is crucial to my desire to understand you and the choices you made. I have learned about affairs, abuse, all things you would not have wanted me to know. Yet they explain the missing blanks in my memory bank and round out your humanity.

> Who did you dream you would be?
> Did you ever live alone?

Why did you divorce?
Did you believe in God?

One thing you said haunts me still. When I asked about motherhood, you said that children don't need as much as you gave. "Eighty percent is probably plenty." I was shocked by your words. Did you regret having given so much of yourself? Now, those words seem like a gift. A way of offering me a model of motherhood, beyond even your own example.

Becoming a mother is something I think about a great deal, almost to the point of preoccupation. I have heard it said that constant dreaming about birth often signals a desire to birth one's self, to come into one's own. My process of grieving the loss of you has been as much about birthing myself as letting you go.

What were your last thoughts?
Were you proud?
Were you at peace?
What is it like to die?

How frightened you must have been shouldering so much of your illness alone. The level of your own isolation is a mystery to me. In my life, I try hard to reach out, to let others in. I fear loss more than anything. I turn on my computer. Make things up. I tell the truth. My daily work is toward connection. All these questions move me to search, less and less for your answers and increasingly for my own.

Love,
Karin

Part Five

WHERE TO FROM HERE?

Women Pass the Torch to Coming Generations

Eisa Davis and Ntozake Shange

Jennifer Baumgardner and Judy Blume

Patricia Wakida and Yeong hae Jung

Catherine Gund Saalfield and Dr. April Martin

◆ This section stresses, once again, the need for intergenerational dialogue, where young women can ask advice of older generations and older women can be inspired by the new insights and life paths of younger women. Our society tend to look to pundits and "experts" who spout savvy analyses of contemporary women's issues. The writers here ask more probing questions about what fosters *enduring* social change for women. How does poetry fuel activism? What are new ways to parent? What do we teach children about racism?

As the population of America and the world becomes more diverse, how are we passing on a feminist legacy to our daughters, sons, nieces, nephews, and mentees? What values are we instilling in coming generations that they might create a more livable world? These letters remind us that the struggle and work of older generations of women have borne bountiful fruit.

187

if we've gotta live underground and everybody's got cancer/will poetry be enuf?

Eisa Davis to Ntozake Shange

dear ntozake,

i got sacks of mercury under the skin beneath my eyes
either cried too much or i'm abt to
the cool war's burnin up my retina again
does poetry start where life ends?

i know i'm supposed to be cool:
i wear corrective lenses that feature
high definition tragedy.
baby in the dumpster ethnic cleansing
assassinations multinational mergers
i'm supposed to shake my head
write a poem
believe in ripples.
but i ain't cool.
i emit inhuman noises
i imagine terrorist acts as i flick my imaginary ash
onto the imaginary tray
i imagine going insane with a purpose
and writing it down feels sorta unnecessary
does poetry end where life begins?

189

berkeley girl black girl red diaper baby
born of the blood of the struggle
but with reaganomics and prince pickin up steam in '81
nothing came between me and my calvins
10 yrs old unpressed hair playin beethoven
readin madeleine l'engle got scared in my pants when i heard
this girl testifying 'TOUSSAINT'
in the black repertory group youth ensemble
i was just sittin in a rockin chair pretendin to be 82
and talkin like i knew all bout langston's 'rivers'
i wasn't as good as her
and i definitely wadn't cool
so i gave up drama
and decided to bake soufflés

zake
you wda beat me up on the playground
if we'da grown up together
and you did
eighth grade 'he dropped em'
at the regional oratorical competition
i saw another fly honey rip it
this time it's 'a nite with beau willie brown'
i was bleedin on the ground
i became yours
no more soufflés
i jacked *for colored girls* right off my mama's shelf
my mama fania who was sweatin with you
and raymond sawyer and ed mock
and halifu osumare
dancin on the grass back in the day

in you i found a groove
never knew i had one like that

did that monologue over and over
alone in my room
my bunk bed the proscenium arch
13 yrs old screamin and cryin abt my kids
gettin dropped out a window
didn't know a damn thing about rivers
but i knew abt my heart fallin five stories
you were never abbreviated or lower case to me
you just pimped that irony
that global badass mackadocious funkology
you not only had *hígado*
you had ben-wa balls in yr pussy

betsey brown on my godmother's couch
nappy edges in mendocino at the mouth of big river
spell #7 after the earthquake in silverlake
the love space demands had to be in brooklyn
yr poems are invitations to live in yr body
love letters yr admirers dream they coulda written themselves
no one cd find a category that was yr size
blackety black but never blacker than thou
you teased me into sassiness when i had none to speak of
you made profane into sacred but never formed a church
sanctified women's lives
whether we were reading nietzsche or a box of kotex
we were magical and regular
you many-tongued st louis woman of barnard and barcelona
you left us the residue of yr lust
left us to wander life as freely as sassafrass cypress and indigo
and even the unedumacated could get yr virtuosity
cuz you always fried it up in grease
you built an aqueduct from lorraine hansberry's groundwater
and it bubbled straight to george c wolfe

you never read what the critics said
and you scrunched up the flesh between yr eyebrows
like everybody else in my family

but zake
is poetry enuf?

i beg the question cuz you grew me up
you and adrienne kennedy and anna deavere smith
and all my mothers
you blew out the candles on my 26th
so when there's mercury under the skin beneath my eyes
and the world ain't so cool
do you write a poem
or a will?

like leroi jones said if bessie smith had killed some white people
she wouldn't have needed that music
so do we all write like amiri baraka does
or do we all get our nat turner on?

i beg the question cuz i wanna get my life right
do some real work
and i really don't want to kill any white folk
i mean can we talk abt this
maybe it's just my red diaper that's itchin
but i still got that will to uplift the race
sans bootstraps or talented tenths or paper bag tests
this time we uplift the human race
and i know the rainbow might be
but is poetry enuf?

it's a naive question but i'm old enuf to ask them once in a while
if we do finally unload the canon
clean it out
stock up on some more colorful balls

ain't we only gettin the ones that are available at a store near you?
doesn't the market end up setting the new standards anyway?
is poetry enuf if it ain't sellin?
if ain't nobody readin it?

can poetry keep a man who can't read
from droppin his kids out a window?

and how can i call a ceasefire to this cool war
in stanzas of eights
when we've declared poetry a no fly zone?
we have learned to protect it and its potential politics
like a mother
shoot down anyone who might overdetermine a poem's meaning
(while we poets divebomb everyone else's politics with impunity
like we're the United States or something)

if poetry is just poetry
we save it from the conservatives
but doesn't that mean it's of no use to the progressives?

is poetry enuf?
cuz that's all i'm doin.
makin up stories on stage on the page
keepin the beat
and that's all my friends are doin
and that's what a lot of folks my age are doin

but if we've gone and burnt up everything in the sky
if there's nothin else to eat but landfill stroganoff
if we've gotta live underground and everybody's got cancer
will poetry be enuf?

my aunt angela says i can do my thang
and keep swinging left hooks to oppression
if i stay up stay into it stay involved

just one form of praxis will do.
it's just my guilt that thinks i need twenty-two
what's enuf?

shouldn't i (or somebody) be our secular bodhisattva
become a real power player but skip the talk show
can't we stabilize, rekindle collectives
and cooperatives and collaborations
therapeutic communities that double
as creative juggernauts
a publishing house a theatre where the plays
cost less than the movies
get the neighborhood coven back together
take dance breaks in the cubicles
sing until the flourescent lights burst into snow
i ask you because you changed me zake
you changed thousands of women
and i know poetry can't be enuf if you drunk

i ain't tryin ta walk off wid alla yr stuff
and i got nuttin but love for ya
so that's why i gotta know
i'm sittin on my bed encircled by every book
you've ever published
they're open like fans
marking pages with the flint of genius
all i want is for this circle to grow
so tell me:

is this where poetry and life are twins?
i felt so crumpled up when i started writing you
poetry seemed so useless and dingy
next to all the bright red bad news
but now that the poem is over i feel wide open

like an infant of the spring
just tell me how
to feed this light
to my responsibilities
and poetry just might be enuf
 love
 eisa

❖ ❖ ❖

 querida antigua eisa,
you almost got it-you really did
'born of the blood of struggle' we all were/ even if we don't
know it/ what if poetry isn't enuf?
whatchu gonna do then?
paint ?
dance ?
put your back field in motion & wait for james brown to fall on his knees
like it's too much for him/ what?
too much for james?
yeah/ didn't you ever see the sweat from his brow/ a libation of passion
make a semi-circle fronta his body/ a half-moon of exertion
washin' away any hope he had of/ standin' it/ can't stand it
& he falls to his knees and three jamesian niggahs in a stroll
so sharp it hurts bring him a cape that shines likes the northern
star/shinin' i say like you imagined the grease in the parts of yr hair/
or yr legs/ or yr mother's face after rehearsal/ after she had you/
james falls to his knees cuz he "cain't take it"/ he's pleadin'
please/ please/ please/ don't go
we look to see who brought james brown to the floor/
so weak/ we think/ so overwrought/ with the power of love
that's why poetry is enuf/ eisa/ it brings us to our knees

& when we look up from our puddles of sweat/
the world's still right there & the children still have bruises

tiny white satin caskets & their mothers weep like mary shda
there is nothing more sacred than a glimpse of power of the universe
it brought james brown to his knees lil anthony too/ even jackie wilson
arrogant pretty muthafuckah he was/ dropped/ no knee pads in the face
of the might we have to contend with/ & sometimes yng blk boys bleed
to death face down on asphalt cuz fallin' to they knees was not cool/
was not the way to go/ it ain't/ fallin' to our knees is a public admission
a great big ol' scarlet letter that we cain't/ don't wanna escape any
feelin'/ any sensation of bein' alive can come right down on us/ & yes
my tears & sweat may decorate the ground like a veve in haiti or a sand
drawing in melbourne/ but in the swooning/ in the delirium/ of a felt life
lies a poem to be proud of/ does it matter?

can ya stand up, 'chile'?

the point is not to fall down & get up dustin' our bottoms/
i always hated it when folks said that to me/ the point
eisa/ is to fall on your knees & let the joy of survivin'
bring you to yr feet/ yr bottom's not dirty/ didn't even graze the earth/
no it's the stuff of livin' fully that makes the spirit of the poem
let you show yr face again & again & again

i usedta hide myself in jewelry or huge dark glasses
big hats long pillowin' skirts/ anythin' to protect me/ from the gazes
somebody'd see i'd lived a lil bit/ felt somethin' too terrible for casual
 conversation
& all this was obvious from lookin' in my eyes/ that's why i usedta read
 poem after
poem with my eyes shut/ quite a feat/ cept the memory'd take over &
 leave
my tequila bodyguard in a corner somewhere out the way of the pain
in my eyes that simply came through my body/ they say
my hands sculpt the air with words/ my face becomes the visage of a
character's voice/ i don't know
i left my craft to chance & fear someone wd see i care too much

take me for a chump
laugh & go home

this is not what happened?

is poetry enuf to man a picket line/ to answer to phones at the
rape crisis center/ to shield women entering abortion clinics from
 demons with

crosses & illiterate signs defiling the horizon at dawn/ to keep our
 children
from believin' that they can buy hope with a pair of sneakers or another
 nasty
filter for cheap glass pipe/ no/ no/ a million times no

but
poetry can bring those bleeding women & children outta time
up close enuf for us to see feel ourselves there/ then the separations
what makes me/ me & you/ you/// drops away & the truth that we
 constantly
avoid/ shut our eyes to/ hold our breath hopin' we won't be found out/
surfaces/ darlin'/ & we are all everyone of those dark & hurtin' places/
those dry bloodied memories are no less ours than the mornin'/ yes
the mournin' we may be honorable enuf to endure with our eyes open
the coroner cannot simply bring her hand gently down our eyelids/
 leavin'
us to the silence of not life/ the solitude of the unreachable

can ya stand up, 'chile'?
hands stretched out to touch again
not so you can get up & conquer the world/
you did that when you cdnt raise yr head & yr body trembled so/
you scared yr mama that was when the poem took over & you gave you
 back
what you discovered you didn't haveta give up/

all that fullness of breath/ houdini in an emotional maze/ free at last
but nobody can see how you did it/ 'how'd she get out'/
nobody'll know less you tell em/

do you really wanna write/
from twenty thousand leagues under a stranger's wailin?
can you move gracefully randomly thru the landmines that
are yr own angola/ hey, your bosnia!
are you shamed sometimes there's no feelin' you
can recognize in yr left leg? does the bleeding you'll do anyway
offend you or can you make a sacred drawing like ana mendieta that will
heal us all? do i believe in magic?

hell yeah.
shd you?
i don't know.
don't know how yr gonna find yr way out the maze/ ancient as it is
no one can tell you the secret/ not me/ not aunt angela/ not yr mama
beautiful as she is/ i usedta watch her legs cut thru space like a ninja in
 ballet
shoes/ i wanted to be tall & clear-eyed like yr mama/ & you come tellin'
 me
i cd beat you up in a school yard/ no
my daddy wda bought the school yard & paid kids not to hurt me/
so what you see is not what you get
i am not a poem/ i am savannah's mother/ savannah sat with her bottle
 thru
the children's class at stanze's once we moved to texas/ but i was always
lookin' for your mother's legs to come slicing the air/ ten years later/
 2000 miles
away/ ed mock dead/ tower of power fallen/ sly stone disappeared/
 oakland
like the back of my hand/ now unknown/ "get it & feel good" i usedta
 say
sometimes still do/ diffrence is i cherish stupid lil things now/ did yr

198

mama

tell you raymond asked our whole class after a bout with possessed
drummers and

gravity/ if we ever took our dance clothes off/ he could smell us comin'
cross the

Bay Bridge/ he shouted & pranced like somekinda stallion/ like his sweat
didn't

stink too/ workin' in the other realm is dirty work/ makes us smell bad/
did yr

mama tell ya? i know she didn't let ya believe makin' art was not a messy
business/

she cdn't have/ we were trained too well

is poetry enuf, eisa ?

that's gonna be up to you ?

is poetry enuf for me?

why do you think i wrote 'for colored girls'

i wanted yall to come out from under yr starched pinafores & pressed
heads

with some notion of dream & sanctity of spirit/

looks like some of it worked

but remember i'm still writin' still dancin'

fell on my knees so many times now/ i wrote rev. ike for a prayer cloth

it's serious like that

peaceful like that

i sweat when i write/ do you?

> the original aboriginal dancin' girl
> love,
> ntozake

How Did You Manage a Writing Career While Raising Kids?

Jennifer Baumgardner and Judy Blume

Dear Judy Blume,

Ever since I was a five-year-old lugging my baby sister around in a laundry basket, hollering, "Make way for the queen!" I knew that someday I would be a mother. Children were so precious. I loved to smell their skin and feel the weight of their warm little bodies slumping against my puny chest as I rocked them to sleep. A committed baby-sitter from the age of eight, by the time I hit high school I took care of the two kids down the block so regularly that it was me—not their parents—who took them to the movies, dentist, and day care. I was the one who brushed their hair and grocery-shopped for them.

Now I'm twenty-six. I look around my studio apartment that I've struggled to attain. It's overflowing with the gadgets that prove I exist: phone, Filofax, and laptop with modem. In between meetings and late meals, amid the lists of people I have to call and notes to myself to remember to brush my own hair and grocery shop, I sometimes wonder where a child would fit into this schedule, into this apartment, into my aspirations. Or, rather, because I know that a baby simply takes, and there would be no tucking the child into the margins, what I now call "life," and "work" would become marginal. I have to ask myself, what am I willing to give up?

I want to believe that I can create both a family and express myself,

and so I find myself with a million questions. How did you do it, Judy? When I interviewed you for *Ms.,* you told me that in order to write, to create, you had to protect yourself from critical voices. What about children's relentless little voices telling you the same story over and over and the prospect of never having privacy, not even in the bathroom? Was someone there (like your partner) to help with the children when you were writing? Perhaps having a child forces you to become very focused and, hopefully, creative when you do have an hour or so to write. But then again, I can think of a couple of great writers I admire who dropped out of sight after having children. Sigh.

My questions encompass the age-old motherhood problem: fear of screwing up the kids versus the fear of losing oneself. It's fitting, of course, that you're the foremother I'm addressing. I've had a relationship with you (one-sided) since I was eight and read *Tales of A Fourth Grade Nothing,* laughing like a lunatic, sunk in my lime green bean bag. I then read *Are You There God? It's Me, Margaret* like it was the Talmud before blowing my mind with *Forever . . .* and *Wifey.* In a way, you were a surrogate parent to my generation.

And a liberal parent, at that. My mother recently reminded me of a car trip we took when I was about nine years old. I was in the back seat, totally absorbed in *Forever . . .*, your novel about a teenage girl and her first lover. After I piped up with "What does 'I'm coming, I'm coming,' mean?" Mom admitted she felt taken aback that I was learning about orgasms (at least at that age) from you. Did you ever face hostility from parents who felt you were encroaching on their territory? Conversely, did your children ever feel exposed having a mother who wrote so intimately about puberty, sex, and involuntary erections? Where do writing about it and living with it meet?

On the topic of rhetoric versus reality, I've been wondering lately whether feminist parents really feel differently than "conservative" parents about their kids being gay, or having an abortion, or even having sex. My parents talked to us about sex and birth control freely, yet it was also clear that they thought high school was too young to be doing it. So . . . we didn't tell them. My mother tells me it's not easy hearing that your own

kids are having sex, nor, I suppose, is it easy to have a queer child. Since I came out about being, for lack of a better word, bisexual, my parents have struggled to understand my life even as they support it. And they have felt guilty about their ambivalence because, intellectually and philosophically, they aren't homophobic.

I know that I'll make mistakes with my children. I know that no matter how hard I try to protect them from disappointment and pain, there will come a day when my child will feel betrayed by me. Still, even if the emotions of parenting aren't any easier, I'm thankful to second-wave feminists like you who have lessened the pressure to procreate and who have made feminism and motherhood mutually inclusive. But even a respectful appraisal of motherhood doesn't alter the daunting reality that having a child means ceding one's life to another, at least for a while.

Take my mom, for example. She was a feminist. I grew up with *Ms.* in the house and a "Sugar and Spice, Will it Suffice?" sticker questioning me and my two sisters from the bumper of her Oldsmobile. At age forty-five she went back to school unapologetically for her master's and made it clear that she was doing something just for her, not us. Despite her attention to herself, she still felt drained. Her book group would read *The Women's Room,* and she'd come home mad as hell, inspired to change the household politics again. When I was about fourteen, she informed us that there was no God-given reason that she was supposed to be cooking dinner for us every night, she didn't particularly like cooking, and so she was retiring. (We adjusted, of course. Dad began making chili and homemade cheesecakes to unwind after a day at the office, and one of my two sisters even became a chef.) Like nearly everything during my zits and Guess jeans age, her protests merely added to my constant state of horror and embarrassment. I now realize, proudly, that she was successfully negotiating motherhood and personhood—and I anticipate parenting with the full knowledge that my child will be superhumiliated by me.

And what about women who aren't just juggling the kids' needs and selfhood but are fighting for an abstract ideal like freedom? For instance, I went to a Courage in Journalism Awards luncheon a few months ago. The honorees were all journalists from war-torn countries, women whose

attempts to tell the truth required bravery and sacrifice. They were also, all of them, mothers. One woman from Zambia, Lucy Sichone, was forced into hiding after she covered a controversial story about the government. Running for her life with a baby strapped to her chest, her three older kids hidden with relatives, she still filed stories. When she received her award, she dedicated it to her children because "They had no say in their mother's decision to become a journalist," and they might even lose her because of her calling. I left the luncheon inspired by her utter bravery but also appalled by how selfish she seemed. She had children and didn't put them, or their right to have a mother, ahead of her ideals.

Of course having the opportunity, as well as the character, to be heroic on the scale of Lucy Sichone is rare. It's the more domesticated details of procreating, the little things that still manage to take up your whole day, that are the most worrisome for me. I remember being a child and how crucial it was to me to feel like I came first to my mother. She remembers not having a moment's peace for ten years, not even in the bathroom, because one of us three girls was demanding her attention. (I recall, with a chill, a day when Mom came home to find my sister and me slack-jawed in front of the TV, the kitchen in ruins from a "snack" we had made after school. She surveyed the mess and us and said in a flat voice, "It's the little things that will make me leave, you know.") How did you cope with being imprisoned in your home with a couple of pint-sized overlords claiming food, comfort, and cleaning?

It's been nearly five years since I left college. The night life is just beginning to lose its luster, and I feel like I'm in some new kind of puberty: fascinated and frightened by motherhood the way I once was about, you know, sex. Are you there, Judy? It's me, Jennifer. Bring on the wisdom.

Sincerely,
Jennifer Baumgardner

◆ ◆ ◆

Dear Jennifer,
Yes, I'm here, Jennifer! And how I wish I had that wisdom to bring to you. But all I have is my own limited experience. There aren't any easy

answers. You already know that. And there certainly aren't any right answers. I change my mind regularly about how I'd do it if I had it to do over again.

But to have children or not to have children has never been an issue for me. Like you, I always dreamed of being a mother. And I've never regretted having kids. Even at our most painful moments, and there have been many, no voice has gone off in my head saying, "Don't you wish you'd never had them?" Or, "How easy your life would be without them."

Instead, I ask myself, when is the right time to have kids? Young, the way I did it, before I knew anything, before I knew myself? Or later, the way so many of your generation are doing it? I weigh the pros and cons, but still I reach no conclusions. While I think it's probably better for kids to have more emotionally mature parents, I see a younger generation who put off having children, struggling with fertility problems. We worried about unwanted pregnancies, you worry about not getting pregnant when and if you decide to have kids.

I was programmed to marry early, have babies, and become, maybe, the president of the PTA. Dutiful daughter that I was, I married the summer between my junior and senior years of college, the first of my friends to walk down the aisle. But just five weeks before the wedding my beloved father died suddenly and from that moment on my life would never be the same.

I had no one to talk to about my loss. My mother was in denial. My new husband wasn't one for showing emotion or dealing with feelings. I felt isolated. So I did what I knew how to do best, what I thought my father would want me to do. I pretended to be happy. I finished school. I became pregnant. I played house. I had a second child. I was twenty-five years old. I chased away my inner voice and suffered a series of exotic illnesses. Fevers, rashes, infections. Depression? The word wasn't a part of my vocabulary or my family's or any of the doctors treating me. I felt old, much older than I feel now as I approach my sixtieth birthday. Then I began to write and writing changed my life.

The women's movement came late to suburban New Jersey. I had no consciousness-raising group. No friends who were supportive of my at-

tempts at writing. I felt resentment from the other young women on the street where I lived. Maybe even fear. It was a question of, "Why can't you be like us? Why don't you stop trying to be different and just concentrate on fitting in?" They didn't want anyone rocking their boats. And neither did their husbands.

I never felt imprisoned by my children. I felt imprisoned by my marriage, a marriage born in another era that never moved forward. Marriage itself isn't imprisoning. It can be liberating with the right partner (and I've been with the right partner for the past eighteen years). You ask if my then husband helped with the kids, and I laugh, reading your question. He wanted a traditional wife. He felt deceived, I think, that the girl he married turned into some rebellious woman he didn't know, didn't want to know. He didn't give a damn about my needs.

Ultimately, it was my growing awareness of the women's movement that helped give me the courage I needed to make changes in my life. How I longed to be a part of it, to carry a banner. I understand your mother, Jennifer, and how, after reading *The Women's Room,* she came home mad as hell! For me it was Erica Jong's *Fear of Flying.* I wanted to fly, too, to take off and try my wings and taste life. All the rules had suddenly changed, and I wanted to play by the new ones. Your mother was brave enough to try to change the rules within her marriage. She wasn't afraid to speak out. Maybe that's why your parents are still together.

Writing saved my life, physically and emotionally, but it couldn't save my marriage. When I decided to leave after sixteen years, in 1975, my children (who were then twelve and fourteen) came with me. They were the most important part of my life, and we were never apart.

That age-old problem you wrote about—motherhood versus losing oneself—well, yes, having a baby may stop you for a while. So what? Give yourself permission to enjoy your baby. Having a family takes time. Hell, having a relationship takes time! Don't beat up on yourself. If you decide to have a child, be realistic. You can't always have it all. Not at the same time, anyway. All that bullshit we were once fed about being superwomen drove some women mad. It made them feel guilty about doing less, wanting less.

Some women will be able to have kids and never miss more than a couple of weeks at work, if that. Others will find it impossible. Listen to your inner voice. Don't chase it away because it frightens you or because it's not PC. Don't let anyone else make the decisions about what's right for you.

Look, some women will have no choice, ever. They'll have to work to support their children whether they want to or not. That's reality. All I'm saying is there's no way to know ahead of time what's going to happen. You can analyze ad nauseum but you still can't plan life because life is a series of surprises.

But just because you're not actively writing doesn't mean you're not thinking. I often get my best ideas and thoughts away from the computer. I keep a notebook and jot down notes at those times. Through my worst years, my least stable years (following my divorce) I was still able to write. I can't explain how, but *Starring Sally J. Freedman As Herself, Wifey, Superfudge,* and the idea for *Tiger Eyes* came out of those four years. My angst was good for my work. I sometimes joke that finding happiness in my personal life has screwed up my career.

I used to fantasize about how free I'd be to write when my kids were grown. Instead, I find the opposite to be true. I was actually far more prolific in the early days of my career when my kids were in school. Now, after twenty-two books, I don't feel the same urgency as when I was younger and sure that my life would be cut short like my father's. I have to remind myself that that's okay.

Having a family isn't going to keep you from writing. You wouldn't write unless you had to, and by having to I don't mean to pay the bills. There has to be an easier way to pay the bills. You write because it's there, inside you, and it has to come out one way or another. Better for you and your children if it happens in a positive way.

You want to know the nuts and bolts of writing with little kids around? Okay. I would say it comes down to four things. Structure. Discipline. Determination. No Excuses. (All writers are great at coming up with excuses.) *You* have to make it happen. You have to figure out a way to grab those two-hour blocks every day. (I rented office space in order to start

Wifey and, a few years later, a motel room which became my writing studio while I was trying to finish *Tiger Eyes*.)

It's not going to be easy. Talk to any parent who works at home. Because I didn't start to write until my kids were in preschool, I didn't have to worry about child care when they were very young. You will. For me, it meant focusing on my writing every morning while they were out of the house. A couple of years later they were at school all day. I wrote in the mornings. Did everything else in the afternoons. I still do my best creative work in the mornings.

I once asked my son if it bothered him that I was the only working mother on our street, and he looked at me as if I were crazy. "You were always home," he said. "I never thought about you working." That's the truth. For better or worse, I don't think they thought about my work. If I were doing it today I'd make my work more important in our lives. Whether it was guilt or not, I never made a big thing out of it. They never saw the struggle. I don't think that was wise. They still have the mistaken idea that it all came easily for me.

Don't deny yourself the joys of parenthood, Jennifer, not if you really want a child. You won't lose yourself by becoming a mother. Kids have a way of helping you put everything else in perspective. Easy? No. It's the toughest job there is. Rewarding? Oh, yes! But also demanding, frustrating, sometimes painful, even humiliating. Sounds a lot like writing, doesn't it?

In friendship,
Judy Blume

How Are You Preparing Your Daughter to Face Racism?

Patricia Wakida and Yeong hae Jung

Dear Yeong hae,

I was twelve years old the first time my mother told me this story: It was 1945, just after the end of World War II. One night, my mother was walking home from school alone when a gang of white men attacked her, each taking turns pounding on and humiliating her. Eventually the police found her, shivering with fear, covered with blood, bruises, and mud. My mother had just spent three years fenced in by barbed wire at a Japanese-American internment camp in Jerome, Arkansas. You would have thought that she had learned how to fight after living with sentry guards pointing their guns towards the barracks where she lived. She had endured racial slurs like, "Tojo, go home! Jap, go back!" shouted by mean-hearted schoolmates, who pinched her small breasts. Perhaps she had seen cartoons in the newspapers depicting the Japanese: rats with squinty, buck-toothed faces or a pack of slit-eyed lice squashed beneath an American GI's boot. With each experience, she must have learned by sheer instinct to hesitate before acting, to live with the fear daily. In the eyes of postwar white America, she was the enemy, the Yellow Peril to be exterminated, even though she was only a six-year-old Japanese-American girl.

It has taken me fourteen years to even begin to understand exactly why my mother told me this story. Subconsciously, her words taught me to fear and distrust a world that might hate me because of my skin and gender.

My mother is a sansei, a third-generation Japanese-American. Like many children of immigrants, she was determined to cast off both the economic and social burden of being an "outsider" and a young woman in an atmosphere that respected neither. She pursued a career in medical school until pressed into marriage. My grandmother had worked as a piece seamstress in a sweatshop for wages as low as a dollar a day and had little belief in higher education for girls. The trauma caused by racism was nearly impossible for either of them to discuss. My mother bore no visible scars, there were no numbered tattoos on her arms. But she had swallowed years of rage, shame, and a sense of helplessness, all at the price of her own sense of worth. When I look at photographs of that time, my mother's face swims up from the sepia prints asking, "Who am I? How did I get to this place?"

Growing up in California, I experienced my own string of racial incidents that only seemed to confirm my mother's fears. My earliest memory of hate is from elementary school. My younger brother and I are walking to the bus stop, lunch pails in hand, backpacks slack on our shoulders. We squabble over a Chinese yo-yo, each of us obsessed with possessing the toy. But as we round the corner, we catch sight of a rowdy pack of kids. As soon as the children spy us, my brother and I clasp hands and slow our pace, our bodies tense as we approach them. There is rough laughter, then the shock of the first rock hitting my lunch pail with a hollow metal clang. "Ah so! Ah so! Asshole! Asshole!" they chant, pulling at the corners of their eyes. The bolder kids kowtow, screaming with joy at their mockery. "Chingchongchingchong chop chop!" I burn with fear but try to ignore what is happening. I pray for the bus to come and save us. Being a Japanese-American was a curse, I thought, with no escape.

Even in the classroom, where I was the sole Asian among classmates of European stock, I struggled to interpret our textbooks' illustrations of "heroes" and "winners." I spent eighteen years in California public schools reading the stories of a European America, of the multitudes of Italian, Irish, and German immigrants coming ashore led by the beacon of Lady Liberty's torch. One day I came across a page about "the Good War" and a photo of General MacArthur signing the armistice treaty with

the Japanese, clearly defeated, shame across their faces. I was supposed to recognize them as the "enemy," but they looked just like me. I was further disheartened to see photos of Americans' glee as they celebrated the ending of the war, which came with the atomic bomb being dropped on Hiroshima—the very city my ancestors were from. Yet no teacher, no textbook ever mentioned the sweat of the brown, black, and yellow hands that helped build the United States or the history of racism that coexisted with each "victors" tale. No one ever mentioned my mother's story.

As I grew up, I saw signs of the kind of hate that smeared dirt on my mother's face when she was a child. I witnessed a KKK rally in the middle of downtown Fresno and drove past, gripping the wheel, terrified. Another time, as I sat on a bus, I was spat on, full in the face, practically smelling my aggressor's hate. Through the media's stereotypes of Asians, I learned that Asians are scheming and incomprehensible, distrustful and backwards. Even worse were Hollywood's celluloid images of Asian women: tottering Geishas from movies like *Sayonara* and *Teahouse of the August Moon* or the come-hither hips and eyes of Southeast Asian prostitutes in Vietnam. Perhaps all this drove me to become a writer and explains why the issues of immigrant Americans concern me and the threat of racism continues to haunt me. I am trying to break a cycle of oppression and historical amnesia that has lasted four generations in my family. I am searching for the roots of my fear. I know that my family was concerned that by questioning history, I would be "rocking the boat" and starting an avalanche of questions which would never end.

I never dreamed that one day these stories would lead me to you. We met on a pilgrimage to the sand-blown shells of a Japanese-American Internment camp in Tule Lake, Oregon. We were both in search of truth in the desert for a history most people want to forget. I was working as a volunteer distributing documents and name tags. You were in the seat behind me, and I was intrigued to find you speaking in fluent Japanese to your three-year-old daughter. You introduced yourself as a third-generation Korean born in Tokyo. I wanted to know more about your history and asked why you were retracing this chapter of the war. I learned that you were a single mother and a professor of sociology at Shudo University in Hi-

roshima on a one-year fellowship at the women's studies program of the University of California, Berkeley. You were traveling everywhere possible with your daughter, Remy, to get a feel for the American social landscape.

On that long bus ride from Berkeley to Tule Lake, we sparked a dialogue about the parallels between Japanese-Americans and Korean-Japanese women that continues to this day. Our conversations are deeply precious to me. They move like the stream of our own lives, layered and chaotic, veering off into other memories and ideas. You were an immediate friend, Yeong hae, a rich and provocative well of stories and wisdom. You knew so much about the Japanese culture, people, and history that I had so long tried to avoid. Secretly, I longed to go to Hiroshima. At the time my thoughts had started to move backwards in time, across the Pacific following my great-grandparents' path of immigration to the United States. Maybe I was trying to undo my knotted sense of personal history. Something inside me was urging me to learn about my past. When I told you about this, you were curious, wholly supportive, and absolutely serious. "Come talk to me in Hiroshima," you said, and eventually I did. Strange, isn't it, how a history we had no part in making eventually linked us together?

I came to Japan in 1995, the fiftieth anniversary of the end of the war. I landed in Tokyo and was enveloped by Japanese faces and words. It was exhilarating, exhausting, like a chase in a hall of mirrors. I wasn't prepared to find a culture of people that would shock and disappoint as much as it delighted and inspired me. After I met you again, you must have recognized my state of blissful confusion, and you later told me that you had made the same journey to Korea when you were my age. And so I want to ask you, Yeong hae, why do the descendants of immigrants like you and me search for our roots? What are we hoping to find?

From the moment I came to Japan, I have devoted myself to the study of the Japanese diaspora and my family's decision to immigrate. One of the most frustrating aspects of being in Japan has been learning to speak Japanese. Because I couldn't speak her language, I have an enormous sense of loss about my great-grandmother, who was born in Hiroshima. She died in the United States at the age of 103, and I had understood

none of her feelings, desires, disappointments, and sense of humor. Maybe this is just what happens when the mother tongue of an immigrant is lost several generations down. I often felt despair because of my inability to express myself in Japanese or my often slowness or mental blocks that occurred while trying to master the language. Sometimes it even turned to anger at my parents for being so ashamed of their heritage. Why didn't they teach me Japanese? Should I teach my own children Japanese when the time comes?

At many points, I have felt like an immigrant in Japan. I learned that, above all, being an immigrant is lonely. The crippling struggle with language and the infantlike status you attain is a humiliating blow to one's pride. But you have kept me on track, encouraging me in the right directions, even offering criticism when it was needed. You taught me how important it is to find a community of people to trust and from whom to learn their strengths. And through the museums, festivals, people, books, and films you've introduced me to, I have widened my circle of knowledge. I can never forget the day I discovered that Koreans whose relatives were killed by the atomic bomb on August 6 were forbidden to memorialize their dead within the perimeters of Hiroshima's Peace Park. Slowly, a hidden dimension to World War II and ultimately my interpretation of truth emerged. I didn't know about Japan's aggression toward other Asian countries or how it had invaded and colonized Korea, using the Koreans as expendable slave labor both before and during the war. I had never been told that the Japanese had denied the descendants of the Koreans in Japan citizenship and the rights of ownership, how they forced your ancestors to take Japanese names, and forbade the use of the Korean language. Discovering this I began to wonder, is it better to hide history from your children to protect them from how horrible human beings can be or to tell the truth, no matter how terrible?

Your daughter, Remy, is now five years old. She will likely encounter the same prejudices of being Korean in Japan that your grandmother, mother, and you endured. What will happen when she confronts you with the questions, "Who am I? What is my history, my language, my home?" Being Korean in Japan is tricky, I think. If one chooses, one could silently

take the outward identity of a Japanese (unlike me, since I could never "pass" as European-American). What will you do if Remy hides behind her thick black hair and slender Asian eyes that allow her to deny her Korean heritage? How will you respond when she is hurt by others who tell her that she isn't a "real" Japanese? Will you emphasize the differences or the common ground? How are you preparing your daughter to cope with the barriers thrown up against her as a Korean woman in a country with a devastating history of racism?

My mother taught me fear as my only defense against racism. I had no other tools with which to protect myself. I write this letter imagining future conversations with my own children, helping them to make the right choices and figure out how to carve out a life of their own. I want to affect the future through my children in a positive way. How do I protect, educate, and strengthen them at the same time?

With great love and respect,
Patty

❖ ❖ ❖

Dear Patty,

Unlike your mother, mine loves to tell me how she fought racism in her daily life as if she were a military hero. She was born in Osaka, Japan, in 1938, a "subject in need of control" during the Japanese colonization of Korea. Although it was possible for her to "pass" in Japan as an invisible minority because of her father's affluence, she lived proudly, openly expressing her Korean ethnicity. Even before I entered elementary school, my mother often explained to me that since I had no brothers or sisters, in order to live as a Korean woman in Japan, whatever difficulties I had were to be overcome by my own will and power. "If you have no disadvantages, the Japanese will not look down upon you. Do your best to make an effort," she insisted.

Her words showed her feeling that discrimination against Koreans was due to a lack of effort on their part and that she put the burden of racism on Koreans, not the Japanese. It was not acceptable for me to lose or to cry, for example, and I soon learned to only accept myself if I were a win-

ner. But she never taught me about discrimination in the context of social structure or history.

She herself was robbed of so many resources, including an education, which kept her from making her own interpretations, justifications, or decisions about her life. A long time ago, when I was just a small child, my mother once showed me the place where she tried to attempt suicide because she had suffered at the hands of her family. My grandfather, who loved Korea greatly and was a strongly political person, was a farmer who had lost his land during colonization. He came to Japan in search of a profession and eventually became economically successful there. While he was a calm and virtuous man, he kept a mistress and believed that it was a waste to spend money on daughters who were to be married off anyway. Not only did he refuse to pay money for his daughter's school excursions, he also wouldn't pay for her school entrance fees. My grandmother, who was stronger than any man, fought against her husband constantly, and my mother grew up in a house that was a hell.

Grandmother treated her only son like a king and her daughters like servants. She proudly told her daughters that they all were able to live in the house because there was a son. Even though my mother was the oldest daughter, her existence was always ignored, and I think she rejected her mother's love as insufficient. To make matters worse, my mother was often the victim of ethnic discrimination and did not have her family's love or protection. My mother has shown me that it takes extraordinary strength to live.

I am trying to pass this strength on to Remy, but I am also making sure to give her love.

I have made the choice to be a single, unmarried mother. Most members of the Korean-Japanese community, having lived through the Japanese invasion of Korea and being forced to learn both the Japanese language and culture during World War II, tend to adhere to a Confucianist observance of traditional customs and beliefs. However, I believe that rather than running to the safety of a particular community, I must make the choices that allow Remy and me to live freely, even if that is at the cost of judgment by a discriminatory society, family, ethnic group, or any nation.

Originally, I was afraid that Remy would have trouble attaining citizenship, so I went to Canada to give birth. (In 1952, there was a conservative law forbidding Koreans born in Japan to acquire Japanese citizenship.) In the end, she was lucky. Because her father has Japanese citizenship, she now holds citizenship in three countries—Canada, Japan, and Korea. In order to possess a free concept of national identity, isn't it best to have three or more choices? I believe that multiple alternatives are essential to avoid indoctrination by a dominant viewpoint and to avoid falling into the trap of internalized racism. Rather than making such decisions about her citizenship, I will do my best to prepare her to make her own decisions in time.

In Japan, people often say, "If you live depending on a big tree for shelter, you will live peacefully," meaning that trusting in predictable things (government, social norms) for protection gives peace of mind. However, I cannot tell if this will be true of Remy's future. I don't know where she will end up choosing to live. Perhaps no matter where she goes she will be a minority. So instead I have tried to give her opportunities to meet people who have a variety of viewpoints and lifestyles so that she will have enough stimulus to lead her own creative, vivid, and exciting life. I can only hope that regardless of the discrimination she may face, Remy will have the vitality to live an independent life free of lies or ready-made ideas of satisfaction or happiness.

So Remy accompanies me wherever I go. I am a university professor, I enjoy long holidays and am fortunate enough to have many opportunities to research and travel. These trips are not for sightseeing. Remy and I try to meet, know, and listen to people and experience their viewpoints firsthand, so we often board in home stays. This summer, on Remy's fourth visit to Korea, we stayed in a university dormitory for one month. It seems that at the age of five, Remy has acquired the identity of a traveling entertainer. Every day she played with the mountain and field grasshoppers or dragonflies and chased the neighborhood children. She was deeply cherished by both the university students and the local restaurant's elderly aunties, who fed her sweet cakes and treats of dried seaweed. It was a simple existence. Because the village was unsanitary and void of any conveniences, it was a true countryside experience. Although she may not

have understood the trip's significance then, I wanted to show her the remaining signs of the Japanese occupation in Korea, and its effects on her people. In the future, when she faces insults for being a non-Japanese living in Japan, the memories of Korean nature and people's warm embrace will become valuable to her.

So in answer to your question, yes, I do believe it's important to tell our daughters and sons the truth about racism, about nationality and identities. I can only hope that Remy will have the vitality and curiosity to absorb all that comes her way and have the strength to accept all parts of her identity and herself wholly.

Perhaps it takes many generations of Korean women to overcome the raging waves of one's life. I feel extremely fortunate and grateful to have inherited the strong will, diligence, optimism, and vitality of the women from Saishu Island, a volcanic island surrounded by cliffs at the southernmost point of Korea from which I trace my "roots." The land is naturally rugged and hard, making it unsuitable for agriculture, so many women worked as pearl divers. It is said that the men on Saishu were responsible for raising the children, and that it was not uncommon for the pearl-diving women to take lovers.

My grandmother was born on this island. She was extremely vivacious and well known for saying outspokenly, "If you make your man work, you have no value as a woman." Although she always dreamed that one day she, too, would dive in the sea, her father stood in the way, refusing to give her an allowance simply because she was a woman. So at the age of thirteen, she ran away from home and fled to Japan by sneaking onto a liner bound for Osaka. Once aboard, she lost herself amid the crowds and hid in the storage room, so as to avoid paying. "I was so beautiful that to board I didn't have to buy a ticket," she would boast, laughing loudly. Even today, although she is nearly eighty years old, she manages to surprise me with her courage and spirit of activism.

Whenever I am exposed to discrimination and bias or face hard times, rather than feeling discouraged about myself I remember my history and feel the power of life springing out all over my body. Undoubtedly, Remy will also have such days in the future. In order to tear down many of the

obstacles that surround her and to not then become someone who discriminates against others, Remy must have true friends and resist depending on existing institutions.

Despite countless miles of distance and over a fifty-year-span of history, through our mutual searching for a better future, you and I met at Tule Lake. As a Japanese-American woman and a Korean-Japanese woman, you and I have both lost "native lands," but I expect we will overcome the failures of nationalism, imperialism, and racism to cooperate in finding a solution towards a better future. You and I share the same goal of creating a society where human beings have mutual respect for one another, despite our difference in our points of departure, our methods, and roads. Ironically, discrimination is what brought us together, so let's deconstruct that authoritarian structure, transform culture, and re-create it. Patty, you have done wonderful work as a writer. Let's knit our work, which echoes each other, into one.

Love,

Yeong hae

[Yeong hae Jung's letter was translated from the Japanese.]

What Do You Love About
Being a Lesbian Mom?

Catherine Gund Saalfield and Dr. April Martin

Dear April,

I remember the first time I met you. I had seen pictures since by no small measure you're a lesbian and gay community hero. My lover Melanie and I were negotiating with the sperm donor for our first child, and we all turned to you for guidance. We felt relief because of your very existence. Our need for role models, mentors, foremothers (and fathers) was thick. And so was our faith in you. Here was a lesbian who had two teenage children of her own, wrote the book about lesbian and gay parenting, and was a practicing therapist. When Melanie, our donor, and I walked into your office, we knew we had hit the jackpot.

As needed, you supported the three of us through several weeks of emotional work about parenting, our own parents, our childhoods and siblings, our experiences of the queer community, our individual relationships, and our expectations of each other and ourselves as we took on the making of family. With your help and resourcefulness, we didn't have to go that road alone. As well, you wrote the book you wish you'd had when you were considering parenthood and called it, appropriately, *The Lesbian and Gay Parenting Handbook*. I now have the book I need, the book you wrote. So this is mostly a thank you letter.

You've written that in the late '70s, when you and your partner were planning your family, you didn't know of any lesbians who'd had children

together, and you certainly didn't know a doctor who would do an insemination for lesbians. Today, many of my lesbian friends have kids ranging from newborn to ten years old (but certainly more of the toddler variety than school-aged!). When I came out I didn't assume being a lesbian and being a mother were mutually exclusive. I never thought I couldn't or wouldn't have children. And so my lover, Melanie, and I have. Our baby girl Sadie Rain will turn three years old on November 1, 1999.

A few years ago, with four other couples, we had some informal dinners and ongoing conversations about choosing to have children. We talked about adoption, foster care, and pregnancy. Also about how to get pregnant, anonymous or known donors, known donors as daddies or uncles. We discussed using midwives or doctors, our parents' presumed reactions, which one of each couple would carry, how many kids we wanted, whose biological clock was ticking loudest, whose relationships were solid enough for this calling, and so on. From that group, we now have two girls and at least five more babies twinkling in their mothers' eyes. In our little circle, as in the wider United States society, there is a veritable lesbian baby boom underway.

The week our daughter was born, *Newsweek* hit the stands with a cover photo of Melissa Etheridge and her pregnant partner, Julie Cypher, and a screaming headline, "We're having a baby. . . . " When people query our friends and relatives about our family structure, Etheridge and Cypher regularly provide a simple, well-known and accessible reference. People know their story. I appreciate that couple for being like you: comfortable, honest and happy with who they are and open about their lives.

When we were planning for our first child, I used your book as instructed, as a handbook. I skimmed the chapters and resources I needed at any given moment: contracts with known donors, relatives as biological fathers, legal issues like second-parent adoption, wills, and so forth. I didn't dare peruse the pages on infertility, choosing not to have children, crisis, and tragedy. (This reminds me of our childbirth classes when many couples skipped the night we covered cesarean births and other complications in the hopes that scary things would never happen to them.)

As I prepared to write this letter, I really read your book, the hand-

book, without skipping over any sections, not even the ones I'd referenced before. You've woven together the stories of many different families. When I'd call out a quote to Melanie, I'd preface with, "Well, you know I know all about these people from previous chapters," and then fill her in on some of their background information before proceeding with the snapshot on hand. I couldn't put it down. It was like reading a nonfiction novel. A literary community photo album. A group biography. And yet your book is also an autobiography. You share your beautiful and tragic and unique story with clarity, honesty and confidence. It is a gift.

In my second reading of the book, I discovered the threads of your intense story and I came to appreciate you more. You recount your experience of having a son with dwarfism and then of losing him to sudden infant death syndrome (SIDS). You are a brave woman for sharing your situation with the public. One thing that struck me was that the biggest crisis in your life had nothing to do with you being a lesbian. In the book you enumerate several minor problems you have faced as a lesbian parent—a few people's ignorance impinging on an otherwise perfect (or at least perfectly normal) day. But your tragedy (coupled with the ensuing infertility) are problems faced by all types of straight women. And now as a parent (and not just a "lesbian parent"), I have a more intimate and powerful reaction to what it takes to survive losing a child or what it takes to face the scary aspects of motherhood.

All I need to remind me of the importance of publishing a letter like this, of being interviewed for an article on lesbian and gay families, of responding affirmatively to negative comments at the doctor's office, at the supermarket, on the airplane—is to remember what reading your book has done for me.

All that presence in one place, presence that is a present. I never forget how revealing oneself—being so visible—has its risks, not to mention its tedium. Your book is so wonderfully positive, but not naive, about real challenges, things that hurt. You're constructive, always with a head toward making things work out. While reflecting the struggles faced by those portrayed, you maintain an underlying optimism, an understanding

about families and parenting and "childing" (being a child) that embraces both the mundane and the extraordinary.

It's a cliché to say that many aspects of parenting are the same for everyone; we all change diapers, have nursing/feeding routines, bathe the little ones, create spaces and time for them to sleep and play, and consider their health, safety, intelligence, looks, and well-being. A cliché maybe, but all of that is true. However, as lesbian moms, we have a good share of unique issues to deal with.

In our case, we have a known donor who lives nearby and will know our daughter and be part of her life. Since most of our friends have used anonymous donors, we didn't have a lot of known-donor role models (maybe the next generation will have that in us!). Putting our feminist, hands-on, dialogue-based approach to family planning into practice, we brought our challenges and our donor to your practice. You set us on a path paved by those who did it when most people didn't know it could be done. You helped us see that joy and disappointment are common feelings for both parents and children, that we won't be perfect at this, and that giving our daughter a base of love, realism, and commitment is the best we can do.

And that we need to remain vigilant . . . and visible. People call us all the time now: "Can you believe the sperm bank won't take deposits from gay men?!"; "We're four months pregnant, and we have some friends in common who said we should get together to chat with you"; "How did you print your birth announcement . . . we're getting ready to make ours?" We love helping other people out, sharing our often humorous experiences of the whole baby making process. We're compelled to make it possible for straight people and people who aren't parents to imagine our lives and include us in this living. (We draw the line at talk shows. I just can't handle the smug carelessness of them, and I doubt the context fosters teaching or learning.)

I just finished writing a letter to my mother about how parenting has changed over the last thirty years in general and our particularly different situations. One thing that came up in that letter is the primary role of ac-

tivism in my life and how in parenting I will be no less visible than before. Like Etheridge and Cypher and their fame, like you and your published writing, and like my mother who has to come out as a grandmother with a lesbian daughter every time she comes out as a grandmother, I am committed to visibly and energetically being out about who I am and what my life is really like. If it can make the kind of difference your experience made for us, I'm happy and proud to do it.

April, not only did you pave this road but you're still on it. You wrote the book when your children Emily and Jesse were eight and eleven. Knowing what you now know, what would you change in another edition of the book? Are there things you would have done differently in your parenting? And now that the kids are older, I wonder what's new for you, not only in their lives (and yours) but in the life of a society coming to terms with families like ours. You continue your psychotherapy practice, which includes many lesbian and gay families. Are you drafting the sequel to the handbook yet? (Maybe "Lesbians and Gay Men Living with Adolescents"!) What do you love about being a mom?

I share with you and your family the happiness of my family, wherever and however that takes us. Thank you for being here before us. And thank you for being here with us.

Love,
Catherine

◆ ◆ ◆

Dear Catherine,

Your letter is a blessing.

"Blessing." That's a word I never used to use, having come of age as a tough-minded atheist. Words like "blessing" made me squeamish. Reminded me of smiling gray-haired church ladies pinching babies' cheeks. Sentimental. Even repulsive. I'm a slow learner.

I am looking at a photo you sent me of your beautiful Sadie Rain at one day old—soft and new in the world. A blessing, for sure.

I look at Sadie Rain's photo and see you and Melanie. I see your donor

and your parents and your friends and all the lives you touch. I picture you at the dinner table spreading our culture, talking about creating your special family—how it felt, your future plans. Teaching all who come to know you that it's love and character that matter, not gender or race or sexual orientation.

I see the children of your friends—the burgeoning offspring of our lesbian and gay baby boom—mostly babies and toddlers but ranging on up to school-age children. And the older children I know with gay and lesbian parents, the ones who are even young adults now. We are raising an amazing generation of young people. They have a consciousness about the world, about the nature of difference, about the need to keep working for change. They are our newest activists. The lessons that we've struggled so hard to learn are, for them, just a part of breathing. Their struggles, in turn, will unearth truths we have not yet imagined.

We are creating goodness. A blessing.

They ask us all the time, as lesbians, gay men, bisexuals, and transgendered people, why we want to have children. An important question. A question that everyone who wants children should have to answer. I have often answered defensively, politically, that we want to have children for the same reasons heterosexuals want children. But heterosexuals are rarely asked why they decide to have children. Their having children is such a "given" that it would be rude to ask whether a conception was passionately desired, planned, and prepared for or whether it simply happened unawares in the conjugal bed. As long as a man and woman are married and decide to raise children, it seems, the rationale or lack thereof makes no difference. As if once the cigars are passed out and photos taken (like yours of Sadie Rain at one day old), it's all the same how you got there.

The care and responsibility with which you came to my office is the very model of goodness. You came for help in preparing for parenthood. You asked, "How can Melanie and I be clear about the roles of parent, and of donor? How can we resolve differences without hurting each other? What can we learn about each others' perspective? How are we

each affected by where we come from? by the world we live in? How can we promote trust among the three adults creating this baby? What are the best ways to help our little one understand these things as she grows?"

Implicit in your questions, in the very act of your seeking my help, was your answer to "why have a child?" You were having a child to create goodness. You wanted to know that Sadie Rain would find goodness in her family. That she would feel secure, that her parents would bring her the most mature and prepared love, along with their many talents and resources. That she would grow up to spread that light wherever life might take her. You were having a child to add your measure of sweetness to the continuity of life.

There are, of course, fringe benefits to parenting. By now you have already been enraptured by smiles so sweet it almost makes you ache. You know the joy of living intensely in the moment. You feel pride in her achievements and in the admiration of the world. You find yourself being sillier—laughing more than even in your own childhood. And you are daily gaining the self-esteem that accrues to those who do a hard job well. But none of these is the reason you had Sadie Rain. You will love her just as much, and even love being her mother just as much, when she is sad, angry, sick, when she intrudes on you, rejects you, won't let you sleep, or when she stumbles and makes mistakes or even takes wrong turns in her life. We may even love our children more at these times, because that's when they need our love the most.

No, the overarching reason for having a child the way you did—with so much loving preparation—is spiritual. It is born of a sense of connectedness with life to come, with the infinite, with forces of love and compassion too awesome to name.

I have just been blessed with a newborn godson. Just at a time when I was missing the sounds of babyhood in our house but too old now to consider becoming a full parent to another child, a dear friend has given birth and chosen us as godparents. She is Nigerian, and this is her first child. She gave him a Nigerian middle name, Chukwudi, which means, "Now I know there is God." I am a former hard-boiled atheist who now knows

exactly what she means. Whatever your religious beliefs may or may not be, you also know what she means.

What I have learned from being a parent at this time in history, a lesbian parent, watching this amazing coming of age of our gay and lesbian brothers and sisters, is that life is not lived in isolation. Parenting both intensifies this universal truth and makes us take more notice of it. At one time I actually believed that life is lived pretty much alone. Not that I didn't always need people and gravitate toward relationships—I did. But I also imagined that our lives were separate, individual. As I get older I know better.

Once you are a parent there is never again a time when your actions affect no one but you. Your life is permanently and radically transformed by the vulnerability of your child. And by her thirst to learn all she can from you about what it is to be alive. And by her growing eagerness to go out and greet the world with what she's learned. If you didn't know it before, you know it now: That your actions, your character, your decisions, your words are all seeds, spreading in ever-widening circles, changing the landscape.

When Susan and I became parents we did it boldly, at times defiantly, certainly a bit defensively. We were more alone than a family should have to be. Unaffirmed in our union, suspect in our intentions, the object of a fair amount of tongue-clucking and incredulous head-shaking. I'm glad we never had to hear most of what was said about us.

But we had the same mission in parenting that you have. That goodness thing. And we came to see, gradually, that other people respond to goodness. That when we were open about our lesbianism and our family, conveying our humanness in all its mottled glory, people came forward. People who were previously counted among the gay-negative or at least the gay-cautious, if not the outright heterosexual supremacist, found themselves rethinking their prejudices. They found themselves laughing with us and feeling for us when we suffered, sometimes despite themselves. Goodness finds more of the same wherever it goes.

And then lesbians and gay men, many of whom viewed our joining the

ranks of parents as tantamount to sleeping with the enemy—afraid that it might bring down the wrath of the system upon them, that it might challenge them to look at their own choices, that it might cause them to grieve for aspects of life that had been denied them, or just that it might stretch the envelope of their newfound pride—began to understand. A light began to dawn on the collective consciousness of our community, and they started to welcome us in—hungry for information, for contact, for options to explore their own yearnings to nurture and create.

You asked what I would have done differently, knowing what I know now. I would have been less afraid. Susan and I were really so afraid in those uncharted waters. Afraid that we wouldn't be good enough parents. That our children would not grow up kind or responsible or with an understanding of the consequences of their actions or with an ability to discipline their talents or to communicate their needs. Afraid that they would not be happy, might not like themselves, might not make good and loving friendships. Afraid, of course, that they would suffer from homophobia. And secretly fearful that they might not love us or might resent having been brought into this pioneer family.

I think the biggest mistakes I've made as a parent have come from fear. From feeling that I had to control the outcome. Putting pressure on myself and the kids to insure that all would go well.

I know now that you simply have to love them, teach them, and retain a sense of wonder about who they are. Not that you should stop caring intensely about doing the best job you can as a parent. But keep the bigger picture in mind, and don't get too dismayed by stones in the path. Trust that your loving attention to them, your generosity of spirit with them, your honesty, and the courage and integrity with which you live your own life will provide all the nourishment they need to become who they are meant to be. Enjoy them. Be open to surprises. Realize that they may be inventing a way of being wonderful that hadn't occurred to you.

One of the things I feared most was adolescence. Don't we all? Don't we live in a culture which is phobic about the intense explosion of energy and sexuality that happen in the teenage years? Our foes on the political right wing, when confronted with tableaux of our beautiful children, in-

tone ominously, "Yes, but just wait until these youngsters reach adolescence." They stir up our own fears that adolescence will be an unmanageable, largely angry and rebellious, painful and unhappy, even dangerous time.

I can only say that I was unprepared for the joy of watching my children become teenagers. Suddenly, it seemed, they were bursting with things to say about life, the world, politics, philosophy, music. They had opinions on everything and an urgency about voicing them, wearing them, living them out. Hair was dyed green (and worse). Clothing got creative, to say the least. Activities, friends, interests all took on a dizzying intensity. And yet the thing I feared most has never come to pass: I have not lost them to sullenness, alienation, or uncommunicativeness. Instead it has been clear that while they are eager for me to dislike their tastes, they also expect to find in me a willing and respectful ear, someone to share a good laugh with, and someone they trust to help them with the difficult judgments they are suddenly challenged to make. It is an incredible joy for me to hold that position. And it has been immense fun.

Susan and I no longer feel alone as parents. We are accompanied through this profound journey by an extended chosen family that carries us through hard times and laughs with us through good ones. It was absurd to imagine we could do this alone but foolish to worry that we would have to. You and Melanie and your beautiful daughter and your other children to come are part of our extended family. A blessing indeed.

We have watched the world change in a decade and a half. The ranks of gay and lesbian parenting groups continue to swell, as do the support and peer groups for kids of diverse families. Queer parents swarm on the Internet. We are almost ho-hum in the media. Sadie Rain's future teachers will not be shocked that she has lesbian mothers—at the very least they will have read of others. I still occasionally meet a cab driver from a faraway country who says, when I tell him about my family, that he has never heard of such a thing, but they are harder and harder to find. The boundaries between gay and straight are a little softer, the realities a little more truthful.

Sadie Rain has entered a world of powerful beauty for sure but also of

great need. The care and loving thoughtfulness with which she came to be are a blessing. They will allow her special gifts to flower unencumbered by fear and shame. Her light will be felt by many.

So thank you. For giving me the opportunity to be a mentor and role model to you. For letting the seeds of my heart grow in yours and in Sadie Rain's and wherever the winds will carry them. For being part of my growing certainty that God is among us.

With love and gratitude,
April Martin

Contributor Biographies

Jennifer Baumgardner, born in 1970, is a writer and editor originally from Fargo, North Dakota. She immigrated to New York City's East Village in 1992 and was an editor at *Ms.* magazine until 1997. Her work has appeared in *Bust, The Nation, Jane,* and *Ms.,* among other magazines, as well as the book *ALT.CULTURE.* She was an editor for *MAMM* until recently and is now at work on a book about feminism. Judy Blume's degree of importance in Baumgardner's childhood was somewhere between Mother Goose and Jesus.

Judy Blume is the author of twenty-two books including *Are You There God? It's Me, Margaret; Forever...;* and her latest novel for adult readers, *Summer Sisters.* She is an active spokesperson for the National Coalition Against Censorship, working to protect intellectual freedom. She and her husband live in Key West and Martha's Vineyard. Visit Judy Blume at her website: www.judyblume.com.

Anna Bondoc is a first-generation Filipina-American who has worked as an advocate for young women's reproductive health, a chef, and a food writer. She recently completed a Chef's Apprenticeship at The Natural Gourmet Cookery School in New York City, which inspired her to write about the relationship between food and health. Her writing has appeared in *A. Magazine: Inside Asian America,* the *Asian/Pacific American Journal,* and the anthology, *To Be Real: Telling the Truth and Changing the Face of Feminism* (Anchor Books, 1995).

Sandra Butler is a writer, counselor, trainer, and organizer in the fields of child assault and violence against women. She wrote the pioneering work, *Conspiracy of Silence: The Trauma of Incest;* and she is the co-author with Barbara Rosenblum of *Cancer in Two Voices.*

Phyllis Chesler, Ph.D., is an acclaimed psychologist and feminist. She is a professor of psychology and women's studies and is the author of nine books, including *Women and Madness, Mothers on Trial,* and most recently, *Letters to a Young Feminist.*

Christine Choy is a producer, director, and cinematographer who has worked on over forty-five films including the Academy Award-nominated "Who Killed Vincent Chin" (1989). She is a founder of Third World Newsreel and the National Asian American Telecommunications Association. Ms. Choy has received the Peabody Award for Excellence in Broadcast Journalism, a Guggenheim Memorial Fellowship, Mellon Fellowship, Rockefeller Fellowship, and the American Film Institute Woman's Director Fellowship. She was a Professor of Film and Television at New York University and recently was named Director (Dean), School of Creative Media, at the City University of Hong Kong.

Pearl Cleage, best known for her plays *Flyin' West* and *Blues for an Alabama Sky,* has also published several books of nonfiction, including *Mad at Miles: A Black Woman's Guide to Truth* and *Deals with the Devil and Other Reasons to Riot.* Ms. Cleage recently published a novel, *What Looks Like Crazy on an Ordinary Day.* She resides in Atlanta, Georgia.

Annemarie Colbin, has a Masters degree in Holistic Nutrition and is a Certified Health Education Specialist, lecturer and consultant. She has been teaching about food and health since 1972. She is the author of *The Book of Whole Meals, Food and Healing,* the award-winning *The Natural Gourmet* and *Food and Our Bones: The Natural Way to Prevent Osteoporosis.* She has appeared on numerous radio and television shows around the country and abroad and is the recipient of the Roundtable for Women in Foodservice 1987 Pacesetter Award in Education and the Avon 1993 Women of Enterprise Award. Her website is: www.foodandhealing. com.

Karin Cook is the author of the novel *What Girls Learn,* which won the American Library Association/Booklist Alex Award and was a finalist for the Barnes & Noble Discover Great New Writers Award. A youth advocate and health educator, Cook is currently the Director of Public Relations for The Door, a multi-service youth center. She lives in New York City and Provincetown, Massachusetts.

Meg Daly is the editor of *Surface Tension: Love, Sex, and Politics Between Lesbians and Straight Women;* her writing has appeared in *The Women's Review of Books* and

Tikkun, as well as several anthologies. She works at In Other Words Women's Books and Resources in Portland, Oregon, where she hosts a women's open mic reading series. She is also an active volunteer for the Cascade AIDS Project.

Angela Y. Davis is Professor of History of Consciousness at the University of California, Santa Cruz. She is the author of five books, including her autobiography; *Women, Race & Class;* and her most recent work, *Blues Legacies and Black Feminism.* Her next collection of essays will examine the proliferation of the expansion of the prison industrial complex in the United States.

Eisa Davis' writing has appeared in *To Be Real: Telling the Truth and Changing the Face of Feminism, The Source, RapSheet,* and *Urb* magazine. She is a graduate of Harvard College and received her masters in acting and playwriting from the Actors Studio School of Dramatic Arts in New York. Eisa has appeared in Athol Fugard's "Valley Song," and in Adrienne Kennedy's Obie award-winning "June and Jean in Concert" at the Public Theatre. She loves Debussy and grits.

Susan Faludi is the author of *Backlash: The Undeclared War Against American Women* (Crown, 1991), which won the National Book Critics Circle Award in 1991. She is at work on a forthcoming book on the masculinity crisis, which will be published by William Morrow & Co. Faludi won the Pulitzer Prize for Explanatory Journalism in 1991.

Liza Featherstone is a freelance critic and journalist who has written on feminism for *Ms., The Nation, In These Times, The Boston Phoenix, Nerve,* and other publications. She lives in Brooklyn, New York.

Nisha Ganatra's first short film, "Generation seX," premiered at the Women and Film Festival in 1994 at Universal Studios, California, and received an honorable mention from HBO's New Writer's Project. Nisha recently graduated from the Film Program at NYU where she was the recipient of the 1995 and 1996 Tisch Fellowship. She is a dedicated activist, scholar, and filmmaker who is committed to making films that transform the norms of accepted images in popular media.

Jennifer Gonnerman, born in 1971, is a staff writer at *The Village Voice.* Her work has also appeared in *Ms., Vibe, Glamour, Spin, Feed, New York, Newsday, The Nation,* and *The New York Observer.* In 1996 and 1997, she won a Front Page Award from the Newswomen's Club of New York.

Emily Gordon lives in New York and is *Newsday's* assistant book editor. Her articles have appeared in *The Nation, The Village Voice, In These Times, Salon* and other publications.

Born in 1971, **Sara Hammel** is a journalist based in New York City. In 1995, she was a reporter for the *Middlesex News* newspaper in Massachusetts and joined a six-month Army study of women's strength at a local base. She wrote a series of articles about her Army experience and the thirty civilian women who participated in the study. The series ran for almost a year, and won national and regional awards. Her writing has also appeared in *Shape, Glamour,* and *U.S. News & World Report.* A former ranked tennis player in New England, she is currently a reporter in the New York bureau of *U.S. News & World Report,* covering health and technology.

Jennifer Hunter has been a Witch all her life, but first figured it out at age sixteen. She is the author of *21st Century Wicca.* She works as a magazine editor and freelance writer, and lives with her partner, Orin, and their fiendish cat, Smudge.

Emily Jenkins is the author of *Tongue First: Adventures in Physical Culture* (Owl Books, 1998). She has a Ph.D. in English from Columbia University, and is also co-author of a children's novel, *The Secret Life of Billie's Uncle Myron* (Holt, 1996). She contributed an article, "Photographs and My Faux-Lesbian Body" to Meg Daly's last essay anthology, *Surface Tension,* and her writing has been seen in *Swing, Mademoiselle, Glamour, Nerve,* and *Feed.*

Tayari Jones is currently completing a Ph.D. in English at Arizona State University. Her prose has appeared in several anthologies, and she is currently at work on a novel.

Yeong hae Jung is a third generation Korean who was born in Tokyo in 1960. She is an Assistant Professor of Sociology, Korean Culture, and Women's Studies at Hiroshima Shudo University. Since 1980 she has participated in the antidiscrimination movement against ethnic minorities in Japan. She organizes a women's network in Hiroshima to stop sexual violence against women and children and writes about postcolonial feminism, multicultural citizenship and the postnational state of Japan.

Elaine H. Kim is Professor of Asian American Studies and Chair of the Comparative Ethnic Studies Department at UC Berkeley. She is the author of *Asian*

American Literature: An Introduction to the Writings and Their Social Context, the co-editor of many books including *Dangerous Women: Gender and Korean Nationalism,* and the co-producer of several films. She is a co-founder and member of the Board of Directors of Asian Women United of California, and co-founder of the Korean Community Center of the East Bay and of Asian Immigrant Women Advocates.

Marie G. Lee is a second-generation Korean American who was born and raised in Hibbing, Minnesota. She is the author of the novel, *Finding My Voice,* which won the 1993 Friends of American Writers Award, as well as several other novels. Her short stories have appeared in a variety of journals and anthologies and one was an honorable mention for the O. Henry Award. Ms. Lee is a founder and former president of the Asian American Writers' Workshop. She is a graduate of Brown University and has taught literature/creative writing at Yale University. She is a 1997–1998 Fulbright Scholar to Korea.

Wilma Pearl Mankiller is both the first woman deputy chief and first woman principal chief of the Cherokee Nation of Oklahoma. She was born in Tahlequah, Oklahoma, the capital of the Cherokee Nation, in 1945. She was entered into the Woman's Hall of Fame in New York City in 1994 and is the author, with Michael Wallis, of *Mankiller: A Chief and Her People.*

Dr. April Martin is a clinical psychologist in private practice in New York City. She is the author of *The Lesbian and Gay Parenting Handbook: Creating and Raising Our Families.* April and her life partner of twenty years are raising their two children, ages sixteen and thirteen, both conceived by donor insemination. She wants especially to thank queer parents and their children for the community of loving support created by their courage.

Betty Millard, although not a contemporary of Abe Lincoln, was born in an Illinois log house. Like Lincoln, she has spent time in the nation's capital, most pointedly by testifying as a hostile witness before the House Un-American Activities Committee. Her claim to fame is coming out as a lesbian in her eighties.

Mariah Burton Nelson, a former Stanford and professional basketball player, is the author of *Are We Winning Yet?, The Stronger Women Get, the More Men Love Football,* and *Embracing Victory: Life Lessons in Competition and Compassion.* She has won several awards for her writing and public speaking.

Suzanne Pharr is founder of The Women's Project in Little Rock, Arkansas, and a long-time economic and social justice organizer from the South. She is the author of *In the Time of the Right: Reflections on Liberation* and *Homophobia: A Weapon of Sexism.*

Katha Pollitt is the author of *Reasonable Creatures: Essays on Women and Feminism* (Vintage) and *Antarctic Traveler* (Knopf), a book of poems. She has won many grants and awards for her writing, including the National Book Critics Circle Award in Poetry, a national magazine Award for Essays and Criticism, and grants from the Guggenheim and Whiting Foundations. She writes a column, "Subject to Debate," for *The Nation.*

Amelia (Amy) Richards is a co-founder of the Third Wave Foundation, a contributing editor to *Ms.* magazine, and a research and editorial associate to Gloria Steinem. She works on a consulting basis with the Ms. Foundation for Women, Voters for Choice, First Nations Development Institute, and for other social justice organizations. Amelia is also the voice behind "Ask Amy"—an on-line activist advice column located at www.feminist.com. Her writings can be found in *Listen Up! Voices from the Next Feminist Generation, Ms. Magazine, The New Internationalist* and *Bust.* In 1995, *Who Cares Magazine* chose her as one of twenty-five Young Visionaries and in 1997 *Ms. Magazine* profiled her as "21 for the 21st: Leaders for the Next Century."

Catherine Gund Saalfield is a film/videomaker, writer, teacher and activist. Her productions include "Hallelujah! Ron Athey: A Story of Deliverance"; "When Democracy Works"; "Positive: Life with HIV"; "Sacred Lies Civil Truths"; "Not Just Passing Through"; "Among Good Christian Peoples"; "I'm You You're Me—Women Surviving Prison Living with AIDS"; and "Keep Your Laws Off My Body"; as well as work with the collectives DIVA TV and Paper Tiger Television. She currently serves on the boards of The National Gay and Lesbian Task Force, The Third Wave Foundation, Reality Dance Company, and The Vera List Center for Art and Politics.

Catherine Sameh has been an activist in Portland, Oregon for over 15 years. She writes a regular column for the *Portland Alliance* and *Against the Current.* Catherine is also a co-founder and the manager of In Other Words Women's Books and Resources, a non-profit feminist bookstore in Portland.

Ntozake Shange is the author of the Obie Award–winning *For Colored Girls*

Who Have Considered Suicide/When the Rainbow is Enuf. She has also written several novels, including *Sassafrass, Cypress and Indigo; Betsey Brown; and Liliane: Resurrection of the Daughter,* and is currently working on her new novel, *Some Sing, Some Cry.* Ms. Shange is Associate Professor of Drama & English at Prairie View A&M University in Texas. She was named "A Living Legend in Black Theatre" by The National Black Theatre Festival in 1995 and Heavyweight Poetry Champion of the World 1992-94.

Lisa Springer, a fiction and essay writer, has been published in *Ikon, Cover,* and the anthology *Surface Tension.* She received a B.A. from Barnard College and an M.F.A. from Warren Wilson College. She has been a resident artist at the Millay Colony, the Virginia Center for the Creative Arts, and Ragdale. She teaches at NYU and is currently at work on a novel.

Starhawk is a witch, ecofeminist, peace activist and the author of several books, including *The Spiral Dance* and *Truth or Dare.* She is co-founder of the Reclaiming Collective, a group of women and men working to unify spirit and politics in the San Francisco Bay Area.

Gloria Steinem is one of the most influential writers, editors and activists of our time. She travels in this and other countries as a lecturer and feminist organizer, and is a frequent media interviewer and spokeswoman on issues of equality. She has helped to found the Women's Action Alliance, the National Women's Political Caucus, and the Coalition of Labor Union Women. In 1972 she co-founded *Ms. Magazine,* the international feminist bi-monthly, and she is the founding President of the Ms. Foundation for Women, a national multi-racial women's fund that supports grassroots projects to empower women and girls.

Arie Parks Taylor, a long-time champion of the rights for women and minorities, was the first Black noncommissioned officer in charge of all Women's Air Force (WAF) training, the first Black WAF classroom instructor, and was named Airman of the Month. She received the Martin Luther King Jr. Humanitarian Award in 1990 and the Colorado Sickle Cell Association Individual Humanitarian Award in 1991.

Lisa Tiger is a member of the Muscogee Nation. An artist, public speaker, fitness instructor, and AIDS educator, Lisa travels nationwide speaking at colleges, high schools, clinics and conferences. Her most cherished wish is to see a day when all

Native American tribes are in alliance to preserve the health, history and culture of each individual and community.

Eisa Nefertari Ulen received a 1995 Frederick Douglass Creative Arts Center Fellowship for Young African American Fiction Writers to complete her first novel, *Spirit's Returning Eye*. She has contributed to *Am I the Last Virgin? Ten African-American Reflections on Sex and Love* and *Scared Fire: QBR'S Guide to 100 Essential Black Books*. She has written for *Vibe, Emerge, The Source,* and *Heart & Soul*. Eisa earned a B.A. from Sarah Lawrence College, an M.A. at Columbia University, and now teaches English composition and literature at New York City's Hunter College.

Patricia Miye Wakida was born in San Diego, California, in the year of the dog (1970) but spent her significant childhood years in Hawaii. She received her B.A. in English literature from Mills College in Oakland, California, and co-founded a literary magazine for women of color. She is currently a member of "Rice Papers" an Oakland-based Asian American women's writing group. She also spends time in Japan handmaking paper.

Copyright Acknowledgments